# Experimental Drawing

# Experimental Drawing

## By Robert Kaupelis

WATSON-GUPTILL PUBLICATIONS/NEW YORK
PITMAN HOUSE/LONDON

Copyright © 1980 by Robert Kaupelis

First published in 1980 in the United States and Canada by Watson-Guptill Publications,
a division of Billboard Publications, Inc.,
1515 Broadway, New York, N.Y. 10036

**Library of Congress Cataloging in Publication Data**
Kaupelis, Robert.
  Experimental drawing.
  Bibliography: p.
  Includes index.
  1. Drawing—Study and teaching.   2. Drawing—
Technique.   I. Title.
NC660.K34   1980          741.2          79-27803
ISBN 0-8230-1618-8

Published in Great Britian by Pitman House, Ltd.,
39 Parker Street, London WC2B 5PB
ISBN 0-273-01512-5

Manufactured in U.S.A.

5   6   7   8   9/90   89   88

Dedicated to Stanley Czurles, Howard Conant, and
Angiola Churchill, who made it all possible

## Acknowledgments

It was first Howard Conant and presently Angiola Churchill who have made it possible for me to teach drawing at New York University, and my indebtedness to them is immeasurable. At Watson-Guptill, Don Holden encouraged me to get started on another volume on drawing and then turned me over to Dot Spencer, whose endurance as an editor is formidable. Bonnie Silverstein helped enormously with her final editing, while Marsha Melnick's cheerful countenance helped all of us. The final appearance of this book attests to the design capabilities of Jay Anning. The museums, galleries, artists, and students who allowed me to reproduce their work are noted throughout, and I am particularly anguished over those artists and students who were omitted because of editorial and space limitations. Pecky, Khym, and Khy were very patient and helped me get through many rough days. Finally, I am eternally grateful to the hundreds of New York University students who have so enriched my life. Thank you.

# Contents

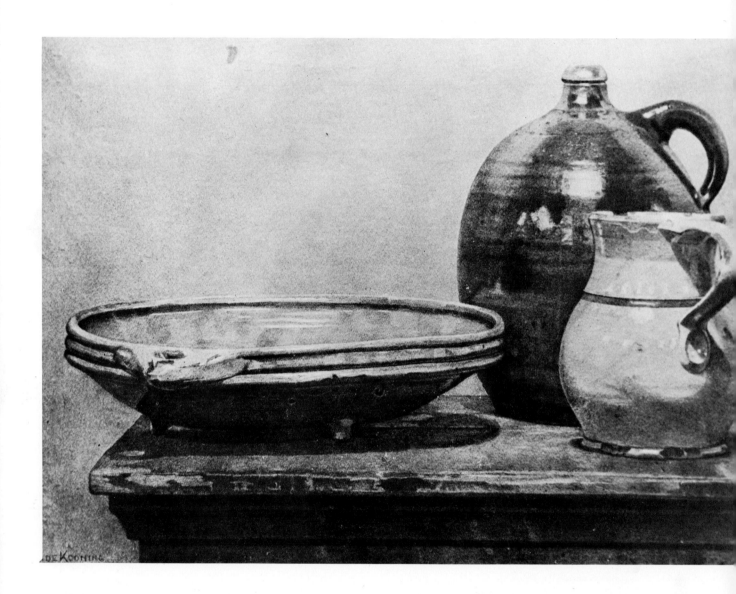

**1.1  Willem deKooning** (Contemporary American). Dish with Jugs, c. 1921. Charcoal on gray paper, 19¾" × 25⅜" (50 × 65 cm). Private Collection.

Born in 1904, deKooning was about 18 years old when he produced this work in his native Holland. He later moved to America and, along with Jackson Pollack, was instrumental in the development of Abstract Expressionism. He is particularly noted for his violent, mutilated, and fractured "Woman" series. This impressive work becomes even more so when it is compared to the more recent "blind" drawing of 1966 **(Figure 8.4)**. It comes as a surprise to most people who are familiar with deKooning's work to discover that he was trained in a traditional and academic manner. As impressed as we are with the discipline and control of tonality in this trompe l'oeil work, the energy and sheer originality of the Crucifixion figure is almost overwhelming. The former is more dependent on "seeing" whereas the latter demands that we empathize and "feel" along with the artist—it demands a more active participation on the viewer's part. Was it necessary for deKooning to be able to produce this kind of a drawing before working in the expressive, violent mode of his later style?

# A Few Words...

This book is about drawing; about the experience of drawing and seeing drawings; and about the possibilities of extending our traditional concepts concerning the parameters of drawing. Having taught drawing at New York University for nearly a quarter of a century, I have had ample opportunity to work with students ranging from non-art majors (about a quarter of the student work illustrated comes from that group) to undergraduate art students and also with students who are pursuing their masters and doctoral degrees. For the *most part* I have found it difficult to differentiate between the course content which should be offered to these highly divergent groups—I cannot state that a student *must* have had this experience and learned that technique before he engages in other kinds of drawing experiences.

Yes, I realize that there is a vast difference between a freshman and a graduate student in art, but I also know that there is no such thing as beginning creative/expressive activity, intermediate creative/expressive activity, and graduate creative/expressive activity. On any of these levels students may have profound experiences and produce work of high aesthetic merit. If a student does not know the meaning of values or how to produce a broad range of them with a variety of materials, I thoroughly believe that he should acquire this knowledge at once. However, I would continue to maintain that although it is impossible to state a prescribed order in which things must be learned or experienced, there *may be* some logical sequences in developing skills such as perspective rendering or the modeling of form in pen and ink. In any event, all that I can do as a teacher and all that this book can do is set up situations that make it possible for students to have meaningful experiences in drawing, whether they are just beginning or more advanced.

My first book was called *Learning To Draw* and my publisher at first suggested that this new book might be directed toward advanced students. Even though I teach advanced drawing, I wasn't at all sure of how to put such information into book form. The primary difference between beginning and advanced is that the advanced student usually has greater self-motivation and, having had a wider range of experiences in drawing, he may begin to "zero in" on some concept or form-idea with which he has become particularly intrigued. In workshop situations where the students have mixed backgrounds, I find advanced students may want "to do their own thing," but more often than not, they also want to once again try some of the more structured experiences designed for the students with little or no prior experience.

Comparing the drawing Michelangelo drew when he was 14 years old (**Figure 7.2**) with the one some claim to be his last drawing (**Figure 1.2**) may be useful. The problem in each case was to draw the human figure—but what a difference! Another revealing comparison is the deKooning drawing of *Plates and Jugs* (**Figure 1.1**) with the drawing he made at the height of his powers *with his eyes shut* (**Figure 8.4**). The point is that all of the problems suggested in this book can be dealt with by anyone just as long as you accept and know where you are. No! You should know where you are, but you should *never* accept it. I don't know a single artist who isn't constantly frustrated just because he doesn't accept where he is—he is always trying to do better!

## Scope of the Book

This volume covers a tremendous amount of ground—all the way from creating form through contour drawings, to drawing with computers. Chapter 2 covers contour, gesture, and modeled drawing and suggests innumerable variations on these basic approaches. Beginners will probably want to spend more time with these modes of drawing than students who have already experienced them in depth. They're basic, not just in the sense of a place to begin; rather they are modes that artists work with throughout their careers.

"Organization/Structure: Making Things 'Work Together' " is the subject of Chapter 3, which deals briefly with theoretical factors involved in organizing visual elements; and then proceeds to suggest a number of exercises in which you can apply the theoretical underpinnings.

Chapter 4 "Using Light and Dark" covers a vast range of exercises designed to help you become more aware of tone and some of its applications in drawing. Topics range from making value scales as *creative problems*, to rendering eggs, to working in the dark from an out-of-focus projected image. Since the advent of the camera, artists have been making use of photographs as an aid. Chapter 5 discusses the merits of using photographs and describes several modes of working. The use of grids and projected images as means to arrive at creative/expressive form is also included in this section. The creative advantages of sticking with one mode, concept, subject, or material is the thrust of Chapter 6 where, in addition to examining several case studies, you'll be asked to produce 50 drawings in four hours!

Artists as disparate as Picasso and Michelangelo copied from or otherwise used those masters who preceded them to enrich and extend their own work. The pros and cons of this practice, as well as numerous exercises for your own development, are covered in Chapter 7. Finally, if your present concept of drawing leans

**1.2 Michelangelo** (Italian, 1475–1564). *Madonna and Child. Black chalk, 11" × 4½" (26.7 × 11.8 cm). British Museum, London.*

*Filled with tender emotion, this is considered by many scholars to be the last drawing created by Michelangelo. There is only the slightest suggestion of a robe, the lines of which are almost exact echoes of the figure itself. We can still discern the first indication of the head, which is larger and moved over to the right. The very slightest amount of tonal hatching indicates both the form of the pelvis and the plane created by the robe stretching between her legs. How many feet can you find? What is it that makes this drawing seem to want to walk right off of the page? Compare this with the Michelangelo that was drawn at age 14* **(Figure 7.2)***!*

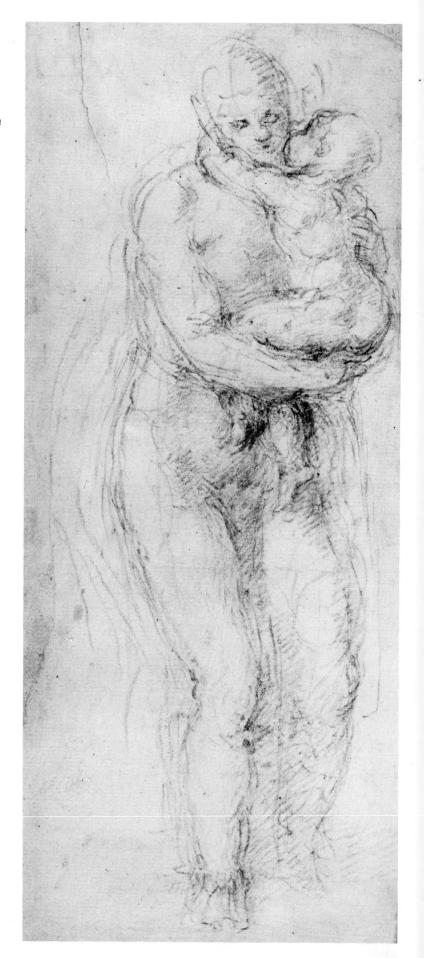

**1.3** **Robert Henri** *(American, 1865–1929). Woman Kneeling on a Chair. Drybrush drawing, 8⁵/₁₆″ × 5⅝″ (22 × 14 cm). Philadelphia Museum of Art. Photo: A.J. Wyatt.*

At the turn of the century, Henri was the leader of a group of former newspaper illustrators who grew tired of the ideal and academic subjects used by their peers. The group has been called "The Eight" and, pejoratively, "The Ashcan School" because their subjects were usually very ordinary and even vulgar. Henri was a most influential teacher and wrote a book called The Art Spirit, which I recommend to you. Compared to the emotional tenderness communicated in Michelangelo's drawing **(Figure 1.2),** the feeling here is almost coarse and brazen. This quality is communicated more by the way in which he used his materials than in his choice of subject or pose. Using a brush with very little ink (drybrush), Henri executed the drawing in a rapid and painterly (as opposed to a tight, linear) fashion. The "center of interest" is a shadow rather than any particular aspect of the figure! Note how a single stroke of the brush defines knee, dress, and chair.

**1.4** **Amedeo Modigliani** *(Italian, 1884–1920). Caryatid. Crayon on paper, 28⅞″ × 23 ⅝″ (73 × 60 cm). Philadelphia Museum of Art.*

Drugs, disease, and alcohol all contributed to Modigliani's tragic and miserable life. Always without money, he would often exchange his quick portrait drawings, which he made in bar rooms, for a drink. The sculptor Constantin Brancusi introduced him to African sculpture, which had a profound and lasting effect on his work. Line was everything to Modigliani, even in paintings and in his colored drawings. This drawing of a Caryatid, which is a column or pilaster in the form of a female figure, often with upraised arms, shows that his primary means of expression consisted of overlapping forms, often with disjointed axes, elongation, distortion, and contraction. You can almost feel and see him going over the outline again and again as if to enclose it in stone. Compare this with the female forms drawn by Michelangelo **(Figure 1.2)** and Henri **(Figure 1.3).** All three drawings have validity for both the artists and the time in which they were executed. Yet, curiously, in some ways the Michelangelo looks more contemporary than the other two!

to the traditional and conservative modes, Chapter 8, "Drawing Extended," should help to stretch your blinders to some of the more contemporary ways of creating marks. These methods range from using copy machines, to working from models while blindfolded, to making group drawings which during the Dada era of modern art were given the exotic name of Exquisite Corpse.

## Materials

The work you produce is intimately related to the materials you have available because it is through particular materials that your drawing/thinking processes are formulated. All you need for drawing is an implement that makes marks and a surface or ground upon which to apply it. I believe that you have it within your power to create drawings that may border or even enter into the realm of the sublime with a mere pencil stump and a scrap of paper from the wastebasket. If that is all that is available to you, just plunge right ahead. However, being the creative individual that I'm sure you are, it won't be long before you discover how radically you can alter that pencil mark by smudging it with your fingers or making a completely different smudge by moistening your finger before rubbing. How different the pencil marks will appear on a crumpled paper as opposed to a smooth or a rough one! Nor will it be long before you discover that both a blunt point and a sharp point have individual characteristics; and that even these qualities can be changed by placing the paper on a hard surface or on a soft, padded surface or even on a rough surface, such as a brick. A few drops from your coffee cup or coke bottle and, like magic, you realize that color is right at your fingertips!

Aside from the economic factor, the use of found or scrap materials can *actually be an asset* to your drawing experiences. As of now, begin collecting anything that is capable of making or receiving a mark. You can draw on the clean side of discarded typing paper, gray cardboard and corrugated cardboard, cloth from satin to canvas, glass and plastic, stone and metal—all can be used for drawings. Franz Kline **(Figure 1.5)** used a telephone directory and deKooning often used newspapers, not because he couldn't afford better paper, but because he liked the *feel* of newspaper. Pencils, pens, and charcoal have been used by artists to make marks for centuries, but they have also used things such as their fingers, the butt of their hand, feathers and quills, twigs, grease, bones, acids, berry juice, mud, plaster, string, wire, sponges, erasers, breadcrumbs (to erase), graphite and metal dust, hair, and fur, to name a few. One of the hallmarks of artists is that they begin to see everything in their environment as having a potential use for either their immediate or some future artistic endeavor **(Figure 1.6)**.

Yes, I do believe in traditional materials for drawing. Purchase as many of them as possible and explore and exploit each one as suggested above for the pencil stub. A list of the materials I require of my students follows. If you have further questions about any of them, my previous book, *Learning to Draw*, explains them in greater detail.

### Materials for Drawing

The following materials are required of all students in my classes, but they may be supplemented with as many materials from the second, "recommended" list as possible. However, art majors are expected to have *all* the materials with them at each class.

1. Pink pearl eraser
2. White drawing paper, 70 lb, 18″ × 24″ (46 × 61 cm)
3. Charcoal pad, tinted paper, 18″ × 24″ (46 × 61 cm)
4. Newsprint paper, rough, 18″ × 24″ (46 × 61 cm)
5. Black drawing ink (Container should accept 1″/25mm brush)
6. Single-edge razor blades (for sharpening pencils)
7. Oil-based crayons (Cray-pas, for example)
8. Black lecturer's chalk, 1″×1″×3″ (25×25×7mm)
9. Assorted brushes, including a 1″ to 1½″ (25 to 38 mm) varnish brush and a striping brush
10. Cro-quil pen
11. Vine charcoal: soft, medium, and hard
12. Synthetic charcoal: soft, medium, and hard
13. Graphite drawing pencils: 6B, 4B, 2B, B, 2H, 4H, 6H
14. Bamboo pen
15. Sketch pad (any size you feel comfortable using)
16. Aspirin, economy size bottle of 1000!

### Recommended Materials

(though I don't really see how you can survive without them!)

1. Gum eraser
2. Kneaded eraser
3. Strathmore or Alexis drawing paper, or similar quality, medium weight
4. Sepia ink
5. Black and colored marking pens
6. General (brand) sketching pencil, chisel point
7. Carbon pencils: soft, medium, and hard
8. White Conté pencil
9. Lithographic crayon
10. Pastels or chalks, hard and soft (the largest assortment you can afford)
11. White lecturer's chalk, 1″×1″×3″ (25×25×75 mm)
12. Black Conté crayons
13. Workable fixative
14. Wax crayons, box of 64
15. Colored pencils
16. Pastel pencils, assorted colors
17. Red rope envelope or artist's portfolio, about 24″ × 30″ (61 × 76 cm)
18. India ink fountain pen
19. Rectangular graphite sticks: soft, medium, and hard
20. Drawing boards, slightly larger than paper
21. Masking tape

### Sketchbooks

Now get up! Go directly to the store and buy a sketchbook. Then come back and take the following oath: "I solemnly swear that from this day forward I shall never again be caught without a sketchbook during my waking hours, and also that I shall *use it* faithfully every day." Get the point? Amen.

**1.5  Franz Kline** (American, 1910–1962) Study for Clockface, c. 1951. Gouache on telephone book page, 11½" × 9½" (29 × 24 cm). Courtesy Dr. Theodore J. Edlich Jr. Photo: Lawrence Cherney.

It's nice to be able to have expensive materials with which to work. But very humble materials, even (as in this case) a discarded telephone directory, can be transformed into important works of art. Here the texture caused by the type actually enhances this work; it is nearly impossible to envision how it would look on a plain piece of paper. Abstractions based on gestural, calligraphic brushstrokes characterize Kline's mature work, which he often enlarged from small studies such as this one. Although the medium here was an opaque water-based paint called gouache, like deKooning, one of Kline's favorite materials at this time was cheap, fast-drying enamel housepaint. Note especially the variety of shapes and sizes of the negative shapes created by the surging, automatic lines. Each page has become an arena, "an arena in which to perform." Why not try a similar exercise in your own discarded telephone directory?

**1.6** **Man Ray** (Contemporary American, b. 1890). Drawing, 1915. Charcoal, 24⅝" × 19" (62.5 × 48 cm). Collection The Museum of Modern Art, New York, Mr. and Mrs. Donald B. Strauss Fund. Photo: Soiehi Sunami.

This work was executed two years after the young artist had experienced the avant-garde European painting exhibited in the Armory Show. The Armory Show was America's first big exposure to such divergent artistic behavior as Marcel Duchamp's Women Descending a Staircase, which the press disparagingly labeled "Explosion in a Shingle Factory." This drawing bears a strong resemblance to the earlier Duchamp work, and Man Ray has stated that it was ". . .based on human forms after studies in life classes (1912–1913)." Like most young artists, he was struggling to find his own mode of working through divergent artistic behavior, or, as he stated, "On leaving art school, this is among [my] early attempts to break away from academic training." Among later work were his aerographs, which resembled photographs but were executed with a spray gun using a three-dimensional stencil; drawings made using a spray gun, pen, and ink; and "assisted" readymades. But most important was his invention of rayograms, photographs of objects made without using a camera, which we now call "photograms."

## Choose Old/Modern Masters—To Love

To *experience* and *extend* both your appreciation of drawing and your ability to delineate form through the meaningful making of marks, for this first problem, I am going to ask you to begin with an old or modern master drawing. I believe that it is as important for you to study, live with, and love master drawings as it is to participate in the actual experience of drawing.

Although you should never miss the opportunity to view original drawings, I know that they are not readily accessible in most areas of the country and that you may have to rely on reproductions. Therefore, a number of books are listed in the Bibliography that contain a *variety* of drawings from different artistic periods, some of which are inexpensively produced in paperback. I know that all your life you have been taught not to damage books, but for this on-going exercise it is important for you to purchase one or more of these inexpensive books which you *will not feel guilty* about marking or even tearing out pages from on occasion. These should be considered *work*books rather than coffee-table decorations!

Glimpse quickly through the reproductions in your "master workbook" and without too much premeditation choose one which, for whatever reason, particularly seems to catch your eye. In as neat a fashion as you can, cut out this reproduction and, to protect it to some degree, either mount it on a piece of cardboard or insert it into a file folder.

Now for several days I'd like you to literally *live* with this drawing. You are to have an intimate affair with it. Carry it with you at all times. Let it be the first thing you look at in the morning and the last thing you look at before going to bed. Really get into and study this work. Just as you would with a new lover, try to find out all you can about the drawing and allow yourself to experience it to the utmost of your ability. As you would with a new friend or lover, introduce the drawing to your friends and acquaintances; let them look it over and ask for their responses to it. As in true life, your friends will often see both strengths and weaknesses that you have failed to notice. As you agree or disagree with their reactions, you may find yourself and your feelings about the work begin to change, either for better or worse. See if you can probe beyond the surface and get into the subtle and intimate facets of its existence—its beingness. Just as you might do with a person who is a new friend or lover, with more knowledge and experience of the drawing, you may find that it really isn't for you or, on the other hand, your initial positive reaction to it may be reinforced.

In your initial "affair" with a master drawing you chose one you reacted to positively. Now flip through your reproductions once again and select a work that basically "turns you off." Live with it, as you did with the prior drawing. As you spend more time looking and your knowledge of the drawing increases, you may discover that you do like a great deal about it—perhaps you will even grow to like it more than the first drawing with which you chose to live. *Perhaps not.*

Living with a drawing in this fashion can be a most profound experience. Certainly you'll come to know it better than any other drawing you've ever seen. Prior to these exercises, you probably have never spent more than one or two minutes looking at a particular drawing. These and/or other kinds of in-depth experiences with master drawings should become habitual in your life.

## Divergent Artistic Behavior

The problems and exercises in this volume are positive suggestions intended to trigger further exploration on your part. In my own classes a few students become quite upset in the beginning when, after having presented a problem to the class, I select examples of their work which has taken wide liberties—have *deviated in significant* ways from the problem—to discuss and often to praise! The suggested problems and processes are simply means to get you thinking and working; they're a hook to hang your "creative coat" on and it's not really crucial if the coat is hung on the hook next to it, across the room, or even next door.

By definition, truly creative art can only result from *divergent artistic behavior*—artistic behavior that was previously unknown or often unexpected and unexplored. Our artistic heritage—that is, artistic form as it has been practiced and *as we know it*—is important because there's much to be learned from it. But it also provides you with the "stuff" from which to deviate. There are many degrees of creative behavior within which most individual creative acts transpire. Most of us create work which remains within these parameters and is therefore not very high on a *universal* scale of creative accomplishment, though it may be *very high* in terms of our own experience and creative accomplishment to date. However, it is only when an artist breaks out of the current creative/expressive form parameters that the "shape" or "direction" or the "style" of art is changed. And this is a relatively rare event. It happened with Masaccio, Giotto, Cézanne, Pollack, and Calder among others, but most of us—and this is not in the least meant to be condescending—continue to produce art forms that are an amalgamation, a reinterpretation, or an extension of artistic modes and styles that are current with or preceded our own era.

I am not suggesting divergent behavior just to be superficially "different" or merely for the sake of attracting attention. But when a drawing or a form-idea *demands* something from you that you have not been taught or that is not a part of the suggested or "normal" steps in solving a problem, I am suggesting that you should not hesitate to *try it*. Almost all *significant* advances in art have looked strange, ugly, and generally *un*accessible, even to the artistic elite, when they were first experienced. (God! How I hated Pollack at one time!) Yet in time, new forms which are unfamiliar at first are absorbed into their historical context and most of us begin to take them for granted.

Work hard. Experiment. Use the suggestions proffered here and from other sources to your own ends (these ends are in a constant state of change). Try anything and everything! We often learn less from our successes than we do from our failures. (Picasso has suggested that painting is a series of destructions—a *positive* notion.) In any event, there really is no failure—only stumbles and steps as you proceed into the experience of the sublime, the realm of art.

**2.1** *Luca Cambiaso* (Italian, 1527–1585). *Hercules. Pen and ink, 10¾" × 5¹⁵/₁₆" (27 × 15 cm). Courtesy The Fogg Art Museum, Harvard University, Cambridge, Mass., Gift of Mrs. Herbert N. Straus.*

I would suspect that this Renaissance master spent about 98 percent of the time it took to produce this contour drawing with his eyes on the model. We are immediately overwhelmed with what he achieved using a super-confident line, with only a slight variation in its width and character. He has left us many other drawings in which he has transformed the parts of the body into geometric solids. You can see how those drawings carry over into this one, where he carefully indicates the top and side planes of major forms. The muscles of the torso are difficult to indicate in pure line but by using short lines, he achieved this task in a convincing manner. Note how the exterior contour of the figure is often repeated within the figure or by the drapery, for example, along the stomach and lower leg. The drawing is beautifully placed on the page; note the difference in size and shape of the five negative or background shapes. What would you say was Cambiaso's purpose in creating this work compared to Egon Schiele's **(Figure 2.3)**?

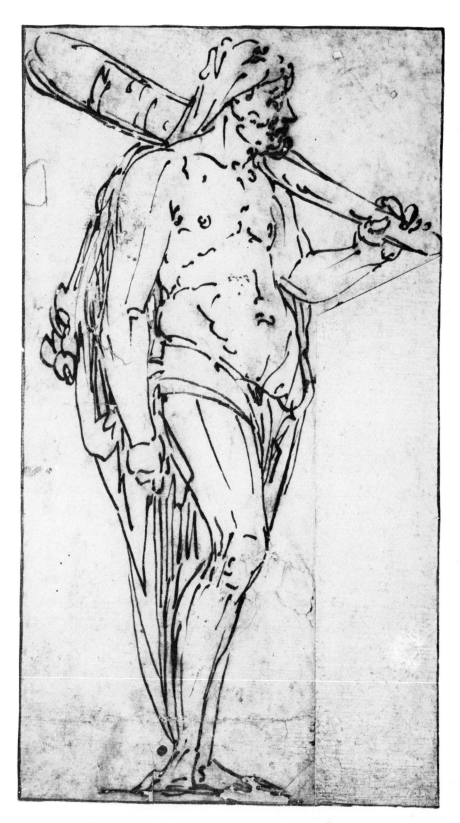

# Some Basics
## Contour, Gesture, and Modeled Drawing

It is my firm belief that contour, gesture, and modeled drawing are absolutely fundamental modes of working for all artists. A quick glimpse at the drawings reproduced in this chapter show that contour (a linear means of defining form), gesture (a linear and/or tonal means of representing the model's action or pose), and modeled drawing (a tonal means of indicating that forms "push back" into space) were and are used by old and contemporary masters; and in this sense I consider them basic or fundamental. No artist that I know ever stops using these modes of working (**Figure 2.1**).

Occasionally I will hear a student protest, "But, I have *already done* contour drawing." I am usually not too patient or discreet in answering such a student! Certainly if you have done a great deal of these drawings you might want to move directly into some of the modes of working suggested in later chapters. But since every teacher has a different approach to teaching contour, gesture, and modeled drawing (**Figure 2.2**), you still might want to skim through this chapter and attempt some of the more unfamiliar problems. On the other hand, if you haven't had a great deal of experience with these basic modes, I believe that you should try a good percentage of the projects covered in this chapter before moving on. If, after trying these projects, you would like to probe these modes more deeply, I suggest referring to my first book, *Learning to Draw* (Watson-Guptill, 1966).

### Blind Contour Drawing—Really without Looking?
Yes and no. Yes, you are going to look at your subject harder than you have ever looked at anything in your life. No, you are *not* going to look at your drawing paper at any time while your pencil is moving! Although they are not literally so, I call these *blind* contour drawings.

To do one, first look at your subject, one line or form at a time, and force yourself to believe that your pencil is touching the form you are attempting to draw. (In this sense, contour drawing is more *tactile* than visual, since its success depends upon your ability to believe that you are actually touching the form or contour with your pencil.) When a particular form disappears behind another or otherwise comes to an end, pick up your pencil, look at the next form, set your pencil down in relation to the prior line, and (again without taking your eyes off the form) proceed to draw it.

When you have completed the drawing and have taken a look at it, you will discover that some of the lines are grossly exaggerated, some don't meet another line where they should, or perhaps some lines continue much too far.

An important lesson for you to learn is to accept the process—remember, you are drawing *blind!* Drawings created in this mode will have particular characteristics and you should not try to make them look like something else. On the contrary, the distortions, exaggerations, and omissions in blind contour drawings tend to give them an expressive quality other drawings may not have.

### "Partial-Peek" and "Quick" Contour Drawings
After you have made many drawings in an absolutely blind and slow fashion, you can move on to producing "partial-peek" contour drawings (where you will occasionally look at the page) or "quick" contour drawings (where you will use the same approach as in contour drawing but with a more rapid execution). Each of these variations is an entirely different process or mode, and your drawings should reflect that. I tell my students that each night before dozing off to sleep, they should repeat at least 30 times, "I accept the process. I accept the process. . . ."

The drawings by **Carol Goldberg, Barbara Betancourt, Chris Rubino,** and **Chio Hatae** are all contour drawings by beginning students, but they are as different as day and night. The Goldberg drawing is a blind contour, and the Betancourt is a slow, partial-peek contour. The Rubino, again a blind contour, was done with the entire body (including the arm and hand) held stiff, while the Hatae, a partial-peek contour, was managed by dragging the drawing hand along the surface of the paper as she worked, smudging the lines arbitrarily. One drawing is no better than the other, just different. All four students accepted the particular process or mode in which they were working!

Now compare Albrecht Dürer's drawing (**Figure 2.2**) with Egon Schiele's (**Figure 2.3**). Again, both artists were drawing contours, but one was working in the 15th century and the other in the 20th, and each one has achieved a completely different mood and expressive content. You see contour drawing is a very traditional mode of delineating form; perhaps the only thing different in their basic approach, and the one I am suggesting to you is that your first 20 or 30 hours of contour drawing is to be done *completely blind*, as explained above.

### Suggested Contour Problems
Here is a list of contour problems for you to try. Each of these suggestions can be varied greatly by simply changing your drawing materials or the size or your page. *Do not* limit yourself to pencils; try everything and anything: pen and ink; ink and a twig from a tree; charcoal; Conté crayon; big, fat kindergarten crayons; oil painting brush and ink; watercolor brush and ink;

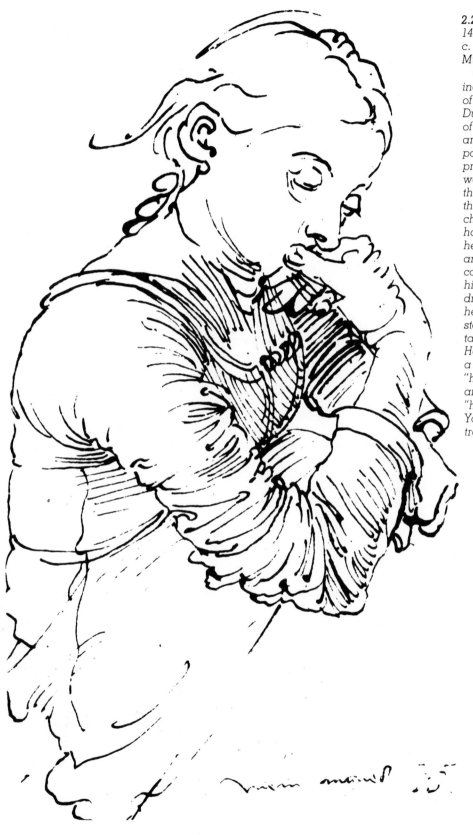

**2.2** (Left)  **Albrecht Dürer** (German, 1471–1528). Portrait of Agnes, c. 1494. Pen and ink. Albertina Museum, Vienna.

One can only gasp in awe at the incredible beauty of this little drawing of the artist's young wife, Agnes. Dürer, one of 18 children, became one of the most influential and important artists of the Renaissance. His output of paintings, drawings, and prints was so precocious and prodigious that it is a wonder how he could have produced them all. There is much to learn from this contour drawing. With a few well-chosen strokes, Dürer has indicated the hair, and even a few loose ends. When he turned his attention to the sleeve and its folds, it would appear that he couldn't see enough to satisfy himself—count the lines he used to draw the face compared to the number he used to draw the sleeve! In this instance, the face became more important visually because of its simplicity. He indicated a little tone by hatchuring a few lines on the front of the torso. (In "hatchuring," the lines indicating tones are curved to follow the form; in "hatching," these lines are arbitrary.) You might find it helpful to make a tracing of this drawing line by line.

**2.3** (Right)  **Egon Schiele** (Austrian, 1890–1918). Self-Portrait, 1910. Pencil. Courtesy Serge Sabarsky Gallery, New York, Private Collection.

Obsessed with his own image, Schiele produced hundreds of self-portraits in this Expressionist and psychologically revealing mode. Our immediate response to this drawing is one of anguish, pity, and empathy. Using drastic distortions and exaggerations of both major and minor forms, his work, like that of most Expressionists, has tragic overtones. His contour line, incisive and direct, was perfect for recording his intentions. In the beginning, the unconscious distortions you achieve in your contour drawings are a result of the process. In time, as you gain greater control, the distortions (or lack of them) should be arrived at consciously to serve your own expressive ends. Note his treatment of body hair, his slight indication of tone, and his "cutting" line quality.

18

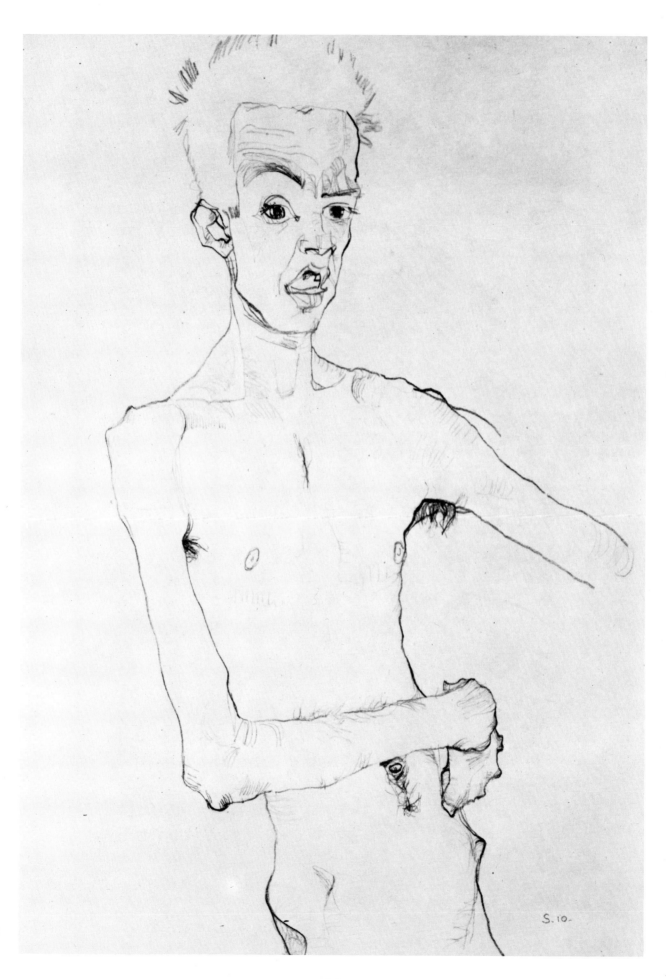

S. 10.

19

Contour drawing demands concentration on the form being delineated; in effect you are "touching" the contour with your eyes and your marking implement, moving along the contour. The drawn line is a "visual trace" of your concerted concentration. Twenty-minute bamboo pen drawing by Carol Goldberg.

This is a "partial-peek" contour drawing in which the student pretended she was looking at herself through a magnifying glass, thus helping her to see details such as the lines on her lips and the thickness of her eyebrows. The drawn format has become an important part of her total form-idea. Drawing by Barbara Betancourt.

Students generally become frustrated if their charcoal lines don't remain clean and crisp. The problem here was to make a partial-peek contour drawing and allow the butt of the drawing hand to drag along the surface smudging the line in an arbitrary manner. A bit "too messy" for this student, she "cleaned it up" slightly with an eraser. Drawing by Chio Hatae.

The procedure for making blind contour drawings was followed but here the students were asked to keep their hands and arms stiff and immobile throughout their drawing. The only way to create a mark was by moving their entire body. Drawing by Chris Rubino.

graphite sticks and ink in combination; paper with different textures; or other combinations that you haven't ever used before.

• Make blind contours of yourself, your overcoat, the corner of your room, trees, a typewriter, a bookshelf, a tennis racket, houseplants, your closet, your medicine chest—everything. With this mode, if you can see it, you can draw it!

• Take 25 sheets of paper and on each sheet produce an absolutely blind contour drawing of your hand. Try to make each one fill the space in an entirely different way from the one which preceded it. Use a different material on each page.

• Using three or four hours, make a very detailed contour drawing of a bicycle or a motorcycle. By detailed, I mean that it should take you two lines to draw the two sides of a spoke, and the slots in a screw must be more than a single line. This may necessitate your getting within inches of the particular section that you are drawing. Don't worry about proportions!

• Just as you had to observe the bicycle or motorcycle very closely, look at yourself as though you were looking through a magnifying glass. You might use the kind of magnifying mirror that's used for shaving or putting on makeup.

• Produce a lifesize contour self-portrait. Use a roll of butcher paper slightly taller than yourself if it's a standing pose. I have my class do this problem, but they are limited to a hand mirror! The drawings that they make (full-scale) are supposed to reflect the fact that they used a hand mirror and were not working in front of a full-length mirror. Your drawing in every case should reflect the processes used.

• Borrow a skeleton, either human or animal, from a biology laboratory and create dozens of contour studies of bones.

• Draw dozens of quick contours. Pick the most important or most "readable" lines and put them down quickly and with authority! If you don't like a line, simply re-draw it very quickly. I rarely allow my students to erase in contour drawing. There are no mistakes, only tracks of where you have been to get where you are. To better understand this point, carefully study the drawings by Raphael and Leonardo (Figures 2.4–2.6).

• Using a brush and ink, produce a series of contour drawings of your model. Look at the pose for about a minute before beginning and then, with a dripping wet brush, attempt to capture the essence of the pose with no more than five brush strokes. The idea is to produce strokes which are not only beautiful, but which also describe the contours of the pose. Try doing the same thing using only four strokes, then just three, then two, and finally one! This is really tough! (See drawings by **Connie Chew** and **Irene Raine**.)

• Try alternating the pace of your drawing. After the loose drawing of the previous problem, return for a while to a more studied, more sustained, and absolutely blind contour drawing. Then try a loose one before going to a tighter style. It will keep you from becoming bored.

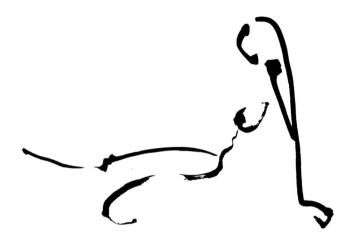

*In six brief but beautiful brushstrokes, the entire pose can be "read," including the knee, which is bent under the model. To achieve such economy of means requires utmost concentration. In each succeeding pose, a line was "dropped" until it had to be done with a single stroke! Bamboo brush drawing by Connie Chew.*

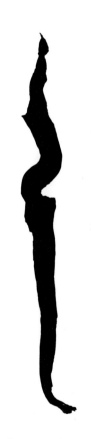

*Starting with five lines to indicate the entire pose, the class then did it with four lines, three lines, two lines, and finally one line. The point is to have brushstrokes that are not only beautiful in themselves, but also suggestive of the figure. Striping brush drawing by Irene Raine.*

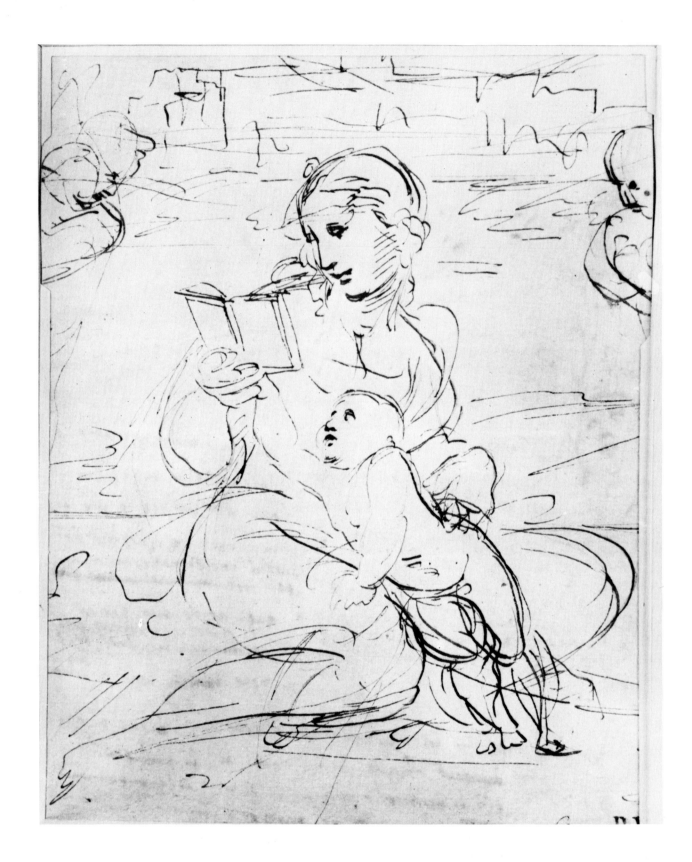

**2.4** *Raphael (Italian, 1483–1520). Madonna Reading in a Landscape, c. 1513. Pen and ink, 7½" × 6", (19.3 × 15.2 cm). Albertina Museum, Vienna.*

*This is a late drawing, done at the height of Raphael's powers. This quick contour drawing has grace, clarity, and simplicity, and an economy of line that has never been surpassed. Two cherubs and buildings are indicated in the background. His*

*emphasis is on the exterior contour, with very little interior drawing. Light, parallel lines indicate a slight shadow on her face and neck. With a little study, you can begin to see his hand literally flying about this drawing, making marks. For centuries, artists have considered his work an apogee to be emulated. Whether anyone has ever surpassed him could provide fuel for an excellent debate between you and your friends!*

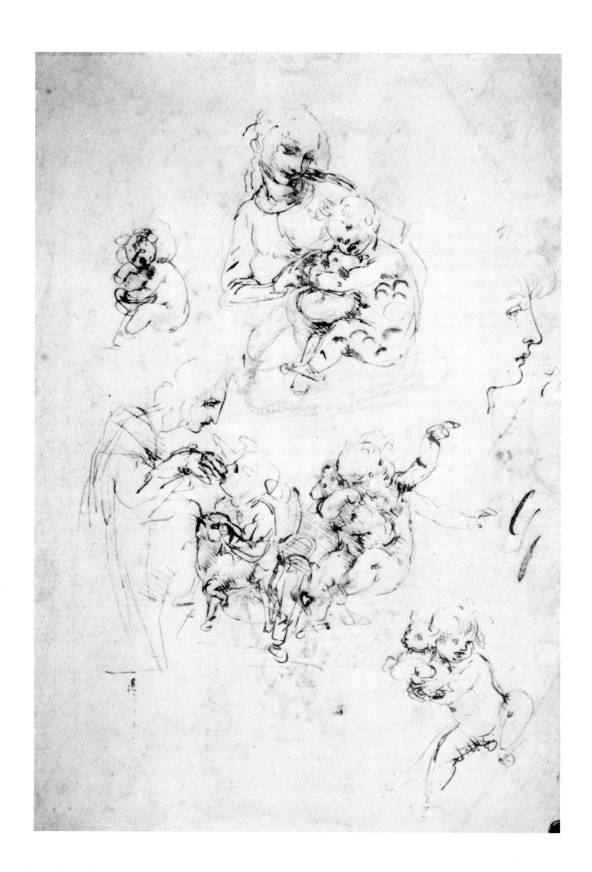

**2.5  Leonardo da Vinci** (*Italian, 1452–1519*). *Studies of the Madonna and Child with a Cat. Pen and lead point, 11″ × 8″ (28.1 × 19.9 cm). Reproduced by courtesy of the Trustees of the British Museum, London.*

This is an early drawing which still reflects an indebtedness to Leonardo's master, Verrocchio. We might study Leonardo's drawings as either quick contour drawings or linear gestures. They show an amazing amount of spontaneity and freedom in the quality of the line which, along with a slight hatching, gives us a strong feeling of light and shadow. Note the incredible differences in the heads of the three Madonnas. Does the head on the far right remind you of any contemporary master? The little curves covering the child's body in the top left drawing are curious, as is the rather "clumsy" hand of the Madonna on the left. There is so much to learn from this work that I suggest that you study it with a magnifying glass.

23

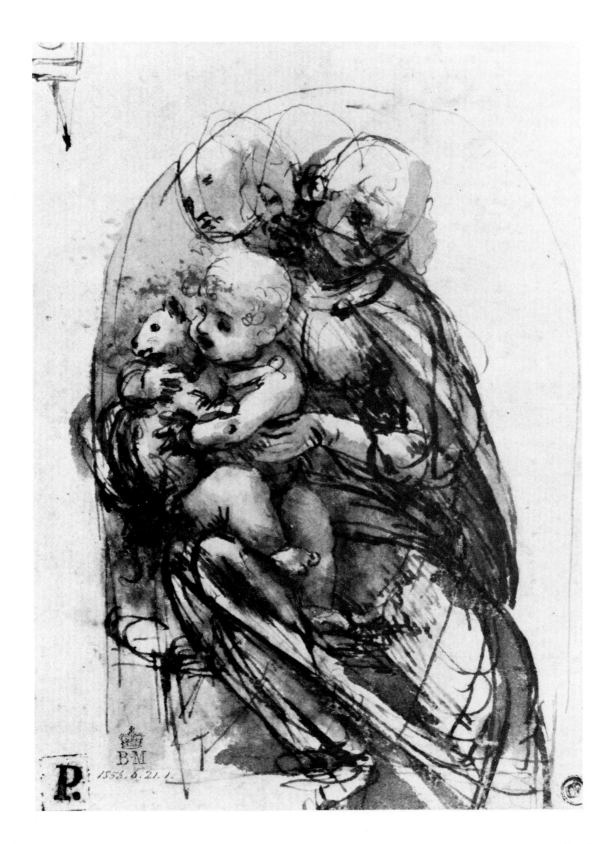

**2.6** *Leonardo da Vinci* (Italian, 1452–1519). Madonna and Child with a Cat. Pen and ink and wash over a sketch with a stylus, (verso of the da Vinci on the preceding page), 5⅜″ × 3¾″ (13.2 × 9.5 cm). British Museum, London.

Along with the preceding drawing, this is another in a whole series of studies that Leonardo produced on the theme of the Madonna and Child. This particular work exists on the reverse side of a sheet dealing with the same theme which he traced through to this side with a stylus. This reversed everything in the drawing so that the child is now on the Madonna's right instead of her left and so forth. Using the stylus marks as a guide, he then added the vigorous pen and wash drawing. In his writings, Leonardo advised artists never to consider any line or tone as unchangeable and final, and he followed his own advice as he searched over and over again for just the right angle for the Madonna's head. This is a combination of contour, gesture, and modeled drawing.

24

*In 20 minutes, using a reed pen and ink, the student created this drawing of a model who was in continuous motion. This gave the student only a second to choose a particular contour to be delineated. This is not so much a drawing of the figure as it is a linear equivalent of movement. Drawing by Barbara Kramer.*

• Tell your model to stay in constant motion and you will have an entirely different problem—one which seemingly is impossible to accomplish using the contour mode that I've described. Of course, it is possible. You just have to find your own way of translating motion into contour drawing. (See **Barbara Kramer's** quick contour drawing of a moving figure.)

• The next two drawings by **Nancy Hom** and **Michele Wong** are also the direct result of movement, but movement of a different sort. While remaining in the chair, the model simply changed position a little bit about every five or ten minutes. In a one-hour, super-detailed drawing, the students were asked to continue to work and adapt their drawing to the model's poses no matter what happened. As in the prior problem, movement is suggested, but with an incredible difference. Try it for yourself.

## Cross-Contour Drawings

Now try cross-contour drawings. These drawings continue to presume that the form is being touched, but the line now moves in any direction across the form rather than along the edge of it. If you can imagine a fly with ink on its feet walking across your face, you can then imagine the tracks that will be left in the hills and valleys of

*The point here was to make very detailed contour drawings and to adapt them to the changing situation: the model changed position slightly and at unequal intervals of time for an hour. This might be likened to stop-motion photography except that the students were supposed to end up with an exciting composition in which they integrated a drawn format after the fact. How would you judge their relative success? Upper drawing by Nancy Hom and lower one by Michele Wong.*

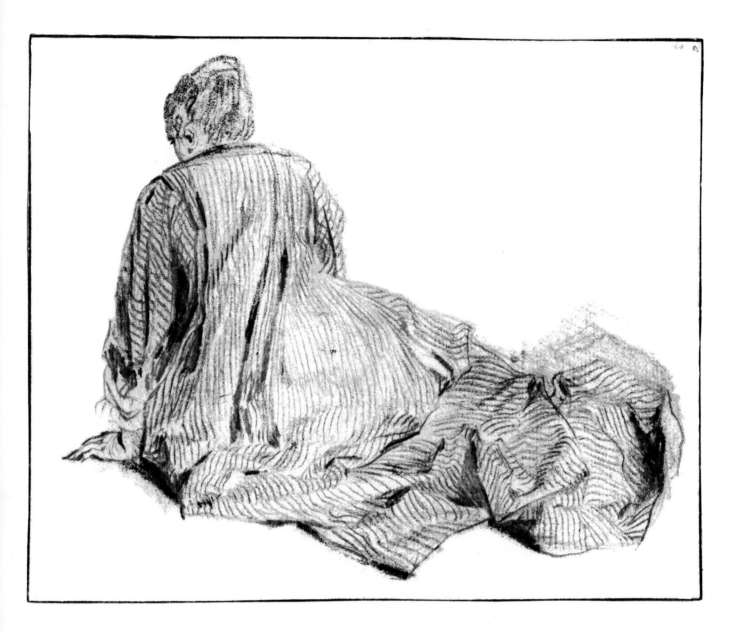

**2.7** *Jean Antoine Watteau* (French, 1684–1721). Woman Seated on the Ground, Seen from the Back. *Red and black chalk, 5¾″ × 6¼. (14.6 × 16.1 cm). British Museum, London.*

*Even though this is not a cross-contour drawing as described in the text, it nevertheless illustrates the point. It just happens that the model was wearing a striped dress, and this is what Watteau drew in such a masterful and form-descriptive manner. Note that there are only about six small areas where he has* laid down a solid tone in the folds and that their shape is described by the everchanging direction of the stripes and by the varying pressure on the line. Despite the bulk of the gown, it is still possible to "read" the posture of the body beneath them. Note how important the solid dark next to the delicate hand is in indicating where the weight of the figure is. To allow yourself to carefully follow the outside contour of this figure inch by inch is nothing less than a "visual adventure."

*This student indicated a very light outline of the head and features with a pencil before starting his cross-contour study in pen and ink. If a fly were to walk across your face with inky feet, it might leave lines similar to these. A more realistic work is achieved using this process. Drawing by Jon Wells.*

*Without removing her eyes from the model while a line was being drawn, this student placed her square graphite stick at the left of the page, drew through open space until she met the model, followed the cross contour, and drew to the opposite edge. By applying different degrees of pressure to the graphite, she achieved a modeled effect. Given this process, it was not her intention to achieve a realistic drawing. Drawing by Gwen Marcus.*

the facial contours **(Figure 2.7).** There is no system or any one solution to this problem except as you may set up "process limitations" for yourself.

The student cross-contour drawings by **Jon Wells** and **Gwen Marcus** show very different approaches. Wells' lines have traveled in a multitude of directions whereas Marcus' lines are all horizontal, beginning on one edge of the paper and drawing across to the other. Also, by changing the pressure on her graphite stick, Marcus has begun to indicate the modeling of the figure as well as the contours. Wells worked over a very light prior sketch, whereas Marcus used no prior sketch; the two works reflect these "process limitations."

There are hundreds and hundreds of other contour problems existing in your head. Just let them out—and try each and every one!

## Gesture Drawing—Getting It All Down Quickly

Gesture drawing demands a perceptual process entirely different from contour drawing. In contour drawing, you look at each little section, draw it, and finally arrive at the whole form. In gesture drawing, you must perceive the form in its entirety, then place marks rapidly

on your paper to represent the model's pose or gesture. (See drawing by **Gail Brown.**) Occasionally teachers refer to gesture drawings as "scribble" drawings, an expression which I feel is unfortunate. These are not scribbles, although at first glance they may look it. They are actually a group of marks that are meant to suggest the movements and distribution of weight inherent in the pose.

Artists use gesture drawings in a variety of ways; most often they are used as a rapid means of studying the articulation of the figure in space. They are also used to quickly record a pose or gesture of a figure in a work that will later be made into a more finished picture, as was the case with the Andrew Wyeth drawings **(Figures 2.8 and 2.9).** The general public often doesn't respond well to gesture drawings because they may have trouble "reading" them and, since they are done rapidly, they may feel that drawings which take hours longer have to be better. It is this very quality of spontaneity that artists and connoisseurs respond to, since they know how difficult it is to achieve. After trying a few gesture drawings, you will probably agree with most of my students that it is much more difficult to produce excellent gesture draw-

In a gesture drawing, you attempt to perceive the form in its entirety and to record the essence of the particular gesture in a matter of seconds. With more time, the initial gesture is then further refined. One-minute chalk drawing by Gail Brown.

**2.8** (Opposite page, top)   **Andrew Wyeth** (Contemporary American). First Thought for "Christina's World," (1948). Pencil, 11½" × 17¾" (29 × 45 cm).

**2.9** (Opposite page, bottom)   **Andrew Wyeth.** First Drawing for "Christina's World," 1948. Pencil, 19" × 12" (48 × 31 cm). Private Collection.

Christina's World, a picture of a crippled girl reclining in a field of grass looking up toward a farmhouse is one of the most popular paintings in America. Personally, I find the subject matter over sentimentalized and overly dramatic. The long series of drawings that preceded the final painting, however, as with most of Wyeth's works, are astoundingly beautiful. These two drawings are of particular interest, the top one being labelled "First Thought. . ." and the bottom one, "First Drawing. . . ." Gesture drawings are not necessarily made from life; they can be gestures indicating the artist's initial impulses toward an entire composition, as was the case here. Compare these very carefully to study how the second work is derived and developed directly from the first. The gesture of the farmhouse, an inanimate object, in the upper work is of particular interest.

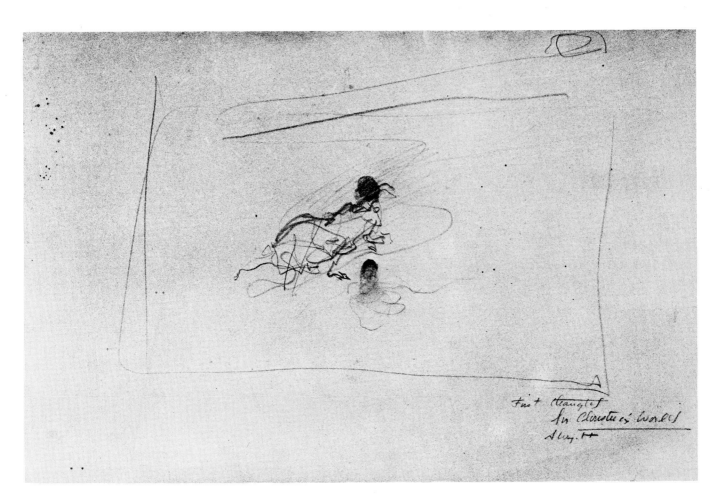

First thought
for Christina's World
Study

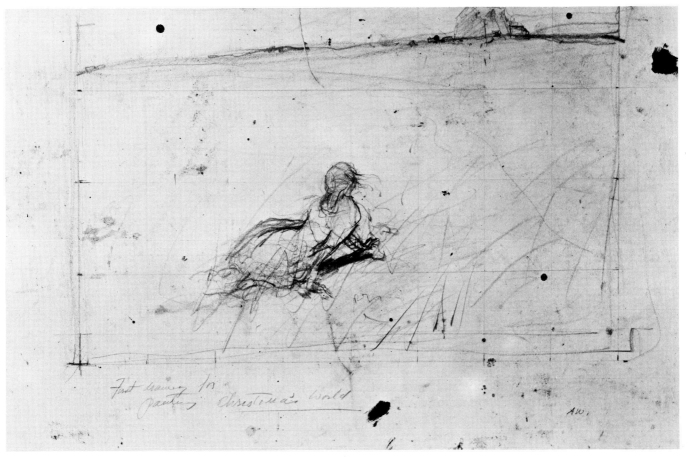

First drawing for
painting Christina's World

AW.

ings than excellent contour drawings.

There are many similarities between gesture drawing and quick contour drawing since both are created rapidly, and the end product reflects this fact. But there are differences, too. Quick contour drawings search out the edge or contour of the forms, while gestural marks attempt to move into, down, through and all around the forms. If you try to think of your chalk as being *inside* the figure or pose, your gesture drawings will be more tonal and less linear than your contour drawings.

To obtain the mass effect that tone provides, I suggest you use a soft, pliable, material such as chalk, charcoal, or oil crayon, and that you start your drawings by using the side rather than the point of the marking implement.

Your eyes should be on the model at least 98 percent of the time, allowing your hand, arm, and *total being* to respond to the pose. You should not only draw the pose, but you should try to *become* the pose. Remember that you are not drawing the *model,* but rather the *action* or gesture of the model. Let your marks flow and as the drawing develops, try accenting the bend of a knee or the twist of the hips or torso with a darker mark. These accents tend to add "color" or tonal contrast and definition to the drawing. Note how Guardi has used these devices in his drawing **(Figure 6.7)**.

Don't draw by just moving the chalk with your fingers or even your wrist. Allow your entire body to move up, down, forward, and backward as *you get into the pose.* Many instructors start their classes with about 10 or 20 minutes of gesture drawings because there is no better way to "loosen up" at the beginning of a drawing session. It might be a good idea to put one drawing right on top of another until the page is completely filled with a black mess. This will keep you from becoming super self-conscious from an over-awareness of trying to make "good" drawings.

## A Few Gesture Problems

• Make drawings from 20 five-second poses. This may seem impossibly fast but it *forces* you to concentrate on the whole rather than parts. Do another 20 drawings that are ten seconds in length—imagine, twice as long! Gradually increase the time until you are producing one-, two-, and finally five-minute gestures. The important thing is that even with gestures that are five-minutes long, you should still start out with an initial mark that encompasses the entire pose in the first couple of seconds.

• Having made many gestures as described above, now try to create drawings using a linear rather than a basically tonal material, such as pencils or marking pens. These materials will force you to become more linear and to build up the tones by hatching.

• A good exercise is to attempt to place 25 two-minute gestures on a single page. The entire page should "work" as an interesting drawing. The first five might be drawn relatively large and along the bottom edge of your paper. The next five can be slightly smaller in size and placed in an approximate row above the first five. Continue getting smaller until you reach the top of the page. This change in size should produce a slight indi-

cation of figures receding into space. When you are finished you may want to go back and work some more tones in the spaces between the gestures to get them to relate better one to another. (See drawing by **A. Louizo.**)

• Try some gestures in which you use both hands *simultaneously.* It might be interesting to have a different material in each hand. Perhaps chalk and graphite stick or charcoal in one hand and an eraser in the other! (See work by **Diane Woods.**)

• Try using a very wet watercolor brush or a striping brush which has long, daggerlike bristles and a handle about an inch (25 mm) long. After producing a few dozen of these, try a drybrush gesture drawing by using a 1" (25 mm) varnish or oil painting brush. Dip the brush in the ink and then wipe it on a paper towel until it's practically dry. You have to build up tones by rubbing over and over again.

• Pour some ink into a saucer and wad up a couple paper towels so that you have a "snowball." Dip this into the ink and try some gestures with it. I used to have a colleague who always had his students draw gestures with a tennis ball dipped in ink.

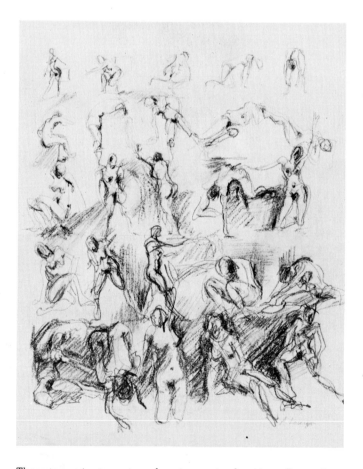

These two-minute gesture drawings not only get smaller as they move up on the page, they also get lighter in tone and less detailed, which makes them seem to recede into the distance. The tones between the figures are important to the gesture as well as to the overall composition. Chalk drawing by A. Louizo.

The homework problem here was to produce a gesture drawing using a graphite stick, and then to work back into it with an eraser until the erasures become integrated with the total form. The obscure subject matter becomes immediately apparent when you know that the title is Piano Player. *Drawing by Dianne Woods.*

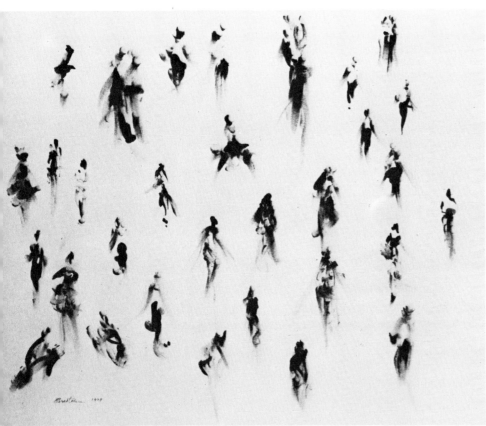

This student was particularly interested in the movement of people walking as a source for visual form. These are gestures of both the object and the movement made by the object viewed from the 13th floor of a building. (This eliminates getting overly concerned with unnecessary details!) Drawn by Charles Bernstein with fingers dipped in ink and smeared.

• Perhaps one of the great virtues of television as far as artists are concerned is the fact that we have a myriad of images at our fingertips. Most of them are usually in motion or at best are still for only a few seconds at a time—just perfect for your needs!

• Try some gesture drawings from a moving model—they should have a different character than the quick contour drawings that you did from a moving model. The "motion" gesture drawing by **Charles Bernstein** was produced by dipping his fingers into the ink. The people were observed from a height of thirteen stories. (This was a perfectly marvelous way to avoid detail and get into the essence of the movements.)

Gesture drawing is an absolutely essential basic, and you should vow right now that you are going to produce some every day.

## Modeled Drawing—"Pushing" the Form with Tone

Modeled drawing is similar to contour drawing since it is also concerned with tactile values, the sense of touch. To create a modeled drawing, you simply begin using a half stick of Conté crayon or a ¾" (19mm) or so length of chalk on its side to "push" the form back as you draw. Again, you have to believe that the crayon is actually touching the form. Press very lightly on those sections of the form that are closest to you and, as the form moves back, increase the amount of pressure on the crayon, thus creating a darker tone **(Figure 2.10)**. The Miró drawing **(Figure 2.11)** illustrates the process in a very clear manner. Miró had already been deeply influenced by Cubism, and the forms in this drawing are quite geometricized. But the point that should be noted is that each form of the figure has been modeled—that part which is nearest to us has been left white and, as the form recedes, it passes through a middle tone (gray), then seems to "turn around" the figure into black. The drawing has nothing whatever to do with the way in which light hits the figure.

*Do not* begin drawing by indicating a rough or tentative outline of the figure which you then will "fill in" with tone. Rather, start in the center of each form with your chalk or crayon and gradually "push" the tone back while you simultaneously arrive at the edge. In other words, instead of starting with the edge, you will end with it. Since these drawings often look like black silhouettes in the middle of the page, it may also be advisable to work some tone into the ground around the figure. These tones can also be used to help describe the edge of the form.

In the beginning, most students have a tendency to smooth out all of their tones which make the drawings shine like the chrome on a new Cadillac **(Figure 2.12)**—the dust, dents, and bangs of an old "tin lizzie" have a lot more character! Note that in the preceding drawing, Miró has achieved tonal character through strong light and dark contrasts, contrasts of smudged and freely hatched tones. Also note the radical changes in direction of the strokes which comprise the tones. It is also a good idea to save your darkest blacks until the very end, thus enabling you to keep the edges flexible and subject to change as the drawing develops.

*2.10  Kathe Kollwitz (German, 1867–1945). Self-Portrait in Profile, 1927. Lithograph. Courtesy Fogg Art Museum, Harvard University, Cambridge, Mass., Gray Collection.*

The greater part of Kollwitz' work was a response to the trials and tribulations of the German people and the social conditions of the time. Considered an Expressionist, her means were totally different from those of Egon Schiele **(Figure 2.3)**. Can you articulate these differences? She produced many self-portraits, and this one is particularly dramatic. A marvelous example of a modeled drawing, you can see how she used the side of the litho crayon and applied greater pressure to it as the forms moved back into space or turned a corner. Would you like the drawing better if she had "finished" the head? (A lithograph is a printmaking process in which the artist draws on a flat limestone with an oily crayon or ink-like liquid called tusche.)

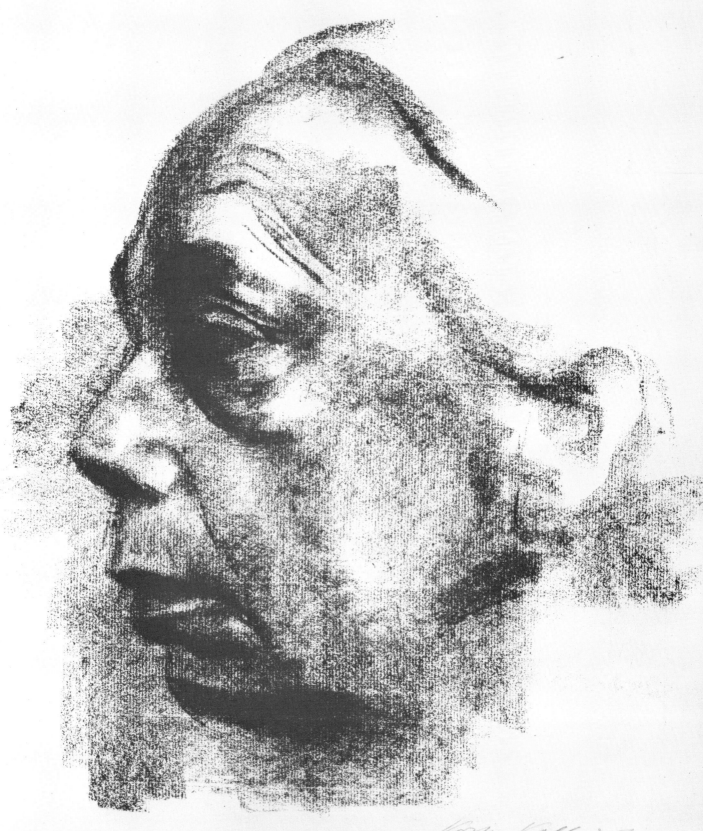

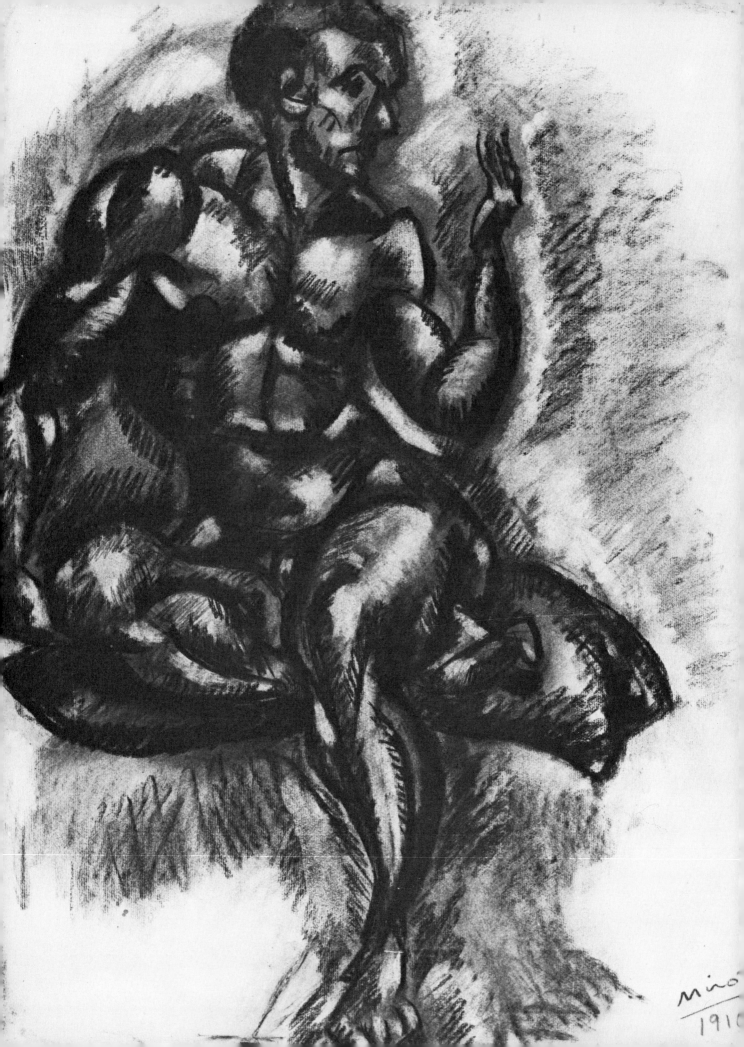

Miró
1919

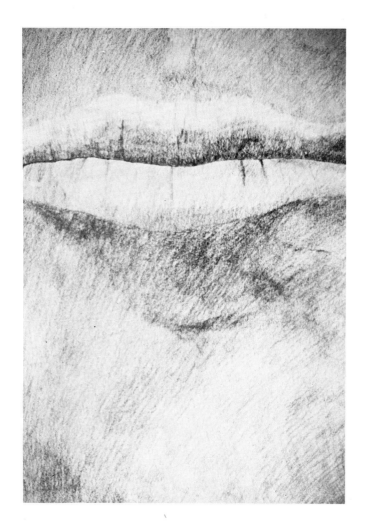

2.11 (Opposite page) **Joan Miró** (Contemporary, Spanish-French). Nu Assis, 1916. Charcoal on paper, 24⅞" × 18⅞" (63 × 48 cm). Courtesy Perls Galleries, New York.
Along with Picasso and Matisse, Miró was one of the nucleus of artists essential to the development of modern art. We know him best for his surrealistic works in which he uses a preponderance of amoeba-like shapes and figures. This early drawing has been influenced by the Cubists, although the forms remain intact and unfractured. In this work, an excellent example of modeled drawing, he has emphasized the major muscles as they move back into space. Each form has a highlight, middle, and dark tone that have nothing to do with shading or the way that light hits the figure. The overall treatment is bold, daring, and physical.

(Left) Instead of making a modeled drawing of the whole figure, it may be interesting to take a detail and then try to see additional details within it. These lips were 18" (46 cm) across—the sheer scale is impressive. Using 4B, 2B, B, and 4H pencils, the student was careful not to smudge the fine texture he achieved. Drawing by Roy Sloan.

## Time to Start Work!

• You should spend a relatively long time on your first modeled drawings, about an hour each. This will enable you to "get into" the process. At this point you should think about it only as a process and not consciously try to make "good" drawings. If you decide beforehand that you are going to tear up the drawings when they are finished, you will probably feel a great deal of relief. The pressure's off!

• The next drawing might take only half an hour, followed by several which take only 20 minutes to do. Eventually, you should work down to five- or ten-minute poses in which you have simply indicated the essential forms through modeling.

• Having worked from a long pose down to rather rapid ones, I suggest that you now return once again to a sustained pose. Ask the model to pose for two hours. Begin to look at the forms within forms, trying to model as much detail as you can in this time (see drawing by **Roy Sloan**). It is a good idea to strive for a balance between long, studied drawings and quick, spontaneous ones.

• As you begin to develop your own approach to the problems of making modeled drawings with Conté crayon or chalk, you should also attempt some with other materials such as pencil or pen and ink. It will take longer to build up the tones with these materials, but through rapid arm movements you will be amazed at how fast you can lay down a hatched or scribbled tone.

• There is practically nothing that I can think of that is more mundane, less picturesque, and just downright boring than a styrofoam coffee cup—the ones you get "to go." After demonstrating "modeled drawing" to the class, they began to work from a model. During a break of five minutes to let the model rest, I placed just such a cup on the model stand and asked the class to see what they could do with it.

The student work by **Barbara Betancourt** is quite remarkable, since the cup has been completely transformed into an unusual and energetic drawing without losing its primary characteristics. Using no line whatever, she applied tones of color, varying the pressure on the Conté crayon as the form moved forward and backward in space. The rim of the cup was left untouched, which helps to relate the object to the background, since they are the same color and no line separates them. (See the discussion of figure-ground interchange in Chapter 3.) The edges of the cup aren't even and the bottom ellipse is too small, facts that add interest to what might have otherwise been a "blah" work. The subject matter in this drawing is the material and the process—the cup itself is quite secondary.

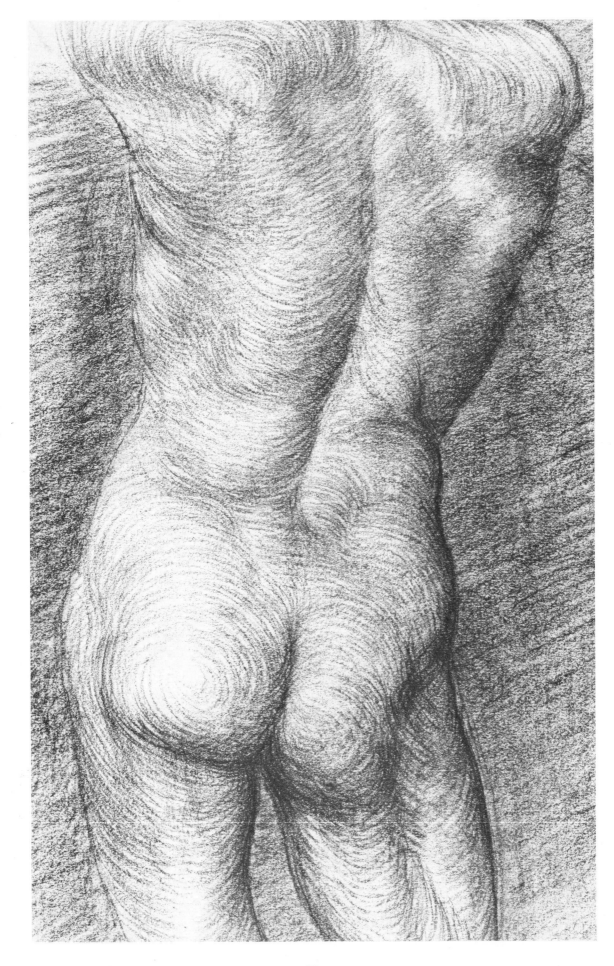

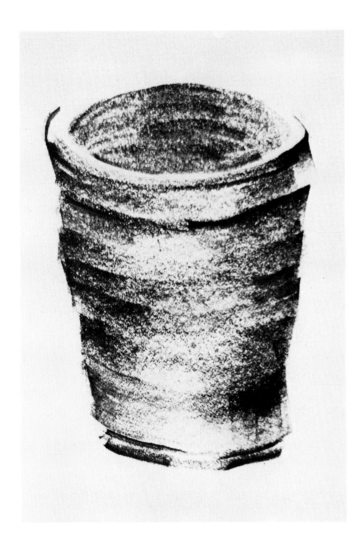

I suggest that you try similar experiments: how about drawing a plastic fork or spoon, a section of electrical wire, a paper clip, a light switch, a cigarette butt, a pencil, a common pin, a thumbtack, or a button? Whatever drawing material you choose—charcoal, Conté crayon or pencil, litho crayon, pencil, brush and ink—should, along with the *way* you use it, become the "new" subject. This could easily become an extension of the "50 drawings in four hours" project described later in Chapter 6.

Remember that all of the approaches suggested in this chapter are basic and you should not feel that, having spent several hours on any one of them, you can now forget about them. No, no, no! You should return to them again and again throughout your artistic career. They must become as natural to you as breathing.

*A mundane object, such as a styrofoam coffee cup, can become an interesting subject when the emphasis is placed on the elements of drawing rather than on the exact duplication of reality. Differing pressure applied to the Conté crayon makes the form in this drawing look like it is going around the corner. The sides are uneven because there was no preliminary sketch, but it is precisely this and other similar visual incidents that can turn the ordinary into the extraordinary! Drawing by Barbara Betancourt.*

**2.12  Giovanni Segantini** *(Italian, 1858–1899). Male Torso. Black chalk, 12¼″ × 8″ (31.3 × 20.5 cm). Courtesy Fogg Art Museum, Harvard University, Cambridge, Mass., Bequest of Grenville L. Winthrop.*

*Most beginning artists and laymen are immediately impressed with this drawing. Personally, I find it to be an overly pretentious display of verisimilitude and not much more. Academic drawings such as this remind me of a new Cadillac with all of its shining chrome—an old "tin lizzie" has much more character! I reproduce it because it relates to the cross-contour exercises we're discussing and to let you know that we don't have to like things just because they are in museums. This is a kind of shading where the artist allows the lines to show and lets them follow the shape of each form. This is sometimes called bracelet shading or hatchuring, and was first developed by Dürer (see **Figure 2.2**).*

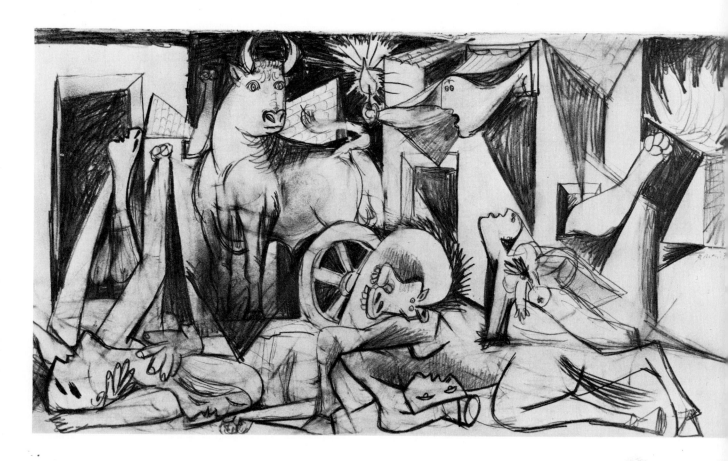

**3.1  *Pablo Picasso*** *(Spanish, 1881–1973).* Guernica studies and "Postscripts," May 9, 1937. Pencil on white paper, 94" × 17⅞" (24 x 45 cm). On extended loan to The Museum of Modern Art, New York, from the artist's estate.

This is one of many sketches Picasso made prior to his monumental painting of Guernica. The painting was done in protest against the brutal destruction of the small Spanish village of Guernica by Nazi planes, testing their bombing ability on behalf of General Franco. Picasso made nearly 100 studies both before and after the finished painting; this one was the final one before he actually started on the 26' (7.8 m)-long mural. Despite this "final" sketch, almost every form underwent radical changes in the painting process, so I suggest comparing this to the painting if possible. The major theme is based on a series of implied triangles culminating in the one formed by the lamp being held out the window, and it is repeated over and over again. How many of these triangular shapes, which seem to be chewing up the people and landscape, can you find? Note the structural importance of the verticals, especially the one in exact center. If you squint, the entire foreground becomes a single tone contrasted against the sharp light and dark changes of the upper portion.

# Organization/Structure
## Making Things "Work Together"

If you have ever listened to artists talking about particular works of art, a phrase that you have no doubt heard over and over again is that "it works" or, conversely, "it doesn't work." Confusing? You bet! If you were to ask these artists what they mean, they would probably come up with such terms or phrases as: it's composed; it has structure; it makes a statement; it's unified; it's well-organized; it's harmonious throughout; it's well designed; there's a total integration of parts; nothing is superfluous; everything holds together. Or they might simply make some strange gestures with their hands over the frustration of not being able to communicate what they mean by the expression "it works." In more detailed terms, what they mean is that the organization of a drawing creates an expressive form in which all of its parts, as well as the artist's intentions, are related to one another and to the total form in a unique and distinctive way. Getting things to "work" is generally the result of years of study and practice until the means at the artist's disposal in achieving his goals are blended into one thing—his intuition.

There are no shortcuts or magic formulas for arriving at the point where your intuition will automatically tell you a drawing is "right" or "all wrong." Many art books designed to help the student arrive at this understanding are divided into sections that describe both the *elements* of art (lines, shape, space, color, and textures), and the *principles* of art (such as balance, rhythm, and harmony). If you want to read about them, they're listed in several books in the Bibliography. But these terms are vague, and it's difficult to find any two authors who agree on their listings of the elements or principles of art. Therefore, although I still use these terms in my teaching, because of their ambiguity, I have found it more and more difficult over the years to work within these traditional boundaries. Therefore, I am going to limit myself here to a brief discussion of the prime perceptual factors used in organizing a work of art, and then suggest several exercises that may prove helpful to you in developing an intuitive sense of organization.

### Proximity

*Proximity* is a factor in the organization of a drawing which causes forms or elements to relate to one another as a result of their location. Generally, the closer forms are to each other, the greater the tension or pull between them. This tension causes the objects to organize into a larger whole **(Figure 3.1)**. Here are a few graphic illustrations that will help clarify this idea.

After a quick look at **Example A,** you can identify the picture as four squares. In **Example B,** you immediately see four squares, but the image is radically different from **Example A.** This is because there is a

tension between the first three squares, causing them to relate to each other. It is not the squares, though, but the empty space between them that is creating the tension! The image is read more precisely as three squares and one square. "Four squares" is again inadequate in describing **Example C.** "Two squares and two squares" is a more accurate description.

When forms touch or overlap one another, their relationship is even more obvious. The *spatial tension* or "pull" in the empty spaces may either disappear or read as a different kind of space, a space that looks like it moves *into* the picture plane, as illustrated in **Example D.**

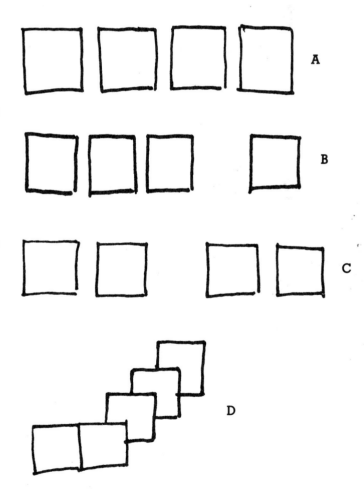

Rembrandt's *A Sheet of Studies* **(Figure 3.2)** illustrates how the organizational factor of proximity works in a variety of ways. I would like you to try to identify them even th ough there are factors other than proximity at work, which we will now look into.

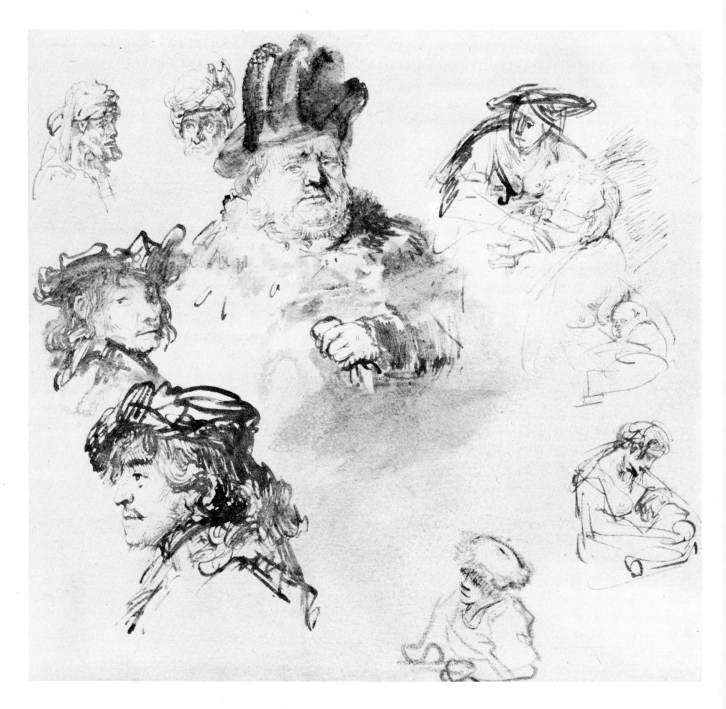

**3.2  Rembrandt van Rijn** *(Dutch, 1606–1669). A Sheet of Studies. Pen and bistre with wash and red chalk. 8¾″ × 9³/₁₆″ (22 × 23.3 cm). Courtesy The Barber Institute of Fine Arts, Birmingham, England.*

Even in a simple sheet of studies such as this, Rembrandt created an intuitive organizational structure, and these organizational factors are worth looking at. The three large portraits work together because of their similar size and treatment as well as their proximity to one another. All the other figures relate because of size and treatment, but proximity makes several work together better than others. Can you identify them? In the three mother-and-child sketches, we "see" the entire mother, even though he has only shown her torso. All of Rembrandt's figures are left "open," which makes them appear to be melting into the background. Openings such as these and smudges like those around the sleeve are sometimes referred to as sliding planes. Why is our attention kept within the page despite the strong psychological direction established by the man staring off to the left?

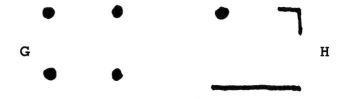

## Similarity

When forms or elements have things in common (i.e., they contain similarities), our brain has a tendency to immediately associate or relate them one to another. *Similarity* is thus another powerful means by which the artist organizes or structures the way in which a work is seen. The similarity factors most often involve line, shape, tone, weight, texture, color, size, direction, and associational, symbolic, or spatial relationships.

For example, the two squares in **Example E** relate because of the similarity of their shapes, but the black circle and the black square relate because of the similarity of their tones. The white square and black circle relate despite their radical differences because of their proximity. It is amazing how much our eyes are forced to move about in this relatively simple configuration. These movements and relationships are multiplied many times in an actual work of art, such as the Rembrandt drawing (**Figure 3.2**). The three largest heads relate because of the similarity of treatment as well as their similarity in size. The fact that they touch and overlap also binds them together so that we don't perceive head, head, head but rather three heads belonging together on a page of twelve heads! See how many other kinds of similarity factors you can discover in this drawing.

## Closure

Closure is a perceptual phenomenon that makes it possible to "read" a given form in its totality, even though only a portion of it is actually indicated. In **Example F** you see a whole person, even though only a highly stylized head and feet are indicated. The blank space is not blank; rather, it fluctuates between being the *figure* and the *ground* (that is, the positive shape, and the negative shape that surrounds it).

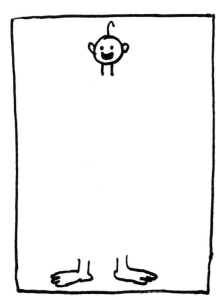

In **Example G,** the phenomenon of closure makes it difficult to describe the image as four dots because it also "reads" as a square; the dots organize into a greater whole. On the other hand, it's much more difficult "reading" an image of a square in **Example H** because of the added *variety* of forms. Their dissimilarity causes them to be less coherent than the dots in **Example G.** In Rembrandt's *Sheet of Studies* (**Figure 3.2**) you see a mother and child in three of the sketches. You never see half of a mother, even though that is all he has given us. By not completely closing forms such as the left sleeve and the front of the tunic of the largest figure, there is a greater relationship between the figure and the ground. We sometimes refer to this quality as *sliding planes* or *passage*; your eyes slide from the interior of the sleeve into the background thus relating or organizing these two entirely different planes into a single whole. To "test" whether or not the figure and the ground are completely related, imagine that you have a scissors and have to cut out the sleeve and tunic. Of course this is impossible, because over and over again you simply would not know where to cut.

## Direction/Movement

In organizing a work of art, it is impossible to separate "direction" and "movement" because they are so integrally related. "Direction" refers to the paths of movement that tend to lead the eye into and around the entire drawing, and is perhaps the most obvious means of achieving organization. While it is obvious that a pointing arrow forces the eye to move in a particular direction, most shapes or lines have an inherent movement or direction, usually along the long axis of the shape. For example, Rembrandt's sketches organize the page into a circular direction/movement which, rather than being flat, is *oblique* to the picture plane, thus giving an illusion of depth. Also note that the way a head is turned causes a *psychological* direction/movement. In Rembrandt's sketches, the psychological directions act as a foil to the predominantly circular path. Similar direction/movements are at work in the Degas drawing of bookshelves (**Figure 3.3**).

## Equivocation—Figure and Ground

Equivocal space or form refers to an ambiguous dimension or element that may be "read" in more than one way and serves the artist primarily as a means of relating *figure* and *ground* (that is, positive and negative space) within a given work. This phenomenon is also sometimes called *figure-ground interchange.*

**Example I** illustrates equivocation of form through the use of *distorted perspective.* That is, we are able to see the complete top of the bottle while the base re-

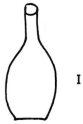

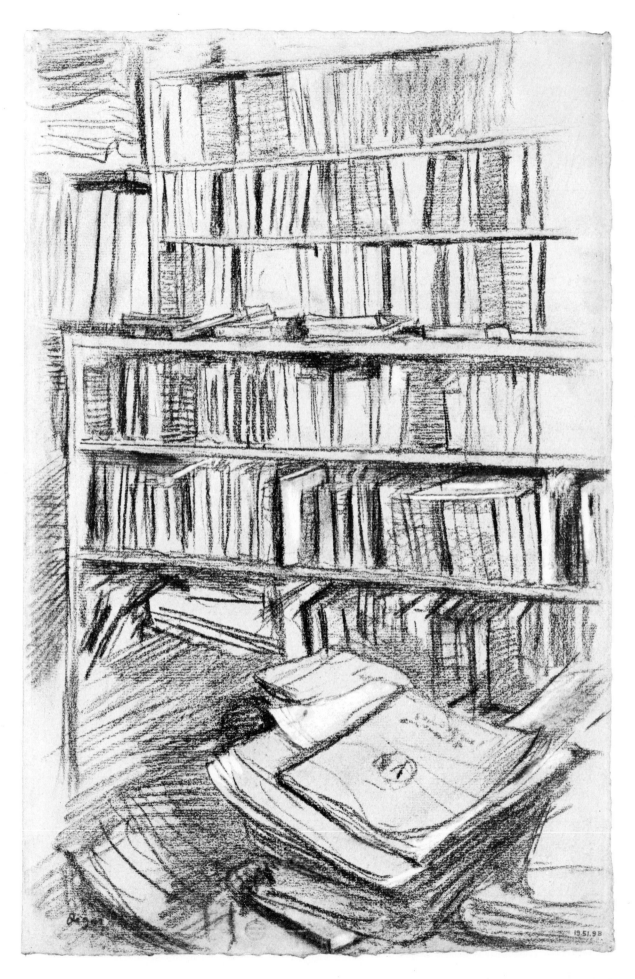

mains flat. This particular quality is also sometimes referred to as "simultaneity," since it includes the use of *multiple eye levels*; we see the bottle from above and from directly in front simultaneously. In **Example J,** equivocation is created because the various bottles are defined by a line which is common to two or more of them. These lines exist both in front and in back, simultaneously relating foreground and background. In **Example K,** the use of *transparency* causes equivocation or an optical illusion since each square is able to be "read" as being either in front or behind the other. *Closure,* illustrated in **Example L,** is another important means of achieving both equivocation and sliding planes. (See also **Examples F** and **G.**)

In **Example M,** it is difficult to establish either figure or ground (positive or negative shapes) because the form is divided equally between two tones, producing a *figure-ground interchange.*

**Example N** illustrates how form may be defined by either line or tone and how the edge of a tone may be either precise or ambiguous. Although we are aware that there are four squares, it would be possible to cut out *precisely* only the one in the lower left-hand corner. The greater ambiguity of the other three squares causes a great deal of equivocation in "reading" them. These contrasting qualities of form definition in a drawing often help to "activate" or provide some "energy"; if carried to extremes, however, either total monotony or total chaos may result.

Keep in mind that all of the organizational factors in a drawing impinge on one another; I separate them only to help you see them more clearly. Now go through the reproductions in this book and try to discover the means of organization various artists have used.

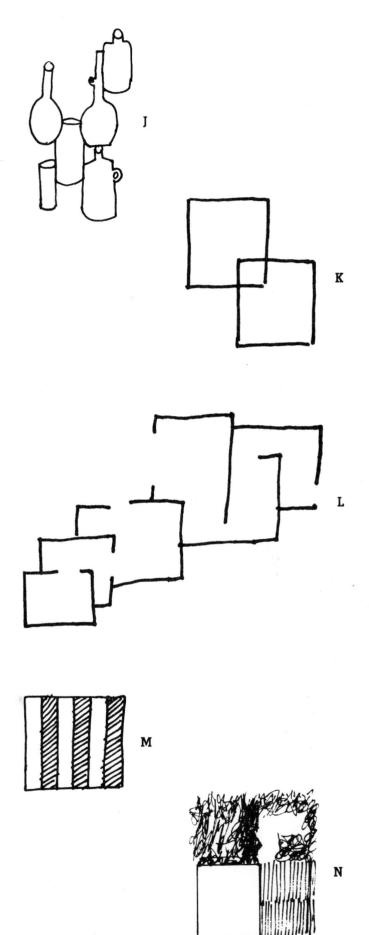

*3.3  Edgar Degas* (French, 1834–1917) Bookshelves in Duranty's Library. *Charcoal heightened with white chalk on buff paper, 18½" × 12" (47 × 30.5 cm). The Metropolitan Museum of Art, New York, Rogers Fund, 1918.*

*This drawing comes as something of a surprise since, when we think of Degas drawings, we usually envision either figures or horses carefully placed into an extraordinary spatial concept. This drawing shows what a master can do with a mundane and inconsequential subject by filling its composition with tension. The bookshelves create a very strong diagonal movement to the left, which is stopped by a strong vertical along the left side. They are also held in tension by the books in the foreground, which act as a foil to the books in the background and create a strong movement to the right. We tend to enter this composition from the bottom and secondarily from the upper right where he has left the paper blank! Notice how the scribble on the top shelf reads as books; also notice the amazing number of variations used to indicate the rest of the books. Even in this reproduction, it is possible to see where he has very judiciously placed a few white highlights, which beginners are almost always prone to overdo. Carefully analyze the lines and tones that define a single area such as the top book at the bottom. Why not set this reproduction aside and attempt to draw a stack of books yourself?*

43

## Drawn Formats and Tondos

*Format* refers to the shape, size, or proportion of the drawing paper. Most students barely give format a second thought, yet it is a basic factor for structuring a drawing. A large majority of drawings in this country are vertical simply because drawing pads are most often bound together at the top. If, however, the pad is horizontal with the binding on the narrow dimension, I find that students will then produce horizontal drawings! In effect, the manufacturer is determining the format of these drawings!

To fit the format to the subject at hand is your first and one of your most important structural decisions. In addition to this general awareness of the shape of the page, I suggest that you begin your work by making a drawn format. A *drawn format* refers to the four lines that define a rectangle within which your drawing will occur. This does several things, the most important of which is to destroy that pristine white surface. It also makes you more conscious of the actual working space since it is clearly delineated by a line rather than simply existing as the edge of the page. Very often my students begin to incorporate the line of this drawn format into the actual work.

In order to become more conscious of formats, I suggest you attempt drawing within a few radically different formats **(Example O)**. Try a format 2″ × 37″ (5 × 94 cm), first horizontally, then vertically; or try a giant 12′ x 1′ (360 × 30 cm) drawing. A most interesting format, which was used a good deal during the Renaissance but is seldom seen today, is a circular one called a *tondo* **(Figure 3.4)**.

Interesting and unusual work is often produced by going completely contrary to any and all previous precepts. Now that you're conscious of the importance of format, try becoming "contrary" and fit a vertical pose onto a horizontal page or vice versa. And to be even more "contrary," make the figure touch all four sides of the format! (See the drawing by **Angela Fremont**.)

## Simple Still Life . . . Use the "Ghosts"

This exercise is designed to help you become more aware of positive and negative shapes. It will also help you use erasure "ghosts" to advantage and to determine the effects of both format and "bleeding edges" on organization.

As I explained earlier, a positive shape is the object being drawn and a negative shape refers to the area that remains, or to the space around positive shapes. These factors are sometimes referred to as *figure and ground*, "figure" being the positive shape and "ground" being the negative one. An awareness of negative shapes is a difficult concept to develop, but most artists pay as much attention to these as they do to the positive shapes, since consideration must be given to *everything* created within a composition. Note how both deKooning and O'Keeffe **(Figures 3.5 and 3.6)** have manipulated this important factor to their advantage.

*Interesting results can be obtained by going against all the rules. Here a vertical pose was forced into a horizontal format. The figure was supposed to touch all four sides of the drawn format. The strong darks in the lower right balance the large space above and to the left. (A mouse can balance an elephant on a teeter-totter—if one end is long enough!) Drawing by Angela Fremont.*

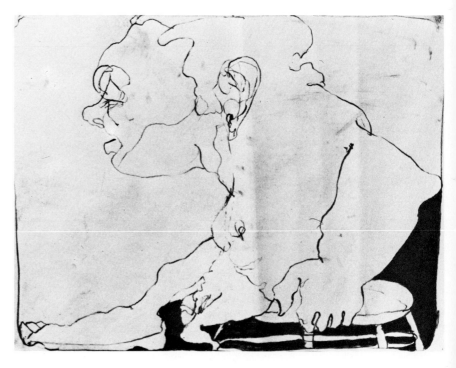

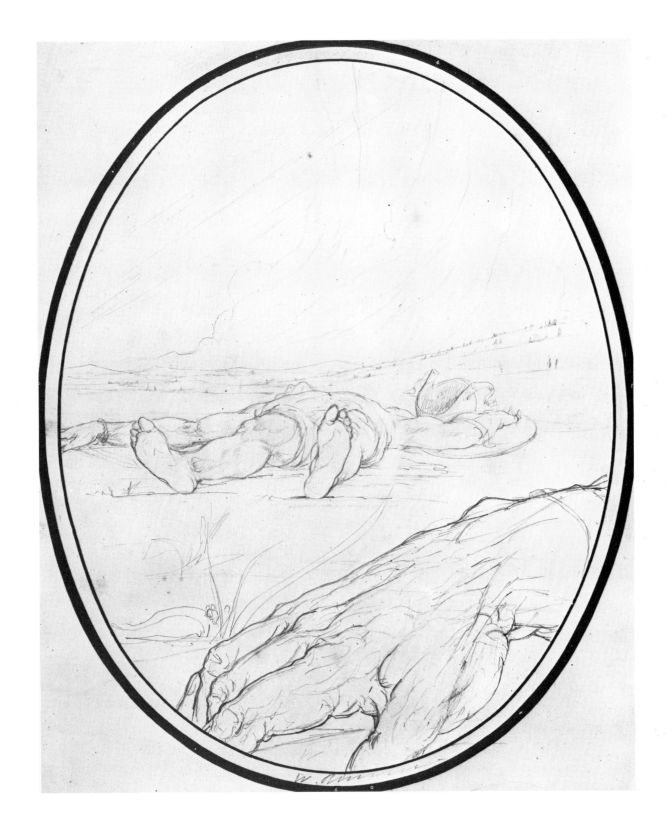

**3.4  William Rimmer** *(American, 1816–1879). A Dead Soldier, c. 1871. Pencil, 11¹¹/₁₆″ × 9¼″ (30 × 23.5 cm). Courtesy Museum of Fine Arts, Boston.*

*Just as the tondo was a popular format during the Renaissance, the oval was a favorite of 19th-century artists. This is an extraordinary composition in which deep space is suggested by the monumental hand, which occupies about a third of the total space and is cut off by the format. It could almost be a closeup of the fallen soldier's hand, which bleeds off the edge of the format on the left. The foreshortening is remarkable; the left foot*

*and right arm are perfectly parallel to the picture plane and the complete torso occupies little more area than the single foot! The dead soldier creates a horizontal that cuts the oval in half. Notice how important the two horizontal lines drawn at his heels are; they anchor the figure to the earth. Rimmer loved anatomy so much that it led him to become a doctor in mid-life. Make a list of the significant differences in this fallen warrior and the one in Picasso's study for Guernica (**Figure 3.1**). Comparing these two drawings should help you understand the difference between subject matter and content in a work of art.*

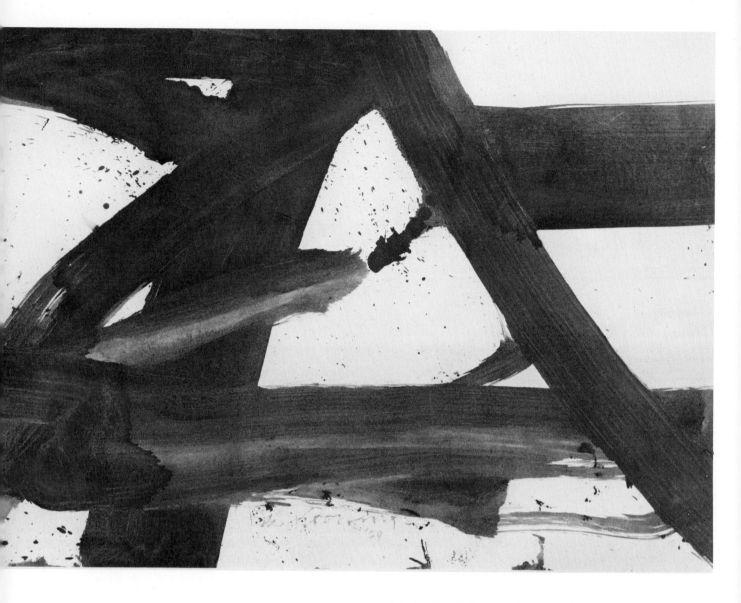

**3.5 Willem deKooning** (Contemporary American). Black and White (two sides), 1959. Enamel on paper, 27¼″ × 39″ (67.5 × 97.5 cm). Collection Whitney Museum of American Art, New York.

Large housepainter's brushes and black enamel housepaint thinned with turpentine are perfect materials for obtaining the results deKooning sought here. The drips and splatters help us to relate to the artist's actions as he impulsively slashed these strokes onto the paper, creating negative shapes with a nice variety of size and shape. Notice how each slash of paint is counterbalanced by another moving in an opposing direction, thus setting up a simultaneous tension and equilibrium. Compare this work with the O'Keeffe drawing on the next page. It is astounding how similar the main structural motifs in these two drawings are to one another, and yet they evoke entirely different feelings in us. DeKooning invented a method of working where he would make a series of drawings on tracing paper, then, by stacking them one on top of another, he would rip out a section here and there, or even try a different page underneath until he arrived at an entirely new image—a result of drawing, collage, and transparency.

**3.6**  **Georgia O'Keeffe** *(Contemporary American). Drawing IV, 1959. Charcoal on paper, 18½" × 24½" (47 × 62 cm). Collection Whitney Museum of American Art, New York, Gift of Chauncey L. Waddell.*

Working in the southwestern United States, and out of the "mainstream" of American art for the past several decades, O'Keeffe has produced some of the most poetic and evocative images of our time. The charm of this drawing lies in its understatement which is almost ascetic, compared to the wet and juicy deKooning on the preceding page. This and the deKooning were produced in the same year, and there is an astounding similarity in the main directions of the forms as well as in the negative spaces. O'Keeffe gives us just enough information to recognize the subject as some kind of tree, and she meticulously models the forms with tones of charcoal. But note that the shading is arbitrary, since the direction of the light source varies on the trunk and branches. Do you think that the texture she has given us resembles the actual texture of the form that she was drawing?

• Draw a still life consisting of a single bottle, the outline (shape) of which you are to delineate with charcoal in a previously drawn format (see previous explanation of formats.) After you have drawn the outline of the bottle, look at the shape you have made. Now, forget about the original bottle for the time being and, through a process of erasing and redrawing, try to improve the shape. (See drawing by **Linda Eidelberg.**)

• Will it be more interesting if the two sides are not identical?

• Or if the central axis is on a slight diagonal rather than perpendicular (as Cézanne so often drew his objects)?

• Could a curve on one side be set against or act as a "foil" for a straight line on the opposite side? **(Figure 3.7)**

• What happens if you "bleed the edge"? (*Bleeding the edge* simply means that an object or shape runs up to or continues outside of the format, as the branch in the O'Keeffe drawing demonstrates.)

• You can bleed the edge by extending the bottle shape to the edge of the drawing or by changing the drawn format. "Bleeding" has a tendency to simplify the negative shape/space and make it more tangible. (For instance, in **Example P** a modified (stylized) bottle is shown in a neutral, but very complex, negative shape. However, the structural center of the bottle (direction) is static since it echos the format. In **Example Q,** on the other hand, the modified bottle is shown in a space where the negative shapes are simplified but somewhat ambiguous. There the tilt or direction of the bottle sets up a tension with the parallel sides of the format. (See also the drawing by **Amy Sillman.**)

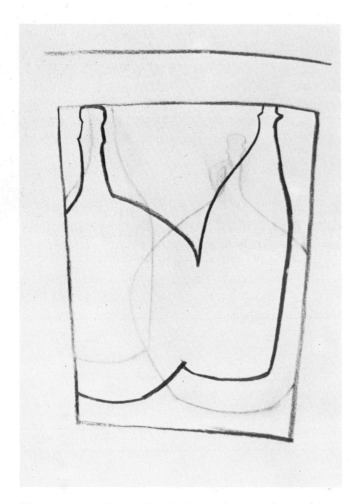

*Was it intentional or not that the drawn format in this work is so far out of square? Is the tension increased or decreased? How important is its being intentional? What do you think about the line above the format; is it a part of the composition or frosting on the cake? Are the shapes, both positive and negative, better in their present form or in the one which is still visible in the "ghost"? Drawing by Linda Eidelberg.*

*Even though this student is not concerned primarily with line, as suggested in the problem, she has taken a simple object and by manipulating it within the format she has achieved an exciting arrangement. Though the subject is well drawn, the vitality actually results from the negative shapes just as much as from the positive one of the paper bag. Bleeding the edge of the bag helped to simplify the negative shapes. Pencil drawing by Amy Sillman.*

**3.7** **Joseph Stella** *(American, 1880–1946). Coal Pile. Charcoal on paper, 20″ × 26″ (51 × 66 cm). The Metropolitan Museum of Art, New York, Whittelsey Fund, 1950.*

*Having absorbed the lessons of the Italian Futurists, Stella is best known for his colorful paintings of the Brooklyn Bridge. He was also a consumate draughtsman, and many of his drawings were based on life around him as he saw it. He spent time drawing in the coal areas of Virginia and Pittsburgh on commission for a magazine. This marvelous composition is so direct, Spartan, and geometric that it could almost be the product of a Minimal artist. The most evocative note is the unbelievable contrast between the big, black, triangular piles of coal in the foreground and the delicate, almost lacelike quality of the bridge form that moves across the top of the page and then down on the left creating another triangle. What makes this strong contrast work? What do you think of the two telephone poles on the far horizon? Are they necessary to the composition or extraneous afterthoughts?*

Henri-Matisse

**3.8  Henri Matisse** *(French, 1869–1954).* Nude Study. *Lead pencil. The Metropolitan Museum of Art, New York, Gift of Mrs. Florence Blumenthal, 1910.*

*Why did an artist who could draw in the traditional academic modes, reject them for a flowing, spontaneous, decorative, simplified, and sometimes "messy" style? His paintings contained such brilliant, daring, and unrealistic color that he and his artist friends were derisively dubbed Fauves, which literally meant "wild beasts"! Essentially this drawing consists of two quick contour drawings. Both were drawn rapidly, although the second one shows considerable struggle as he drew and redrew a form in an attempt to realize his intentions. The first drawing, a ghosted image, is almost one continuous line. Why didn't he take the time to erase that and his other "mistakes," such as the scribble at the wrist and under the arm? Why is the necklace so dark? Why do artists almost unanimously agree that Matisse is one of the greatest artists of our time?*

• In making these changes, try not to erase any line completely. Rather, let them exist as "ghosts," visual evidence of your working process. In the Matisse drawing **(Figure 3.8),** you can see the ghost of his first attempt to delineate the pose; he has simply drawn right on top of the first attempt without even erasing. This double image shows his process and lends excitement to the work.

• Study the negative shape/s in your drawings—which, of course, have been determined by the positive ones—and try to "improve" them just as you have the positive one/s. As you erase and alter the negative shapes, the positive shapes will also change. This is precisely the point. *Everything that you do to a drawing affects everything else that you have already done.*

Try the above exercise over and over again using other subjects such as bottles with different shapes or perhaps various types of fruit. As you try different solutions, you might want to start with distinctly different (drawn) formats.

## A "Clean" Drawing

The use of ghosts in the simple still-life project may seem confusing or perhaps even "messy" if you haven't had much experience in drawing. To "test" whether or not you want to save the ghosts, take a piece of tracing paper and, using a very regular pen line, trace the drawing of the modified bottle as well as your negative spaces. This cleaner and more precise version may suit your taste better than the messier "ghost" version. In any event, by tracing you now have two drawings, and they are *entirely* different from one another even though the basic shapes remain the same.

• To further test the effect of ghosts and variety of line on a drawing, you might try to trace the Matisse figure with a single, unvarying pen line, leaving out the ghost that he left for all to see!

## Complex Still Life . . . A Search for Relationships

As in the simple still life problem, use charcoal and eraser to delineate and then improve upon the positive and negative shapes; but this time add a second, and preferably a different type of bottle, to the still life. The visual situation has now changed considerably, since you now must deal with the positive and negative shapes and also the *relationships* between them.

• Work within a number of drawn formats which have a variety of proportions, and draw, erase, and redraw *both* the positive and negative shapes. (See drawing by **Linda Eidelberg** on page 48.)

• Do several in which the bottles are simply standing side by side with a space between them.

• Try several with one of the bottles standing and one lying on its side.

• Let the bottles *overlap* to some degree and attempt several more drawings.

In your drawings, this overlapped area may serve to indicate that one bottle is behind the other, thus creating an illusion of space not only across the page but also *into* the page. When the flat space of the *real* picture plane (the flat page) and the *illusion* of three-dimensional space appears to hold together, act as one, or to be in harmony with one another, we call it *plastic space.*

• If you draw the shape where the two bottles overlap as clearly as the bottles themselves, you will create an illusion of *transparency* in which it may be difficult or impossible to "read" which bottle is in front and which is behind, thus creating *equivocal* or *ambiguous space.* For example, shape B in **Example R** belongs to both bottles and therefore exists in two places simultaneously.

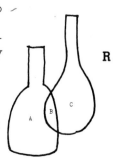

• Add a third bottle or perhaps a piece of fruit to the setup, thus further complicating all of these compositional factors. In these drawings, continue to deal with the positive and negative shapes, the "ghosts," overlapped shapes and/or transparencies. At this point, however, try to add yet another means of indicating equivocal space, one achieved by having part of the outline of one shape *exist simultaneously* as part of the outline of another shape.

Since the line in Example S exists both in front and behind simultaneously, it creates equivocal space. The movement back creates a *diagonal direction*, which always suggests some movement into space or into the picture plane.

Don't become a slave to the setup. Let everything grow, develop, and change in each case until it feels "just right." Your drawings can be made more and more complex by adding additional objects to the setup. However, a more complex arrangement/drawing is not necessarily better than a simple one. A drawing may be so complex that it is visually exhausting to look at or, on the other hand, it may be so simple that it is visually boring. Your objective here should be to achieve both simple arrangements that are visually exciting and complex arrangements that nevertheless "hold together." Although these drawings exist as entities, works unto themselves, you might use one or more of them as the structural basis for a collage or painting. The "structural basis" refers to the primary relationships between all aspects of the work.

Confusing? No doubt about it. There really are no simple or easy solutions to the problems involved in the organization of works of art. All you can do is seek a little guidance, such as I am attempting to give you here, and the answers may become clearer as you work.

## Adding Light and Dark . . . The Plot Thickens

In order to "thicken the plot" of the organizational factors in this series of drawings (not necessarily to improve upon it . . . some of the world's greatest drawings are simple line works!) you are now going to deal with two kinds of light and dark: one in which the drawing is given a more or less arbitrary *flat* light and dark structure, and one in which the light and dark structure consists of shape *modeled* from light to dark. (This subject will be treated further in Chapter 4.)

• Set up a still life consisting of about half a dozen positive shapes or objects. By this time you're aware that six positive shapes also create a number of negative shapes.

• Proceed to draw with charcoal, erasing shapes in order to improve upon them and to create a stimulating visual tension (see **Examples B** and **C**) in the spaces between the shapes.

• You might try to make less radical changes in the shapes than in the preceding two projects so that the drawing relates a little closer to the "reality" of the setup.

• Begin to fill in some of the shapes with light, middle, and dark tones of charcoal. These should be set down in a somewhat arbitrary fashion; that is, by not following the darks and lights in the setup, but by trying to articulate them (set up relationships) into some kind of interesting visual order. (See drawing below by **Linda Eidelberg**.)

• The task is not to model the shapes into three-dimensional forms with highlights, middle, and dark tones, but rather to realize that the light and dark tones in a drawing may serve important compositional ends.

*When tone rather than line alone is used to define form in a more complex still-life arrangement, the difference between figure and ground or positive and negative shape becomes more obvious. For example, the dark bottle on the left is distinctly different from the gray background or the white apple. The dark jug begins to create a larger shape with the ground on which it sits because it's similar in value. Can you find a similar massing of a middle tone and a light tone? Drawing by Linda Eidelberg.*

**3.9 Francisco Goya** (Spanish, 1746–1828). Locos (Madmen). *Black crayon, 7" × 5¾" (18.5 × 14.5 cm). Courtesy Museum of Fine Arts, Boston, William E. Nickerson Fund.*

One of the most intense and imaginative draughtsmen of all time, Goya was always interested in insanity and was himself bothered by terrible nightmares. His composition is almost always tight, simple, and masterful. The central figure is light in tone and is surrounded by figures enveloped in a dark tone, which makes them "readable" as a single shape. The light of the central figure is carried over like a backward L to the lower portion of the figure on the lower left, thus uniting them. Note how the dark of the figures on the left is pulled into the background with the barest suggestion of a line separating these two planes. The figures in the back are all a middle tone, exactly the same as the background behind them. This drawing is a perfect example of how many shapes and forms can be pulled together into a larger shape when their tones are of similar value. See if you can analyze the primary linear thrusts and counterthrusts by placing a sheet of tracing paper over the drawing.

• You can create large tonal shapes out of a number of small shapes by making their tones of similar values as is illustrated by the Goya (**Figure 3.9**) and the Degas drawing of Duranty (**Figure 4.4**). Using a more or less single tone and with strokes going in one direction, Degas has made one large shape out of the myriad of shapes in the coat. Black next to middle gray next to black is a totally different tonal structure than black next to white next to black. Shapes A, B, C, D, and E in **Example T** also operate as a single *new* shape, G, in relation to shape F because they're similar in tone.

• After you finish one drawing, do another using the same shapes but this time *radically* alter the tonal relationships you used in the first drawing. You will observe that this simple procedure produces an entirely new drawing.

• After experimenting with tones that are treated as flat shapes, try several others where each plane is shaded from a light tone to a dark tone or a light tone to a middle tone. If you do not "close" the plane, you can begin to experiment with the phenomenon of *sliding planes* or *passage*. (This was a primary concern of Cézanne, who is sometimes referred to as the "father of modern art.") Besides leaving a plane open, you can also create this effect by having a tone on one plane "scumble" or smudge over into the next one; or by using very similar tones so that the delineation is not very contrasting, or by having similar textures on adjoining planes. **Example N** illustrates some of these phenomena, and you should also try to find them in the Picasso (**Figure 3.1**).

• After achieving a degree of confidence and freedom with these compositional problems, I suggest that you try several with pastels or colored crayons. Be sure not to let the actual color of the setup dictate your color choices; you can be as free with color as with changing and modifying shapes in the setup.

• Be brave, imaginative . . . . Take yourself on a visual adventure.

## A "Test" to See if Things "Hold Together"

A "test" sounds impossible, doesn't it? There can be no test to see if things hold together in all situations. However, I can suggest a test which will often help you to see if all parts of a drawing are working together. It is very simple. Look at the Degas drawing (**Figure 3.3**) and imagine that the objects and spaces in the drawing are three-dimensional rather than two-dimensional. Having done this, imagine that you can grasp the book in the lower right-hand corner and pull it away from the page. You will note as you do this that all of the other parts of the drawing—books, shelves, the space between foreground and background—are pulled off right along with the book in the corner. This is because all of the parts "hold together" in a very tight structural

whole. Now try this with the deKooning (**Figure 3.5**). Grasp the triangular negative space on the left-hand side. When you pull, does the rest of the drawing come along with it?

Now go back to the still life studies on which you have been working and try this test on them. Like all tests, this one is also dangerous because of what it *doesn't* test. That is, there can be dozens of exceptions to this rule, drawings where a part *can* be pulled off without disturbing the rest of the work—and they remain great drawings!

It's tough for the beginner to comprehend that all rules or "tests" in art exist only to be broken. Yet that is precisely what mature artists mean when they stand in front of a work and exclaim, "I can't believe it; the damn thing works!"

## The Big Challenge—Packing It All In

Many years ago as an elementary school art teacher, I developed a lesson designed to help the students arrange what seemed like an impossible number of objects into a single drawing. The drawing couldn't be just bits and pieces but had to be one that would "hold together." This forced them to *overlap* objects and also to use their imagination, since we discussed the possibility of purple trees or even striped clouds. We also looked at the Fauves, such as Matisse, Derain, and Vlaminck to see how they let their color burst forth like "wild beasts." I've since discovered that this problem is equally suitable for college-level students who also think it is a great deal of fun and certainly a big *challenge* to include the myriad of objects. (See the drawings by **Betsy Smith** and **Alice Feinberg**.) Although it varies from term to term, the following is a typical list:

3 mountains
1 sidewalk
1 hill
1 car
1 forest
1 road
4 trees (all different)
1 fire hydrant
1 house
1 dog
1 adult
1 bush
2 children
3 telephone poles and wires
1 bike
1 open window (see into it)
1 path
1 clothesline
   with long red underwear on it
1 cat
1 mosquito
2 birds
1 worm
1 television aerial
3 clouds
1 airplane
1 small crowd of people
1 flower garden
1 fence

An extensive list of everyday objects was listed on the board and the students were "challenged" to incorporate all of them into some kind of a picture, a nearly impossible feat. I always tell my classes that this was a problem I used to give elementary-school children; I find that most college students, when told this, construct pictures that have a childlike quality. Most also discover that regular crayons can become a viable medium. Drawing by Betsy Smith.

Using a ruler and a complete spectrum of colored markers, this student tried to combine the "challenge" problem with another in two-point perspective. To include so many objects in a single picture presents a major problem in composition. Because the vanishing points are much too close together, the space takes on a dreamlike quality. Drawing by Alice Feinberg.

To make it even a little more of a challenge, I suggest that you limit yourself to wax crayons (a giant 64-color box with gold, silver, and bronze!); that you fill all areas of the paper; and that you color them all solid hues, so that no white specks show through the tones.

Go ahead. . . . I challenge you!

## Structured Still Life: Attack on All Fronts!

The "challenge" drawing was fun, but now I want you to bring to bear all of the organizational factors we've talked about thus far. There are many steps involved in this exercise, and you might tend to balk at the complexity of the whole thing. But if you take it step by step, the process will gradually become clear.

• First set up a still life comprised of many objects. Try to include both large and small objects, as well as large and small spaces between the objects. Some of the items I generally include are: six or eight bottles, a plate, a basket, wax fruit, artificial flowers, a tennis racket, a guitar, old shoes, a variety of drapery, a banner with stars and stripes, and, if possible, a model.

In ten minutes, using a soft pencil, make an *information sketch* of the whole thing. In an information sketch, you should not worry about doing anything other than noting for future reference what lies in front of you. Rely on closure a great deal—that is, draw only one side of a bottle, only a small section of the drapery pattern, and so forth. This step is just to get started; to make an initial, introductory probe into the arrangement. It may also serve for information in later stages in case the still life is disturbed or removed.

• Now take a clean page and draw a format with your pencil, but do it freehand. All that follows will take place on this page until the very final step:

• Using your complete range of pencils, create a composition based on the still life, but one consisting of *only* vertical lines. You should be trying to "*activate*" or "*energize*" the page with these verticals while you try to make them seem to have some kind of structure. The verticals may be taken from existing verticals, such as the side of a bottle; or they may be based upon the structural center of objects; or they may be implied lines which exist from one point in the still life to another point either directly above or below it (a line which is being drawn through the negative space). If you can visualize the setup as a flat photograph, lines can then be drawn from distant points to points in the foreground, because a photograph of the still life is already a flat depiction of it and is thus one step closer to the flat page upon which you are working. (In reality, such lines would exist as diagonals into the space of the still life.) Strive for a variety of lines—long, short, very light and very dark. Van Doesburg's *Studies* (**Figure 3.10**), Picasso's *Le Taureau* (**Figures 3.11** and **3.12**) and the *Church Façade* drawing by Mondrian (**Figure 3.13**) may help you understand what your drawing might eventually look like. However, at this stage, it will consist of only vertical lines.

• For about 10 minutes, proceeding as you did with the verticals, now add horizontals to your page. They should still be based on actual horizontals in the setup

**3.10 Théo van Doesburg** *(Dutch, 1883–1931). Studies for Composition (The Cow), 1917. Series of eight pencil drawings, 4⅝″ × 6¼″ (12 × 16 cm) sheets. Collection The Museum of Modern Art, New York, Purchase.*

Along with Mondrian **(Figure 3.13)**, van Doesburg was instrumental in forming the De Stijl or Neo-Plastic group in the Netherlands. They espoused the use of the right angle in a horizontal and vertical position, and the primary colors plus white, black, and gray. In this series, van Doesburg began with a realistic drawing of a cow and, in an imaginative, somewhat doodlelike procedure, searched for a structural basis for it that became increasingly more abstract. This is just about the reverse of the procedure I suggested you use in the text. More important, it illustrates that there is no one solution to a problem, but infinite possibilities. Twenty-nine years after these drawings were made, Picasso produced a very similar series of lithographs where he progressively simplified and abstracted a bull **(Figures 3.11 and 3.12)**. Twenty-seven years after Picasso's series, the Pop artist Roy Lichtenstein was inspired by the Picasso to produce a similar series based on a bull!

**3.11** *(Opposite page, top)* **Pablo Picasso** *(Spanish, 1881–1973). Le Taureau, 1945–1946. Lithograph in eleven states; third state, 11½″ x 16½″ (29 × 42 cm). Courtesy Museum of Fine Arts, Boston, Lee M. Friedman Fund.*

**3.12** *(Opposite page, bottom)* **Pablo Picasso.** *Le Taureau, 1945–1946. Ninth state, 14″ × 20″ (36 × 51 cm). Courtesy Museum of Fine Arts, Boston, Lee M. Friedman Fund.*

Like van Doesburg, 29 years earlier, Picasso has taken the theme of a single animal, in this case a bull, and has drawn a series of variations on it. He also moved from complex and realistic drawings to ever simpler ones as he searched for structural lines and forms that formed the essence of the subject under investigation. His final drawing in the series of eleven is quite similar to drawings on prehistoric caves. Matisse produced a similar series of simplifications using a swan as the subject; and in our own time, the Pop artist Roy Lichtenstein used Picasso's series as the basis for yet another series on bulls! Here the composition is self-contained within the form of the animal itself rather than in the more traditional mode of considering the positive and negative spaces of the entire page. You yourself might want to try this process of searching for the essence of form using another animal as the subject.

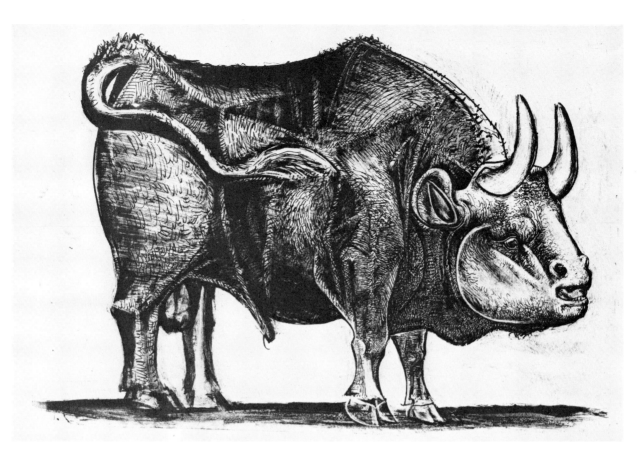

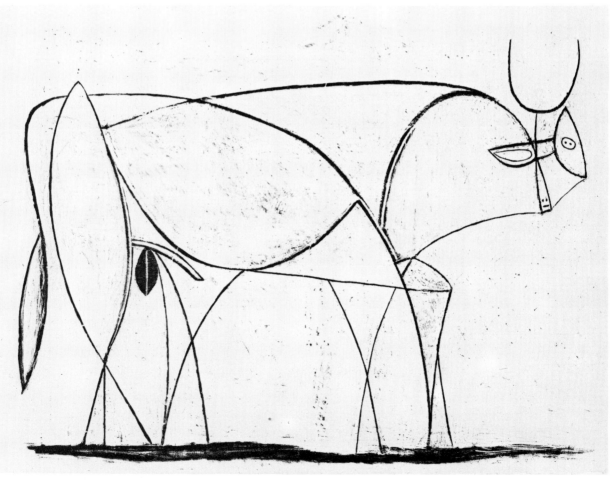

58

This drawing started with an analysis of the horizontal, vertical, and diagonal lines suggested by the forms in the setup and by the relationships between these forms. Using the complete range of pencils on illustration board, the contours of the objects and figure were eventually established and all was incorporated into a tight light-and-dark structure. Drawing by Maria Lino.

or on horizontals between two points. Try to put in lines that will enhance and seem to "belong" to the already existing verticals. Don't hesitate to erase if something doesn't seem to "fit"—the "ghosts" will add another dimension.

• Taking another 10 minutes, add diagonal lines to your drawing; but be sure that they are still based on the still life. You no doubt already have *implied* diagonals in your drawing (see **Example U**). Amazing! We are able to build round buildings with square bricks!

• Working quite rapidly and forgetting all about the still life for the time being, work three arbitrary tones into your drawing wherever you feel that they will work. Make one tone dark, one light, and one medium in value, and make one quite large, one quite small, and one medium in size. (Note that **Example T** shows how a tone may cover several areas without obliterating them.)

• Having "forgotten" about the setup in the last step, now return to it for about another ten minutes. Look at the setup and create areas of contour drawing on top of the work in progress. You are now returning to the surface reality of the setup. Ignore, if you can, all previous marks and draw a section of a flower in one area, the edge of a bottle and its handle in another and, perhaps, a section of a guitar in yet another. Don't "close" the entire form of any object. Let it flow into and out of the lines and spaces surrounding it.

• At this point, you will probably want to erase some of the underlying lines and/or tones as you attempt to get

**3.13** *(Opposite page)* **Piet Mondrian** *(Dutch, 1872–1944). Church Façade, 1914 (dated on drawing 1912). Charcoal on paper, 39" × 25" (99 × 64 cm). The Museum on Modern Art, New York, The Joan and Lester Avnet Collection.*

If you are attempting to develop the structured still life suggested in the text, after drawing the verticals and horizontals relating to this still life, your drawing may develop a vague resemblance to this drawing by Mondrian. Starting out as a realist, Mondrian was influenced by the Cubists and his style gradually went through several phases, eventually developing into a pure geometric, non-objective style called Neo-Plasticism (or pure plastic art). The major precepts of Neo-Plasticism were the use of right angles and primary colors (red, yellow, and blue). The movement not only influenced the famous Bauhaus in Germany, but also the development of the International Style in architecture. This drawing was based on an actual church façade. The intersecting horizontal and vertical lines Mondrian started with eventually developed into rigid right angles. Only the Gothic windows appear to have any relationship to the original motif. If you're not already familiar with Mondrian's later paintings, look them up and compare them to this early work.

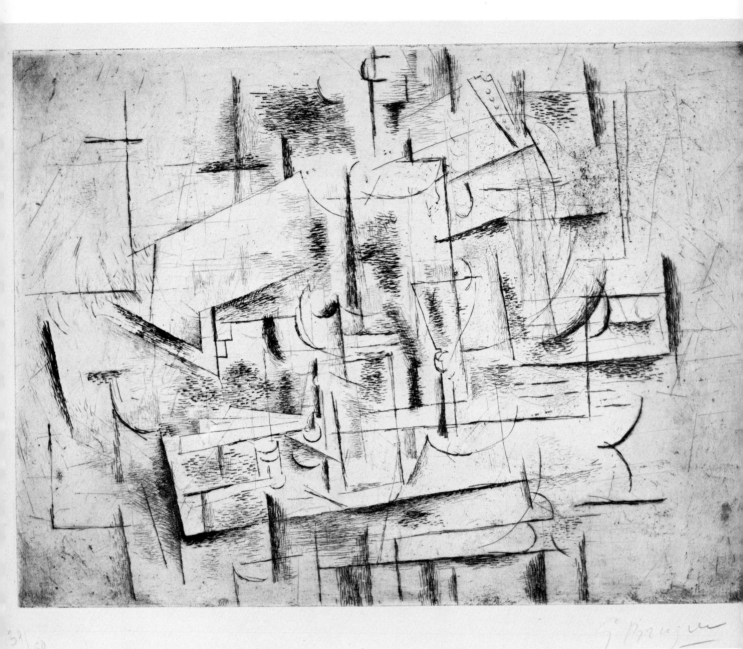

**3.14  Georges Braque** (French, 1882–1963). *Glass, Bottle, Pipe, 1912.* Drypoint and etching, printed in black; 12¹⁵/₁₆″ × 17⅞″ (32 × 45 cm) plate. Collection The Museum of Modern Art, New York, Purchase Fund.

   *This Cubist still life contains many of the compositional devices I suggest you use in your own still life, though your style may bear no resemblance to Cubism and may, in fact, be super-realistic. Can you find the glass, bottle, and pipe here?*

*Are there other objects you can identify? See if you can find instances where Braque has made use of the following compositional devices: sliding planes, simultaneous contours, positive-negative space, simultaneity, fractured form, movement circuits, multiple eye levels, implied lines, closure, arbitrary tones, transparency, and light and dark structuring. Imagine! This example of "modern art" was created about 70 years ago! Can you create a still life that looks as contemporary?*

the reality of the drawn shapes and the reality of the structural underpinnings into something that seems to work. (See the drawing above by **Maria Lino.**) Remember that most of the time you are using your erasers to "draw"—that is, to modify existing forms rather than to eliminate them. Try using all of the knowledge and information you have gathered from the preceding exercises. This includes the following:

sliding planes
multiple eye levels
simultaneous contours
implied lines
positive-negative space
closure
simultaneity
arbitrary tones
fractured form
transparency
movement circuits
dark and light structure

The drawing by Braque **(Figure 3.14)** illustrates the extent to which a still life can be taken, and the exercises suggested thus far have forced you to look at *many* possible means of structuring the still-life setup. The structure of a drawing is equivalent to laying a foundation or constructing the steel superstructure for a building. This is what really holds the whole thing together.

• To sum up all you have learned, I suggest that you now start another drawing on a sheet of illustration board. This will be a rendering. You will be using your complete range of pencils and working for a wide range of tones and excellent techniques. As I tell my classes, you must *never* touch the illustration board except by the edges, just as you would handle valuable phonograph records. If you have to let the butt of your hand touch the surface, put a clean piece of paper under it to keep from smearing previously made tones or leaving a greasy residue that will affect future pencil tones. Work from the very lightest tones to the very darkest; each subsequent tone will cover any mistakes you make. Don't be a slave to the original study or to the still life. Once you "get into" this drawing, you'll find that 15 or 20 hours can fly by in a few minutes! (See still life by **Alisa Hafkin.**)

• Having completed this drawing, you can now begin to think of all the variations you can try in the future:

charcoal on tinted paper
colored pencils and graphite pencils
photocopy prints of your work
paint and canvas from start to finish
a photostatic blowup of your original
lecturer's chalk on large butcher paper
etc., etc., etc.

*Although this student went through all the steps suggested in the structured still-life problem, her drawing is entirely different from the one by Maria Lino. Notice the multiple eye levels, the reverse perspective of the table, and the way she was able to bend the background space. The severe black in the lower left acts as a "surprise" in a most unobtrusive way. Pencil drawing by Alisa Hafkin.*

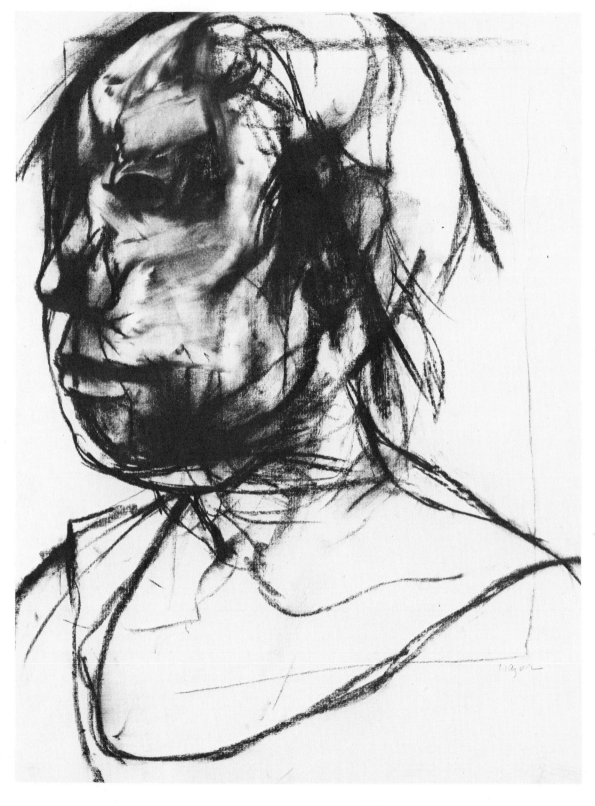

# Using Light and Dark

Most people tend to equate *line* with drawing, and there is no doubt that line is the basic element in the majority of drawings. After line, the next most important drawing element is light and dark. In this section, I use the terms "light and dark" as a catch-all expression for tone, value, modeling, light and shade, and chiaroscuro. Although there are shades of difference in the meaning of these words, they are used here as being nearly synonymous. The major difference is between light and shade and the other terms. "Light and shade" generally refers to the way light hits a given object and to the shadows such light creates. The other terms are more arbitrary and refer to the light and dark aspects of a drawing whether or not they are related to the "real" world of highlights, middle tones, dark tones, reflected light, and cast shadows.

Traditionally, art students spend hours and hours, even years, trying to master the so-called "rules" of light and shadow. Although you should have an undersanding of light and shadow, our modern concepts of art make it much less important than in previous eras. We now tend to use light and dark intuitively to achieve our immediate expressive ends rather than as a means of duplicating "reality" **(Figure 4.1)**. The following exercises are intended as suggestions to help you develop a greater sensitivity to the role of light and dark in your drawings.

*4.1  Michael Mazur (Contemporary American).* Untitled (head), 1965. Charcoal on paper, 32" × 26" (18 × 66 cm). New York University Art Collection, Grey Art Gallery and Study Center, Gift of Paul Schupf. Photo: Charles Uht.

*The dynamic energy of the artist and of the drawing process transforms this black and white drawing into a work which seems to exude color. How is it possible to speak of "color" in a black and white drawing? Because the single hue (black) is used to create a wide range of values (light and dark) and intensities (brightness). The variety of intensities is achieved through a combination of strong and subtle contrasts, such as a black line against a white ground or a black line against a gray, nearly black, ground, which give the illusion of changes in brilliance. The changes in value are created by rubbing, smudging, and erasing into the black to create a variety of textures that, in turn, produce subtle halftones. So much of the working process is left visible that it's almost possible for the viewer to mentally recreate the drawing from its very inception to its present state. Note how the line to the left of the head, while echoing the structure of the skull, also makes it appear as though the head is actually moving out of the picture plane. Most of the tones in this work serve to organize and vitalize the whole rather than to describe actual light and shadow.*

## Value Scales: The Vocabulary of Tone

Over the past several years, on the very first day of class, I give my students a homework assignment dealing with value scales. Almost everyone who looks at a value scale says to himself, "Oh, yes, of course. That makes sense; I could do that." Unfortunately, I find dozens and dozens of students who have never sat down and gone through the discipline required to produce an accurate and craftsmanlike value scale. Reading *Elements of Drawing* by the 19th-century artist and critic John Ruskin a few years back, I was once again convinced of the importance of value scales.

When I assign this problem, my students both hate me and respect me for it. They are sometimes frustrated when they discover the tremendous difficulty in producing a value scale that is excellent in craftsmanship, while being both creative and beautiful. Yet they respect me for simply insisting that they do it. Making a value scale is a good beginning exercise that demands control of the material, a realization of the extent of the values the artist has at his disposal, and as much creativity to be successful as they have ever exercised. *Even the most academic exercises can become important creative/expressive statements!*

• Using your full range of pencils—6H (the hardest and lightest) through 6B (the softest and darkest)—create an eight-step value scale consisting of one-inch (25mm) squares. (See drawings by **Charles Bernstein** and **Martin Bertadano**.) The squares must touch one another in some way. They also must grade evenly from white through the middle grays to black. Each square must have perfectly even tones and razor-sharp edges because each tone has to stay within the confines of the nearly invisible outline. (Shades of coloring books! . . . and at the first class. . . . Tch! Tch!)  I said it was going to be academic!

But wait. Now for the fun and mind-boggling part. You are to turn all of this into a meaningful, visually exciting composition!

## *Achieving Beautiful Pencil Tones*

For beautiful pencil tones, I suggest that you keep your pencils very sharp. Sharpen them with a razor blade and sandpaper block; pencil sharpeners literally "eat them up." When you use sandpaper, be sure to wipe off the graphite dust from the pencil on a rag before continuing to work. That dust can ruin a perfect drawing. Do not try to make any pencil tone darker than it is capable of becoming by exerting excessive pressure —press hard but not so hard as to emboss the paper. Embossing will cause a disturbing texture if you go over it

later with a darker pencil, because the graphite will not cover the embossed sections. If you want to darken a tone, select a darker pencil and allow the tone to develop *gradually*. Do not put down pencil marks and rub them with your finger to blend or smooth them out. This almost always results in muddy-looking tones that have lost their vitality and freshness. If you still insist on smudging the tones with your fingers and they begin to get that "tattletale gray" look, it is helpful to go back over them with a pencil once again and allow this layer to remain unsmudged.

On fairly rough-surfaced paper, smudging may be necessary to force the graphite down into the crevices, which otherwise may remain as little white specks. (But this can be most effective *if that is what you want!*)

Erasing should be held to a minimum and avoided if at all possible. Erasing is apt to disturb the paper's surface texture and create little black specks when you work back over the erased area. If you *must* remove something, try to *pick up* the graphite with the eraser rather than rubbing it. Every art student should be able to produce a beautiful, sensual tone with a pencil, a tone that people will look at and say, "Wow, how in the world did you do that?"

The value scales of students and master work illustrated here indicate (**Figures 4.2** and **4.3**) the "tip of the iceberg" as far as the solutions that are possible. You should probably stop reading at this point and spend ten or twelve hours perfecting this important exercise.

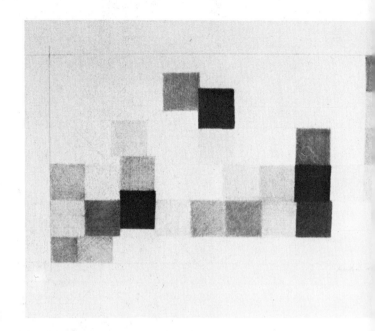

*The light and dark values in Rembrandt's Prodigal Son formed the basis for this value study (it's not really a value scale). Each square is the approximate value of that area within the original work. Graphite drawing by Charles Bernstein.*

**4.2** *Vija Celmins (Contemporary American). Ocean, 1972–73. Graphite on acrylic sprayed ground, 11½" × 98" (29 × 249 cm). Collection Whitney Museum of American Art, New York, Gift of Mr. and Mrs. Joshua A. Gollin. Photo: Geoffrey Clements.*

*Vija Celmins has worked with the essentially structureless image of water for a number of years, revealing a compulsive interest in the subject. Here the artist is interested in how vary-* *ing degrees of light effect an image that's repeated. Unfortunately, it's nearly impossible to communicate the actual effect of this work in a reproduction—it's an extremely long, super-refined rendering of water repeated seven times. Each repeat is slightly darker than the one preceding it, reminding us of a value scale. Celmin's work is certainly a giant creative leap away from the traditional, clichéd seascape!*

The important experience of creating value scales is realized here, but the student has added a compelling creative "touch" by combining both the pencil and pen scales with a figure after Leonardo. Drawing by Martin Bertodano.

**4.3  Susan Weil** (Contemporary American). Sequens, 1977. Ink on paper, 30″ × 100″ (76 × 250 cm). Courtesy Parsons-Dreyfuss Gallery, New York.

This is a gigantic drawing! It is not a drawing of anything, it is a thing. This type of work has been called Conceptual Art or Process Art, which is characterized by a dramatic break away from formal aesthetic considerations. The artist has covered four sheets of paper with graduated tones of black ink. She is as concerned with the physical attributes of the work as she is with the tone as indicated by the piece that's ripped from each one and moved to become a part of the one to its left. Much of the drama is provided by the idea that a piece is left over and also because she has only pinned it to the wall at the top, allowing the bottom to hang and cast shadows. Cover the piece on either end with your finger and you'll see that its look of "rightness" is totally destroyed. Unlike your problem of value scales, this artist is interested in values as they suggest different times of day.

## "Don't Stop Now . . . Try Ink!"

That's exactly what I tell my classes, and I think you should try it too. After explaining how to make a value scale in pencil, I then continue, "Now that's the first part. . . . The second part is to attempt the same thing in pen and ink!" Often at this point one or two students drop out who had thought that they were enrolled in a "snap course."

Essentially, there are only three ways of producing pen tones without diluting the ink with water (in which case, the technique is called a *wash*). They are: (1) *hatching*—creating a tone using small, parallel lines; (2) cross-hatching—first drawing hatched lines, then repeating the lines at an angle to the original hatched lines; (3) stippling—using dots or dotlike marks. The more lines you put down, or the more concentrated they are, the darker your tones become. Each time you dip your pen into the ink, you should make a few test marks on a scrap of paper; this is a check to see that you are getting an even flow and will help prevent accidental "blobs." It is much more difficult with pen and ink to achieve even tones that have no visible variation in value than it is with pencil. (See the drawing by **Robin McKinney**.)

### Eggs—and Their Wonderful Shadows

A short time ago I had the pleasure of working with a young graduate student who proved to be one of the most talented draughtsmen I have ever encountered in my teaching career. One day I asked her how she accounted for her amazing facility; she replied, "Because I had a teacher in undergraduate school who made us render eggs over and over and over again and in every conceivable medium. I hated it, but I now believe that it was the best thing that ever happened to me."

Well, I hope that you will try to "tune in" to this project and, hopefully, get some enjoyment out of it, since I also believe that this is an important experience for all art students, despite its rather academic overtones.

### *Begin with Spheres*

Unlike most of the other problems in this section, this one *does* deal with light and shadow, as opposed to more or less arbitrary tones of light and dark. There is no better way to begin this study than to start with charcoal and charcoal paper and attempt to render a sphere as indicated in the **diagram** above Note that there is only one source of light in this drawing. It comes from the upper right and, when it hits the sphere, creates a highlight, a middletone, a dark or low tone, a slight reflected light, and a cast shadow. The choice of a single source of light and its direction are arbitrary decisions, since light usually comes from several sources and is reflected from multiple surfaces. Despite these limitations and difficulties, I suggest that you set up a sphere with a single light source and make a drawing that will, in fact, be a *compromise* between what you actually see and the theoretical way you know light *should* behave in hitting the sphere.

Although the shadows that are cast by objects often help us to "read" the true form of the object, they can also become distracting and even distorting when

In this value scale, a most exciting composition is created by piling square upon square in a tenuous state of balance. Note the textures she has created. Pen and ink drawing by Robin McKinney.

This drawing indicates the effect of light from a single source on a sphere. Notice the highlight, middle tone, dark tone or shadow, reflected light, and cast shadow. Reflected light results from light bouncing back onto the sphere from the surrounding surfaces.

they are cast upon another object. That is why master artists often soften the edges of these shadows, and may even lighten them considerably. The typical mistake made by beginning artists is their failure to account for the slight amount of reflected light on the dark side of the form.

Draw dozens of spheres, and try to understand what happens as the light source travels 360 degrees around them. Ask yourself: What happens if you introduce a second light source? What if the shadow is cast in such a way as to hit both the table and an adjoining vertical plane (**Figure 4.4.**)?

## Back to the Eggs

An egg is certainly a simple form, yet it is most difficult to draw one that is absolutely convincing—continuously curving, with no flat spots, perfectly shaped and rendered with tones, with a texture that convinces us of its true tactile quality (**Figure 4.5**).

Start with a single egg and apply the same principles you used in drawing the spheres. You may want to add a slight tone to the background. Organize several eggs, along with one that is cracked in half, into a pleasing arrangement and render them. Switch your medium from charcoal to pencil and then, finally, attempt one with pen and ink. (See drawings by **Robert Costa** and **Betsy Smith.**)

*4.4  **Edgar Degas** (French, 1834–1917). Portrait of Edmond Duranty. Charcoal on blue paper, 12⅛" × 18⅝" (31 × 47 cm). The Metropolitan Museum of Art, New York, Rogers Fund, 1918.*

*If you understand how light falls on a sphere, it is a short step to understanding how to deal with light falling on a human head. The blue color of the drawing paper serves as the middle tone, a few judiciously placed whites serve to indicate highlights, and several values of the charcoal indicate the forms that turn away from the light source. Note the reflected light on the side of his beard and the nearly imperceptible cast shadow of the head on the coat. The tone on the coat is loosely drawn, and the lines go in one direction, which tends to unite the various shapes in the coat. Why did Degas define the outline of the arm on the right with three distinct lines? Is the arm leaning on the table, behind the table, or is it in both places simultaneously?*

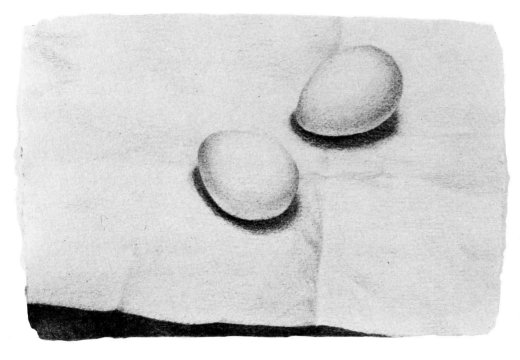

With the light coming from above, there is a very slight indication of a cast shadow. Note the overplayed reflected light, the paper surface on which the eggs sit, and the all-important dark shadow on the bottom left, which changes an ordinary drawing into one that's extraordinary. Pencil on rough paper, drawing by Robert Costa.

Although there are a few unconvincing flat edges on these eggs, this non-art student's formal solution to the entire space of the drawing is truly refreshing. Note the format (square) within the format (rectangular), the contour egg shape in the large white space, the cropping of the one cast shadow, and especially how the near-circular cast shadow both contradicts the egg shape and sets up a nice contrast. Pencil drawing by Betsy Smith.

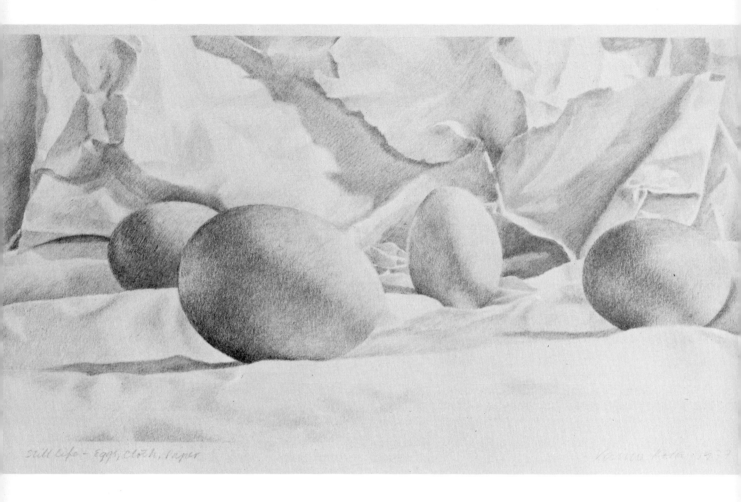

*still life – eggs, cloth, paper*

**4.5** *Vaino Kola* (Contemporary American). Eggs, Cloth, and Paper, 1978. Graphite on paper, 5½″ × 10½″ (14 × 27 cm). Courtesy the artist.

A few eggs, a piece of cloth, and some paper are certainly unpretentious subject matter, and yet the lowly egg begins to take on qualities of monumentality in the hands of this talented draughtsman. Study the highlights, middle tones, darks, and reflected light, all of which are very obvious in this work. The cast shadow of the largest egg is particularly interesting because it helps us to understand the folds in the cloth. The composition is based on innumerable triangular shapes, both real and implied. Despite the overlapping and exaggerated diminution in sizes, this drawing remains relatively flat on the picture plane. Do you know why? How many lines can you find in this drawing? (Be sure that you don't confuse a line with the edge of a form.)

## Local Color

"Local color" refers to the differences in color between objects. Each color, in addition to hue (color name) and intensity (color brightness) has its own unique value (light or dark). The value of a yellow lemon is very high (light) on the value scale, whereas the value of a plum is very low (dark) on the value scale. Place a brown egg and a white egg before you and try to render them in pencil in such a way that you indicate that one is slightly darker than the other. Tough, very tough!

## Complicating Your Life

Here is a difficult and challenging problem: Render an egg at least three times lifesize on a gray piece of charcoal paper and use all of the following colored pastel pencils: red, yellow, blue, green, orange, violet, black, and white. Your problem is to make the viewer "read" the form as being pristine *white*! If you don't have the slightest idea of how to accomplish this feat, I suggest that you look at the so-called "white" areas in a few Impressionist paintings.

## Apples—From One to a Dozen

With the knowledge that you have gained in working from spheres and eggs, I am now going to ask you to see if you can apply it to different means, media, and subject matter.

Although most of this section deals with tones of black and white, I am now going to ask you to set an apple on the table and using a single light source and contour

*lines*—no shading—try to communicate the effect of that light on the fruit and the cast shadow. (See drawing by **Katherine Helstrom.**) Strive to indicate the volumetric nature of the form as well as the essence of appleness. Can you smell your apple? If not, try drawing another one. To indicate light and shadow without laying in tonal areas, you will have to be supersensitive to the weight and character of your line quality. Note in the master drawing by Raphael **(Figure 4.6)** that his line all but disappears at times on the light side of the figure and then becomes extremely heavy or dark on the shadow side. It really is possible to indicate light and shadow without the use of tones!

## Shallow Space

In addition to the variation in line, the following exercise is intended to make you more aware of the problems of composition. Set up two apples and draw them so that the space between and around them becomes a crucial aspect of the work. Don't allow them to touch or overlap. Note that this causes a very shallow spatial effect.

## Deeper Space

Add another apple to your setup and proceed to draw them as in the previous problem, but here you should try to overlap all three apples to some degree. Since overlapping is the most positive means of indicating the illusion of three-dimensional space on a two-dimensional surface, you will note a vast difference between this drawing and the previous one of two apples. There are an incredible number of ways these apples can be overlapped. Experiment not only with the overlapping, but also with the location of the forms on the page. What happens if all three are placed very low on the page or close to the top or just off center? What happens if you overlap two of them and allow the third one to exist at the furthest possible spot on the page? (See drawing by **Cecilly Bowden.**) Within a drawing format, overlap all the apples—but also have each one "bleed" across the edge. What kind of space have you now created? Do your forms continue to "read" as apples?

## Back to Tonal Light and Shadow—Avoiding Redundancy

Using your complete range of pencils, go back to drawing a single apple and render the light and shadow tones *without any indication of a line to define the form.* Take a good look at the drawings by Martha Alf, Vaino Kola, and Walter Murch **(Figures 4.7—4.10).** You may start with a line, but it should be drawn so lightly that it would be invisible to the average person. It is rare to see a master drawing that has a continuous dark outline defining the form with tones of shadow indicated within this outline. Of course it can be done, and occasionally a master may do it; however, there is a certain redundancy to such a work. Masters, more often than not, will use a combination of line and tone to indicate form, with one of them usually dominant. When you have finished, ask yourself if the *implied* texture of your tones relates at all to the *actual* texture of the apple. Boy! There's a lot to think about—even in drawing a single apple.

*Using cross-contour lines (see Chapter 2), this student was able to indicate not only the form and shape of the apples, but also the way light fell upon them by varying the pressure applied to the graphite stick as well as the thickness and texture of the lines. Graphite stick drawing by Katherine Helstrom.*

*This student certainly succeeded in producing an unusual spatial effect. The overlapped apples at the bottom almost appear to be stacked one on top of another. In the upper right, the common edge between the two apples that just touch creates ambiguity, and the small one could be a more distant apple, or it could read as a growth on the larger one. Chalk drawing by Cecilly Bowden.*

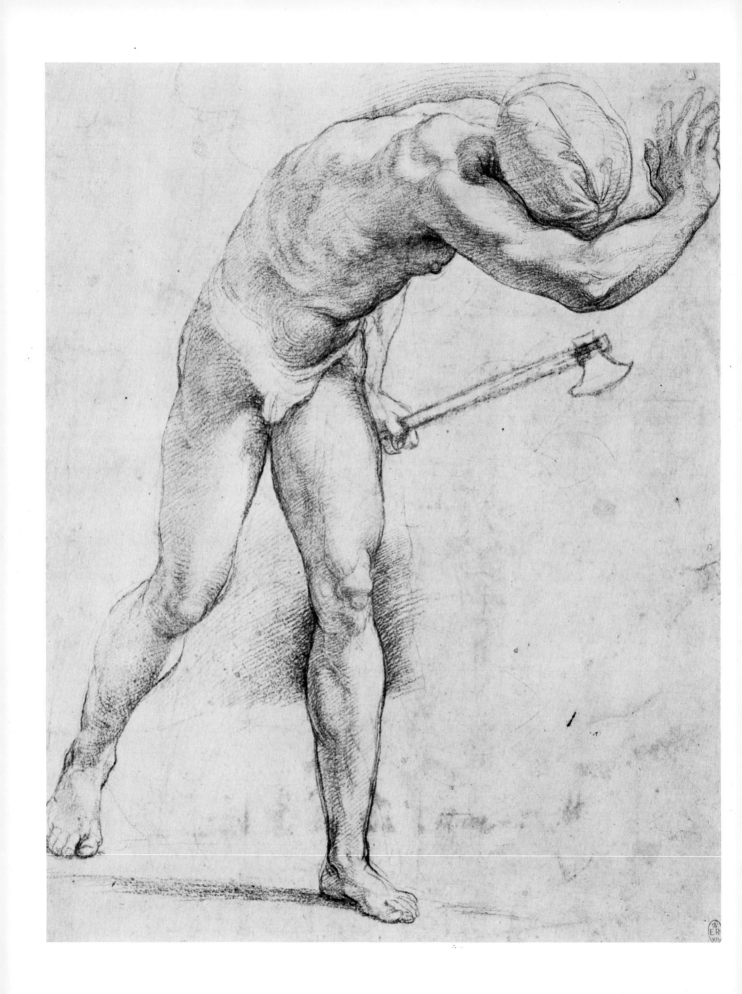

72

**4.7  Vaino Kola** (*Contemporary American*). Nectarines, 1977.
*Graphite on paper, 5½" × 10½" (14 × 27 cm). Courtesy the artist.*
    The voluptuous curves of fruits and vegetables have always
been of interest to artists not only because of their inherent
beauty, but also because they are apt to remind us of human
anatomy. This is certainly the case with these four nectarines.
Note how local color (the actual hue of the object, independent
of the lighting) is suggested, one of them being more yellow
than the others. Notice that the three in front, which appear to
be in a straight line, in fact create a subtle diagonal. Why did
the artist leave the rear fruit in this light, almost unfinished
condition? Why didn't he make the cast shadows on the central
fruits as apparent as those on the side? What did the artist do to
obtain the textural "feel" of nectarines?

**4.6  Raphael** (*Italian, 1483–1520*). Study for "Resurrection."
*Black chalk, 12½" × 10" (32 × 25.6 cm). Royal Library, Windsor.
Copyright reserved.*
    Raphael has indicated the way light hits this figure through
a combination of tone and line. If you very carefully follow the
line that extends from the head down the back and leg to the
inner right foot, you'll note that the line all but disappears at the
calf and is generally much lighter than the line on the opposite
side of the body. As you follow the contour, you will note over
and over again that the line, which at first appears to be a
single line, becomes a double and even a triple one! The
reflected light on the bent arm is readily apparent. The shadow
cast by the head onto the right shoulder is one of the strongest
darks in the drawing and has a slight tendency to distort that
form. What effect does the hand and foot, which just barely
touch the edges of the page, have on the negative shapes? Why
did Raphael choose to place a background tone only around
the left knee?

**4.8  Martha Alf** (Contemporary American). Tangerines on a Window Sill (Magic Rooftop series), 1978. Pencil on paper, 12" × 18" (30 × 46 cm), Private Collection. Courtesy Newspace Gallery, Los Angeles. Photo: George Hoffman.

In the beginning, photographs merely served as a recording device for Alf in the same way that other artists use sketches. About three years ago, however, she started to work from them directly. The tangerines clearly illustrate the effect of a single light source on a sphere, including the weak reflected light. The near-symmetrical balance is offset by the subtle variations in the shape of the fruit and its stems, and the fascinating placement of the vertical telephone pole. If the diagonal stem on the right were extended, it would meet the tip of the pole; and if you extended a line from the tip of the pole to the tip of the other stem, you will note that it meets at the juncture of the windowsill and edge of the paper. These invisible but important devices are called implied lines. They give the work a structure that at first glance may seem quite random and casual, but in reality is carefully planned.

**4.9  Martha Alf** *(Contemporary American). Pears Series II #7,*
*© Martha Alf, January 23–31, 1978. 4B pencil on bond paper.*
*Courtesy Newspace Gallery, Los Angeles. Photo: George*
*Hoffman.*
*    The strong light and shadows of this drawing were produced*
*with a single 4B pencil. On closer scrutiny, you realize that what*
*at first looks like a wide range of values is actually about three.*
*By placing the blackest blacks next to the whitest whites, the*
*apparent differences between them are intensified and help to*
*produce the dramatic lighting situation we observe here. Note*
*that only the center pear has a reflected light and that the*
*entire drawing is produced using only tone to define form.*
*Do you think a slight indication of line would serve to*
*enhance this work? Can you find other artists who define*
*their forms without using line?*

**4.10   Walter Murch** (American, 1907–1967). Melon, 1962. Oil
on paper, 15⅛" × 12¾" (38 × 32 cm). Collection Whitney
Museum of American Art, New York, Lawrence H. Bloedel
Bequest.

Traditionally, oil paint is used on a canvas surface, but many
artists have used it on paper either with or without a gesso
ground. As the boundaries between painting, drawing, and
sculpture are weakened, our definitions must also be ex-
tended. In many institutions, no matter what material is
used, if the work is produced on paper it is classified as a
drawing; if the same work is mounted on canvas, it is called
a painting! Whether or not this particular work is a drawing
or a painting is a moot question, but the work was included in
a very large and important exhibition of drawings. The
beautiful tones and rich, textural surface has resulted in a
work of exquisite beauty.

## Local Color Again

This exercise again deals with local color. (I discussed local color earlier in this chapter.) Arrange six or eight yellow and red apples on the table under one major and one minor light source. This may result in two overlapping cast shadows from a single apple. The problem is to render what you see as precisely as possible, ignoring the theoretical notion of a single light source described earlier. Even though I suggest that you attempt this problem with carbon pencils and charcoal paper, you are to make it obvious that some of the apples are red and some are yellow.

## A Dozen Apples and Incredible Space

Why not? Sure, a full dozen. Here you are not to draw exactly what you see. On the contrary, draw the apples overlapping each other, isolating some. Reverse the modeling from dark to light instead of from light to dark. Try drawing them using multiple light sources of your own choosing. Change the scale of the apples and make some very large and others very small. Combine tonal apples with apples of pure line. Experiment with as many different formats as your imagination will master. (How about trying yet another one using 1″ × 1″ × 3″ (25 × 25 × 75mm) chalk on a sheet of about 3′ × 4′ (30 × 40 cm) brown wrapping paper? You want to make it much larger than that? OK, go ahead.)

The kind of freedom I am suggesting here is most difficult to handle and still end up with a work in which all the elements seem to be an integral part of the whole. This freedom does not in any way imply chaos. But you will have to be even more sensitive than usual if you are to create a harmonious work which, despite some of the *intentional* ambiguities, will still spell A-P-P-L-E.

## Clouds—Try to Catch One

Take a look out of your window. Is it a real cloudy day? Great! Clouds provide us with an almost unparalleled source for artistic form. Forms in continuous movement—a state of flux—were a favorite theme of Leonardo (**Figure 4.11**). It is this state of movement and variation that makes clouds both difficult and desirable as drawing subjects. When I assign clouds as a subject, I never discuss the movement factor; and when my students come in with their drawings, a typical comment is, "Impossible! They *never* stop moving!"

To draw clouds, what you must do is study the general characteristics of the clouds you are drawing and attempt to incorporate these general qualities, rather than a specific cloud, into an exciting drawing. The very nature of cloud forms seems to demand a soft material such as pastel or charcoal. (See drawing by **Janice Scheetz**.) However, it's even more challenging to attempt drawing them in pen and ink, since you will really have to "push" the medium to achieve anything like the soft, fluffy edges which comprise most clouds.

*Working in a variety of colored pastels, this student certainly was able to capture the soft, nebulous quality of clouds. She even went a bit further by drawing a format (perhaps a bit too heavy) around the clouds, and has actually succeeded in "capturing" them. Having the clouds occasionally overlap the format creates an interesting tension. Pastel on tinted paper by Janice Scheetz.*

**4.11  Leonardo da Vinci** *(Italian, 1452–1519). Landscape with Rainclouds. Red chalk, 7½" × 6" (19.9 × 15 cm). Royal Library, Windsor.*

Compared to the rumble and roar of Leonardo's Deluge on the next page, this drawing "reads" as being peaceful, quiet, and serene. What are the specific elements of this drawing that cause such a dramatic contrast with the other one? His observation of clouds is remarkable and very convincing. The bank of clouds and mountains in the upper section would not be visible to a person looking down into the valley from a bird's eye view.

To include them, Leonardo has created multiple viewpoints—one looking down and one looking straight ahead. Notice how the simplified forms echo the mountains in the middle ground. The falling rain has created a dramatic and transparent dark form just above the center. Note the "shorthand" method he used to indicate the buildings and trees in the foreground. Aren't we taught that things in the distant background of a picture usually do not have much light and dark contrast because they are enveloped in atmosphere? Why did Leonardo choose to reverse this axiom?

## Water—Another Elusive Subject

A body of water with waves or ripples on it or a flowing stream presents a problem similar to the clouds. Compare the drawing by Leonardo **(Figure 4.12)** to the Vija Celmins masterful contemporary drawing **(Figure 4.2)**. Leonardo did not attempt a realistic approach; he designed a scheme or symbol for his moving water which is quite geometric and abstract, while the Celmins' drawing might be confused with a photograph of the subject. Can you say that one of them is more correct than the other? Clouds and water are challenging, readily available subjects, and I suggest that you take advantage of them **(Figure 4.13)**. Try one in which you lay down a flat charcoal tone and draw the forms by flicking the tone off with a kneaded eraser. You will literally be erasing a drawing!

**4.12** *Leonardo da Vinci* (Italian, 1452–1519). Deluge. *Black chalk, 6¼" × 8" (16.2 × 20.3 cm). Royal Library, Windsor. Copyright reserved.*

*Deluge indeed! It seems more like the entire universe is exploding! The clouds above and the water rolling over the landscape as if to devour it is a far cry from the realistic rendering of water by Vija Celmins* **(Figure 4.2)**. *Leonardo was never satisfied with the surface appearance of objects or phenomena. He wanted to understand the inherent and underlying structure and forces at work, which was also why he dissected cadavers. His interpretation here is schematic, geometric, and nearly abstract. The cubelike forms on the left are rock formations crumbling under the force of the water. Can you see the artistic order and careful treatment of the lights and darks Leonardo imposed upon this scene of chaos and destruction? Compared to his Landscape with Rainclouds on the preceding page, it is apparent that this drawing was done strictly from imagination while the other is based on years of actual observation. This incredible drawing is as "modern" now as the day it was done!*

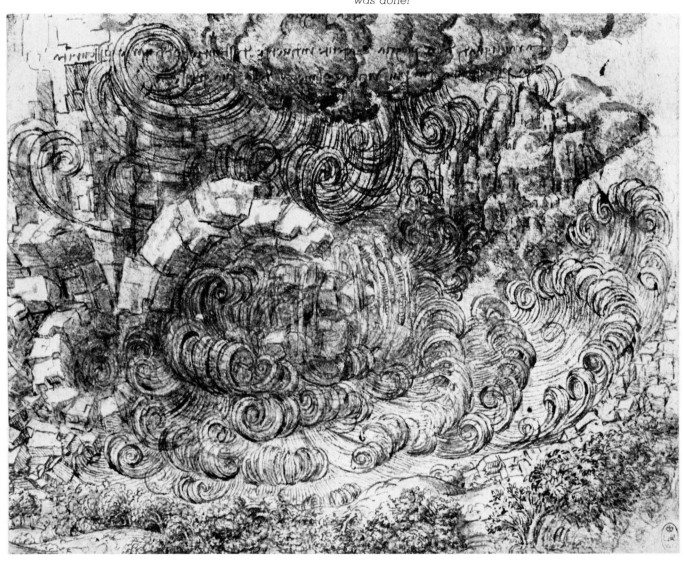

**4.13 Joseph Raffael** (*Contemporary American*). *Scottish Bubbles, 1975. Ink on paper, 22¹/₂″ × 30″ (57 × 76 cm). Courtesy Nancy Hoffman Gallery, New York.*

Note the infinite variety of wiggly inkmarks Raffael has created to communicate the subject of water bubbling over rocks. Only a very slight amount of hatching is needed to create tone, which is suggested by increasing the number of squiggles. Curves and circular shapes are repeated over and over, and a "center of interest" is created by a series of relationships that cause a movement down through the center. The actual space being rendered is only a few inches, so the usual problem of indicating the illusion of receeding space doesn't exist. Since it is an open and flowing composition, it begins to suggest a universe within a few square inches of water. Where might you look for similar kinds of metaphors that suggest a universe?

## Figures—Divided by Four, or Six, or Twelve?

Although "traditional" drawing of the human figure in accurate proportion is an important aspect of your artistic development, this exercise tests your imagination by forcing you to fragment, distort, or otherwise change the figure to *fit* a preconceived form, format, or fractured surface (**Figures 4.14** and **4.15**). It would be helpful to have a model to do this exercise, but you can pose yourself in front of a mirror if one is not available.

Using charcoal, begin by drawing two arbitrary lines within a drawn format, one horizontal and one vertical, which will divide the page into four more or less rectangular shapes. Your problem is to do a modeled (light and dark) drawing of your model, the form of which will be determined by both the pose and the two lines/four shapes. How in all the world can you make a human figure "fit" into this given circumstance? Again, there are no right or wrong solutions, the setup is simply designed to "shake up" your normal way of thinking about things. It might be much easier to begin this exercise using a bottle or some other inanimate object as the subject, since we hesitate to do anything too radical to the human figure—after all, it's us! (See **drawing** on page 84.)

• Try to get an active and interesting distribution of light and dark throughout the drawing. You may want to turn it upside down occasionally, which will make it difficult to see the figure and allow you to see the light and dark configuration or pattern you are developing without the figure to interrupt your "reading" of it. The point is not to create a total abstraction. There should be some careful and well-observed drawing, and a viewer should be able to discern that this is a single human figure.

• Try the same thing with three drawn lines.

• Try it with four slanting lines and use four premixed wash tones of ink and a brush to apply the tone.

**4.14** *Paul Waldman* (Contemporary American). Study for "Leo's Patience," 1975. *Oil crayon, pastel, and litho crayon on tracing paper.* 36¹/₄" × 89¹/₄" (92 × 226 cm). *Courtesy Leo Castelli Gallery, New York. Photo: Eric Pollitzer.*

*What at first glance may appear to be an extraordinarily large abstract drawing is actually an incredible conglomeration of human figures. Human figures, yes; but they have been violently (but believably) distorted to adapt to each other and to the negative space, but most particularly to the arbitrary structural grid. The grid in this case is an upside-down triangle split right in the middle. It is as though through purely aesthetic means (the triangle), the figures have been put into a blender from which they emerge as a new entity, completely and totally related. Make a careful study of the manner in which one form ends and merges either imperceptibly or with a sharp break into the next one. How many figures are there? What do you suppose is the function of the other grid lines that are drawn almost imperceptibly on top of the whole drawing? Why did he make the drawing so big?*

**4.15** **Pablo Picasso** (Spanish, 1881–1973). Man with a Hat, December 1912. Cut-and-pasted papers, charcoal, brush, and ink on paper, 24¹/₂" × 18⁵/₈" (62 × 47 cm). Collection The Museum of Modern Art, New York, Purchase.

It is really quite astounding when we look at this drawing and see it as a man with a hat, that it has become so easy for us to "read" abstract shapes that we know are something else (such as a newspaper). At first glance, it would seem that Picasso pasted the paper down as arbitrary shapes and then fit the rest of the drawing to this visual situation. Upon closer examination, however, details such as the curve at the bottom of the newspa-per, which covers a line on the side of the face that extends down from the ear hidden behind the paper, show us that the drawing came first. But then there are marks on top of the paper, so we have to conclude that the lines and the paper were added in an alternating fashion: the lines affecting the shape and size of the paper and the paper affecting the kind of lines drawn on top of them. The print of the newspaper acts as a tone. These, among other factors in the work, begin to make us question the meaning of reality. Compare this drawing with the Picasso on the next page.

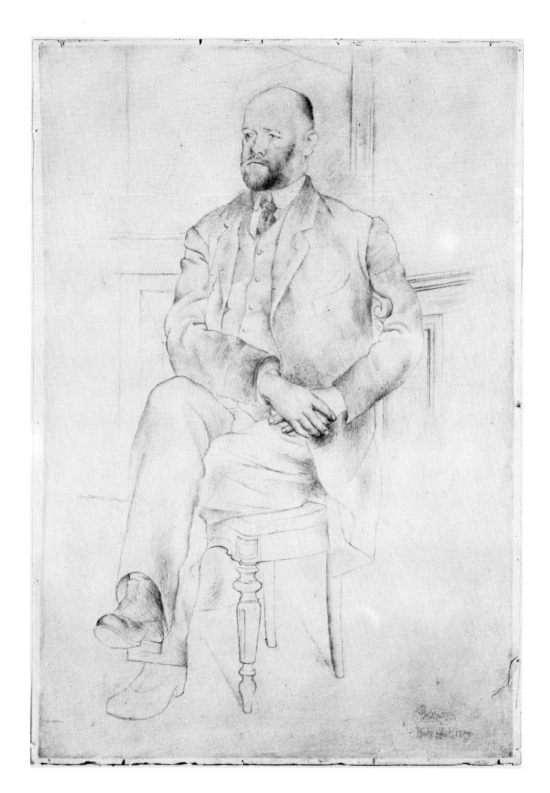

**4.16  Pablo Picasso** (Spanish 1881–1973). Ambrois Vollard.
Pencil on paper, 18³/₈″ × 12⁹/₁₆″ (47 × 32 cm). The Metropolitan
Museum of Art, New York, Elisha Whittelsey Collection, 1948.

This beautiful drawing, which is reminiscent of Ingres in the
clarity and sureness of its line, is included here primarily so that
you can compare it to Picasso's Man with a Hat on the facing
page. This one fits our traditional concept of reality, but then we
must ask if it is more "real" than a real sheet of newspaper?
Within this realistic drawing there is much for us to question.
Why did this master of composition place his sitter smack in the
middle of the page? Why did he leave one shoe as a contour
and also fail to shade the sole of the other one? Why are the legs
of the chair as well as the wainscoting on the back wall out of
true perspective? Why is the right forearm so incredibly long
and the light and shadow completely inconsistent? How come
these eyes are no more convincing than the two dots in Man
with a Hat? Removed from the context of the rest of the face, is
there really much difference in the mouths on these drawings?
With so many questions, perhaps we should allow our blinders
to swing the full 360 degrees before we take a closed position on
aesthetic issues! Picasso once remarked, "I used to draw like
Raphael, but it has taken me a whole lifetime to learn to draw
like a child."

- Try it with five lines using pen and ink on a presoaked paper, which will cause the ink to run in a marblelike pattern. Don't let the running ink get away from you and take over. There must be a marriage of the figure, the predetermined lines and spaces on the page, *and* the running ink.

- As yet another variation, create a separate tonal drawing of the pose and then tear it up, rearrange it, and paste it down in relation to another predetermined set of lines and spaces.

- Continue with this problem by creating ten more variations on this idea.

- Can you figure out some problems where the actual time (a given amount of time) becomes a salient portion of the entire "brew" (process/composition)?

In this exercise, the page was arbitrarily divided into four different rectangles and the student then had to adapt a single pose to fit this arbitrary circumstance. Here, the geometry and the figure have become a new entity. Student drawing in charcoal.

## Dig Up a Still Life—
## From a Charcoal-Covered Page

Paul Cézanne preferred working from still lifes rather than the figure because apples, unlike the figure, were able to sit still! Borrow a book from the library that reproduces Cézanne's work and set up a still-life arrangement using one of his as a model. He spent hours arranging his objects, going so far as to place a small coin under the edge of a plate to make its tilt or slant better fit the arrangement! This process may help you to break away from the usual and mundane kinds of still life.

Begin by covering an entire sheet of charcoal paper with a tone of middle gray. Rub this with your hand or a soft cloth to eliminate white specks and to create a perfectly even tone. Next, using a kneaded eraser, gradually begin to erase the charcoal to indicate those values from middle gray to white. Don't draw separate forms with the eraser. Rather, wipe out broad planes of the charcoal tone. There are no mistakes, only incidents (maybe a few accidents) along the way. The darkest tones in the setup should then be added with free-swinging strokes of your soft charcoal. Your page is now covered with three tones—dark, light, and middle tones. Proceed to refine and extend these tones to approximate those in the setup to a greater degree of fidelity. Try to use about six distinctly different values. A touch of a contour line here and there may help to reestablish the forms if they start to get too hazy. Note how Max Weber (**Figure 4.17**) was able to "dig" his portrait out of the page with a minimum of lines and changes in tone. Also note the similarities between this exercise and the process Matisse used in *Reflection in Mirror* (**Figure 4.18**).

Finally, paying absolutely no attention to the setup and following the "demands" of your page full of visual incidents, do whatever it tells you that it needs. A light here, a dark there, a little harder edge opposite that soft one, a rougher texture to contrast with that smoother one, a working over that dirty, "tattletale-gray" area. Just go ahead and do whatever feels right to you. Don't worry about what other people might think or say. It's been your experience, your process, and it belongs to you—totally.

*4.17 (Right)* **Max Weber** *(American, 1881–1961). Head, 1929. Charcoal and wash on cardboard, 16³/₈" × 13" (41 × 32 cm). Collection The Museum of Modern Art, New York, Gift of Abby Aldrich Rockefeller.*

*Because of its massive and simplified forms, this drawing almost looks like it could have been carved from stone. If you cover the relatively detailed nose and mouth with your finger, the effect that large forms have been chopped away is intensified. I believe that the wash was achieved by brushing the quickly drawn charcoal with water or turpentine; you can see the edges of the wash in the hair. The tone behind the face also seems to have been dragged with a large brush into the face and down into the neck. A bare minimum of lines were then re-established, as well as a couple of dark tones at the side of the neck by using the side of the charcoal stick. The left hand was probably delineated to a greater degree but smudged out with the brush. Notice that if you cover the thumbnail, the rest of the hand might read as clothing. Would you have left the line that shoots out from the shoulder into the background as it is, or would you have erased it?*

## Modeled Space—Accentuating the Negative

To apply some kind of tone, line, or texture to the empty spaces *around* a figure without drawing the figure itself is a difficult concept for beginners to grasp, but one which most masters achieve while barely thinking about it. Everything is *one* to them and they don't really think about first drawing this object and then that object. They all flow together and become one thing, a totally integrated drawing (**Figures 4.18, 4.19** and **4.20**). In this exercise, I am asking you to reverse your usual approach to drawing. You are to ignore the figure completely and try by any means possible to indicate the volumetric space *around* the figure. The "means" of achieving this are not at all clear. They have to be invented by you and re-invented for each and every drawing, since the *empty spaces* will change with the slightest movement of the pose. To better understand how this empty space changes, hold your arm and hand in front of you and move it into different positions. Note what happens to the space rather than to the arm and hand. The shape of this nothingness is what I'm asking you to indicate on your paper. Most students, when first encountering this problem, deal only with that space which moves laterally or to each side of the figure and they end up with a white silhouette. You must remember that this empty space exists in front and behind the model; in fact, all the way around as well as out to the sides. The student work by **Leslie Wasserberger** is an example of an energetic reaction and imaginative solution. Note that the figure emerges even though the emphasis lies elsewhere.

Charcoal is excellent for this exercise, but for a change I suggest that you try some oil washes on paper. Place some black and an earth color or two, such as burnt umber or raw sienna, on your palette and, using a lot of turpentine and large brushes, quickly lay down tones that will become the pictorial equivalents of these visual voids. You are now making *something* out of *nothing*.

*The student covered the entire page with a charcoal tone and then proceeded to model the space, or nothingness, surrounding the figure. Most students have difficulty understanding that this space exists in front as well as to the sides and rear of the model. Black, white, and gray chalk drawing by Leslie Wasserberger.*

**4.18** *Henri Matisse (French, 1869–1954). Reflection in Mirror. Charcoal, 20" × 15³/₄"(51 × 40 cm). The Metropolitan Museum of Art, New York, Robert Lehman Collection, 1975.*

*It does not appear that Matisse started this drawing by covering the entire page with charcoal. However, he has rubbed and smudged so much of the charcoal that the overall effect is similar to the exercise I suggested in the text. You can see that the process is similar to carving or modeling in clay. He placed a tone with charcoal, then rubbed it to the desired value and shape, occasionally using the eraser to remove large chunks of tone. Then, to accent a form (such as on the left hip and thigh), he added a finishing touch or two with a bold charcoal line. Notice how the direction of the tones, especially around the feet and legs, help describe the space surrounding the figure. The image in the mirror lacks the solidity of the figure and even becomes somewhat Cubistic in its overall treatment. Besides studying the light and dark structure of this work, it might prove useful for you to place a sheet of tracing paper over it to analyze the major compositional thrusts and counterthrusts. It seems unbelievable today that at one time critics disparagingly called Matisse a "wild beast"!*

**4.19  Jim Dine** (Contemporary American). Untitled, 1974. Charcoal and mixed media on paper, 30¹/₂″ × 22″ (77 × 56 cm). Collection Wayne Andersen, Boston.

It probably would be fair to state that about 80 percent of this "drawing" consists of marks and tones existing outside of the saw contour. Dine has pushed and pulled the space in back, to the side, and even in front of the saw with an incredible variety of marks and textures. It is through this energetic modeling of the space that a dumb object, such as a saw placed in the center of the sheet, can begin to seem vital and alive. Along with Andy Warhol, Claes Oldenberg, and Roy Lichtenstein, Dine reacted against the Abstract Expressionists and developed an art based on everyday objects such as Campbell soup cans and comic strips. The critics gave this movement the name of Pop Art. Notice how the signature of the artist has become an integral part of the total work. Why don't you try to draw a simple tool and see if, without destroying the basic form, you can imbue it with excitement and a sense of importance?

**4.20** *Hans Hofmann* *(American, 1880–1966). Untitled. Ink on paper, 10³/₄″ × 8¹/₄″ (27 × 21 cm). Courtesy Andre Emmerich Gallery, Private collection.*

Dynamic energy, vitality, and movement characterize most of the work produced by this important artist and teacher. Using a stick dipped into ink, the artist has produced a drawing that's a perfect example of what I call "modeled space," where he has devoted more attention to the space around the figure than to the figure itself. The figure almost acts as an excuse for the artist to "push and pull" (his term) the space into and out of the picture plane, while maintaining its essential integrity—that is, it is a flat surface. Horizontal, vertical, and diagonal planes crisscross, become transparent, and overlap as they "rush" into and back out of space. Hofmann achieves "color" (that is, the look of a lot of color even though it is only black and white) through the use of textures and strong contrasts. Lines and tones of the figure move into the ground, and those of the ground extend into the figure creating a space that is totally integrated. If it were possible to physically grasp any element in the drawing and attempt to remove it, all other elements would slide off along with it. List the similarities and differences between this and the Cambiaso *(Figure 2.1)* and Degas *(Figure 3.3)* drawings.

## From Tone to Subject—In the Dark

Make a realistic drawing without even knowing what the subject is. That's right! My students' enthusiasm for this exercise attests to its effectiveness as a learning device.

The procedure is to project a 2″ × 2″ (5 × 5 mm) color slide, but to throw it as far out of focus as possible, thus obliterating all edges and any resemblance to the actual subject. All that appears on the screen are some very subtle suggestions of light tones. The point is to reproduce the values on your paper as fast as possible, using half a stick of compressed charcoal on its side. In the beginning keep all of the values very, very light. After about a minute, turn the lens of the projector so that the image comes ever so slightly into focus, and continue to lay down the tones and also indicate the subtle *differences* that are beginning to appear on the screen. Don't let your drawing get dark too soon, because

eventually, when the image comes into sharp focus, you will want to use your blackest blacks to refine contours and proportions. In this process, there are no mistakes or need to erase since, as the image comes gradually into focus, each subsequent tone that you apply simply covers and refines the previous ones. (See drawing by **Leslie Axman**.)

At times, to my students' delight, I have projected a portrait of a woman over 100 years old with just about that many wrinkles per square inch of flesh. Not having seen the subject, they plunge right into the drawing, gradually building their light and dark tones. If they had seen the picture prior to starting, most of them would have said it was impossible without hours and hours of work. The biggest surprise for them is yet to come. They not only drew it in about thirty minutes, but they drew it *upside down*, since that is how I projected it! What a discovery! If you start with the *major*

*An out-of-focus slide was projected on a screen and the students were asked to indicate the vague tones they saw on their drawing. As the image was gradually brought into focus, they had to respond by developing the tones in their drawing to match those of the projected image. This student chose to place her composition into a tondo format. Charcoal drawing by Leslie Axman.*

light and dark areas of a subject and work *all over* the page, not allowing the problems of delineating an eyebrow or some other minor detail to distract you from the whole, *you can draw anything!*

## Like a Normal Birth

I like to compare the drawing that results from the previous exercise with natural childbirth. Too often many of our drawings can be compared to a fetus where, for the first five months of pregnancy, only the left ear developed. With four months to go, the rest of the body tries to catch up to the ear, but the chances are very slim, indeed, that it will ever make it. The baby will very likely be stillborn, as it is with so many of our drawings when we neglect the whole for unimportant parts. Can you believe how easily and how naturally the light and dark aspect of these drawings come together? Try many, many of these using all of the subjects that you

no doubt already have at your disposal in the form of 2″ × 2″ (5 × 5 mm) slides.

• For a variation on the projected images, try laying down tones with lines that only go in one direction. (See drawing by **Amber Taylor**.)

• Work from slides of old and modern master works.

• Try the whole procedure using pen and ink or pastels.

• Try, as above, working on a previously toned charcoal page and *remove* the dark tones to arrive at the light ones.

• Do an entire drawing without ever once looking at your page—*and accept the results because you have accepted the process.*

No more hops . . . why don't you take a creative leap, or two, or three?

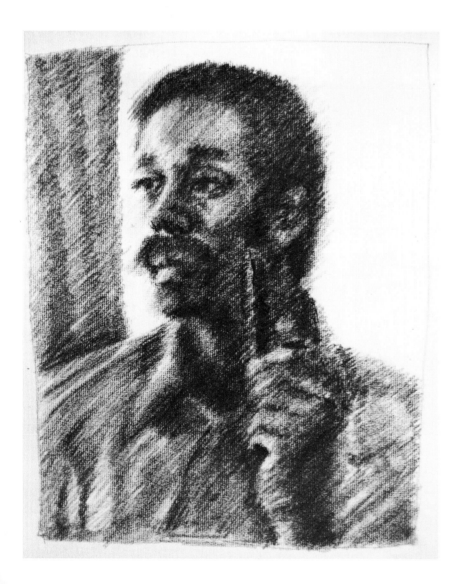

*To parallel the out-of-focus image drawing, this project required that they place a photograph or an old master reproduction across the room so that they could only see large areas of tone. They gradually moved it closer and as the tones developed the detail emerged. They were also asked to experiment by laying all of their marks in one direction. Charcoal drawing by Amber Taylor.*

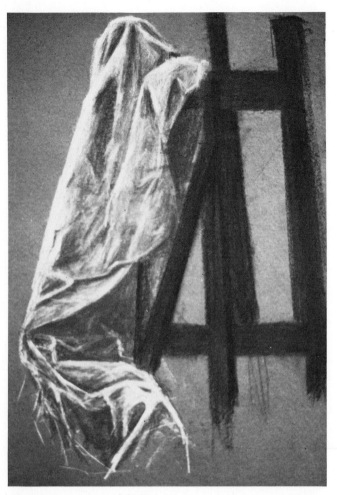

The folds of drapery are both organic and geometric. Their white highlights create a strong contrast with the dark shapes of the easel over which the cloth is draped. Charcoal and white Conté drawing on tinted paper by Jhorhe Cavalier.

## Drapery—A Try to . . .

The highlights, middle tones, and dark tones of drapery offer you still another rich source of subject matter for dealing with light and dark (**Figure 4.21**). Experiment with different kinds of cloth; a piece of satin cloth will drape in an entirely different way than does velvet or corduroy.

• Rather than consciously arrange the drapery, try dropping a piece of cloth over and over again until it falls into a marvelous arrangement, as though it were predestined.

• Let the drapery fall, but then make a few careful, calculated conscious changes in it, to make the arrangement even better.

• Try to pin it to the wall in beautiful swoops and colonnaded falls.

• Try to light it from the side and produce a perfect rendering in chalk, charcoal, pastel, wash, or pen and ink. Or how about a mixed media drawing in which you combine all of these materials. (See drawing by **Jhorhe Cavalier.**)

• Try to render it using only dots of ink applied with a fine felt-tip pen.

• Try to cover a chair with the drapery and render it so that anyone will know that there is a chair beneath it.

• Try to render just the very darkest shadows and use a dot-dash line to delineate the approximate location and shape of the middle tones.

• Drawing, whether drapery or whatever, is really nothing more than a lot of "trying to's." What else can you try to do beyond these few suggestions?

*4.21  Edgar Degas* (*French, 1834–1917*). Studies for a Standing Draped Youth. *Black pencil heightened with white gouache on beige paper, 11½″ × 8⅞″ (29 × 22.5 cm). The Metropolitan Museum of Art, New York, Rogers Fund, 1975.*

*Despite several reproductions in this volume to the contrary, generally when we think of Degas, we think of movement (as exemplified by his ballet dancers) and the spatial effects that characterize photography and the Japanese print, both of which had a profound influence upon him. It is difficult to believe that this stiff, frontal work came from the hands of the same artist. However, it remains a masterful study of drapery and as such deserves careful study. The range of tones is quite limited. How many different ones do you count? The artist was obviously not quite satisfied with the first drawing and so he redrew the drapery a little larger and to the side of the original: What differences can you discern in the two studies? Which do you prefer? The highlights were indicated with gouache, which is opaque watercolor. Note in these white areas that Degas did not attempt to "hide" or blend the brushstrokes. Despite the flaccid and indifferent expression of the youth, the composition has quite a bit of tension. Several people have told me that they feel the composition is too heavy on the right side, but I disagree. What's your reaction?*

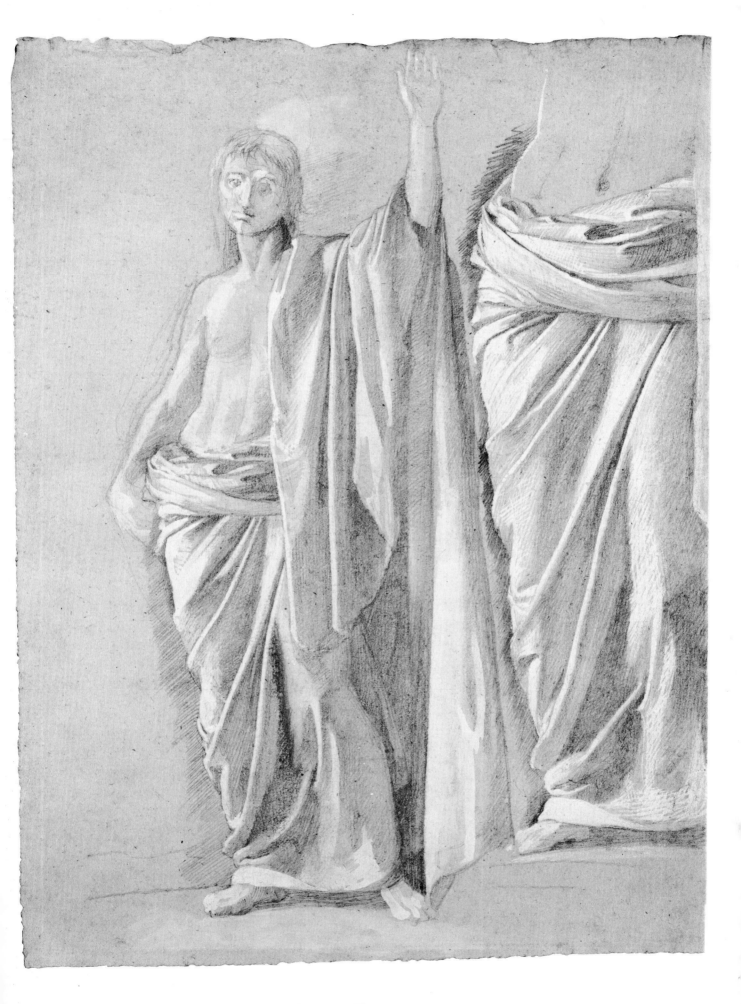

# Photographs, Grids, and Projected Images

"Did you do that freehand? Wow!" How many times have you heard this in response to someone's attempt to delineate form artistically? The praise is often in response to a drawing that has photographic qualities, implying that the artist may have "cheated" by using some mechanical method to achieve such beautiful results. In the past, most art teachers have tried to discourage the use of photographs or mechanical means because such "aids" were considered blocks to the student's own creative imagination.

Isn't it marvelous that times and attitudes change? At this point, many of our foremost artists don't care how images are achieved, so long as the results satisfy their artistic intentions. Many of them not only copy photographs, but even put a premium on the cool, detached mechanical feeling that is often communicated with the use of drawing aids such as grids, photo projections, or photo-sensitized canvas. Students in my classes who've been experimenting with photographs and some of these drawing aids have discovered that by changing the processes slightly they can arrive at images that are warm, expressive, and even emotionally affecting, as well as cool and detached.

## Photographs, Grids, and Fingerprints

"Martha, that's a big photograph."

"Harry, don't be stupid. It wouldn't be here in the painting section if it was a photograph."

"Talk all you want, Martha. You'll never convince me!" The above is an almost verbatim conversation I once overheard in the Whitney Museum while looking at a nine-foot-high (2.7 m) portrait by the contemporary American artist, Chuck Close. Taking his own photographs in dramatic closeups that often reveal minute details such as pimples, blackheads, and facial hair, Close has used grids in a variety of ways over the past several years. His earlier work, which brought him international recognition, was of the super photo-realist variety just described. The finished works revealed no evidence of his having used a small grid over the photograph as a mechanical aid for reproducing it with spray gun and paint. It seems that gradually the process—painting within squares formed by the grids —became more and more visible, and he became as interested in the process as the final result. Even though his work continues to be loosely photographic, the process is now almost in complete command. The content of his work *is* the process.

In the watercolor of *Phil* by Chuck Close (**Figure 5.1**), the original graph paper as well as his drawn grid show through. No attempt has been made to cover the grid or the letters and numerals that run across the top and down the side of the picture. Close even tests some of his watercolor tones directly on the drawing and leaves them as "visual tracks."

The second drawing by Close, *Phil/Fingerprint II* (**Figure 5.2**) includes the above factors but Close adds another unusual process. Using an ink stamp pad, he has inked his fingers, and then applied the ink to the appropriately matching tonal square. Even though the fingerprints show, if you back up slightly, there's still a photographic likeness! (See also **page 97**.)

## Tracings and Accidents

Larry Rivers, considered by many critics to be one of the outstanding draughtsmen of this era, recently experimented with slides projected directly onto paper (see, for example, **Figure 5.3**). By arranging pieces of colored carbon paper between two sheets of paper in an arbitrary way, he created a "sandwich" of paper. When he then traced the slide that was projected onto the top sheet, it was transferred in a rainbow of colors to the bottom sheet of paper. The final colored image was unknown to him until he had finished the tracing and had separated the sheets.

Rivers traced the slide, not because he was unable to draw, but because he simply desired to make use of modern technological developments—in this case, projected images. But even though he traced the image, he still intended to set up a process in which chance and accident played a crucial role. Accidents, in fact, were his intention! Yes, artists like Rivers often *make* accidents happen. As a former colleague of mine, Professor Hale Woodruff, often stated, "It seems that all the good artists have all of the good accidents."

**5.1 Chuck Close** (Contemporary American) Phil, 1973. Watercolor on paper, 21⅞" × 17" (55 × 43 cm). Collection Whitney Museum of American Art, New York, Gift of Lily Auchincloss, in honor of John I. H. Baur.

*Photo-realism was one of the major trends of contemporary art during the '70s, and Chuck Close is one of its best-known practitioners. Photo-realists are not so much interested in duplicating the real world as they are in duplicating the real world as it appears in photographs. Close's early work caused people to swear that they were photographs rather than paintings. But his recent work is more concerned with the process and allowing the spectator to see the process he used to create the image. In this case, he has placed a single dot (much like those in newspaper reproductions seen under a microscope) approximating the general tone in the photograph in the center of the grid. He generally starts in the upper left and works back and forth, completing each grid as he proceeds. The numbers and letters on the grid and the spots on the side where he has tested his airbrush further help to "drag" the viewer into his working process. How do you think Pontormo or Titian would react to these methods if they were alive today?*

95

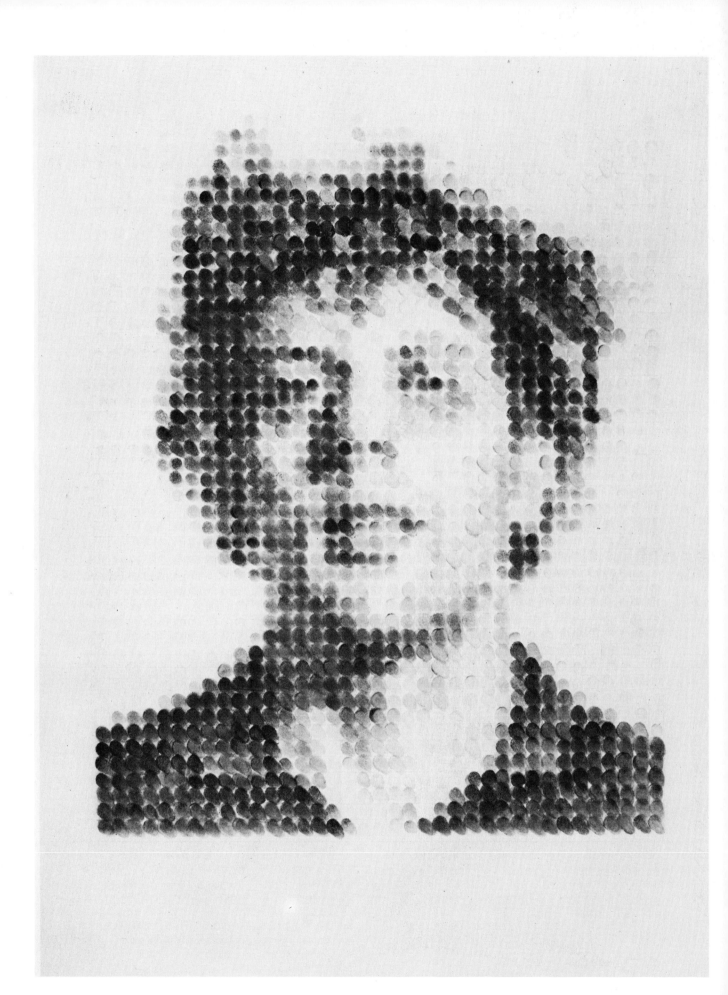

**5.2** *(Left)* **Chuck Close** *(Contemporary American).* Phil/ Fingerprint II, *1978. Stamp-pad ink and pencil on paper, 29¾" × 22¼". Collection Whitney Museum of American Art, New York.*

From normal viewing distance you may have difficulty "reading" this drawing as anything other than a series of near circles. But if you could step away several feet, the dots, which are actually thumbprints, would blend together into a photographic likeness of the person. Produced five years after the drawing of the same subject on page 94 (more than likely the same photograph), this one shows how Close has become even more interested in making the creative process as important as the image itself. (The grid lines, which were hand drawn with a pencil, are nearly invisible in this reproduction.) After reading the caption under the other Close drawing, you might have been prone to say, "Well, I couldn't attempt anything like that, I don't have an airbrush." But you do have thumbs and fingers, and a stamp pad can be improvised with an ink-soaked paper towel. How about giving it a try?

**5.3** **Larry Rivers** (Contemporary American) Carbon Color of Julia Robinson, 1976. Pencil and carbon paper, 19½" × 30"(50 × 76 cm). Courtesy Marlborough Gallery, New York.

This extraordinarily talented draughtsman has recently produced a whole series of drawings in which he projected a photographic slide directly onto paper and then proceeded to trace the image as an early step in arriving at his final drawing. The figure on the right is the pencil image he traced and also the top layer of a "sandwich" of paper. (See description of his technique at the beginning of this chapter.) In the figure on the left, you can see where the edges of the sheets of colored carbon paper began and ended. An interesting paradox is set up between chance (the arbitrarily placed sheets of carbon) and non-chance (tracing a projected image). In effect, Rivers has set up a situation in which an accident has to occur. Do you think it would be more proper to call it a "pseudo-accident"?

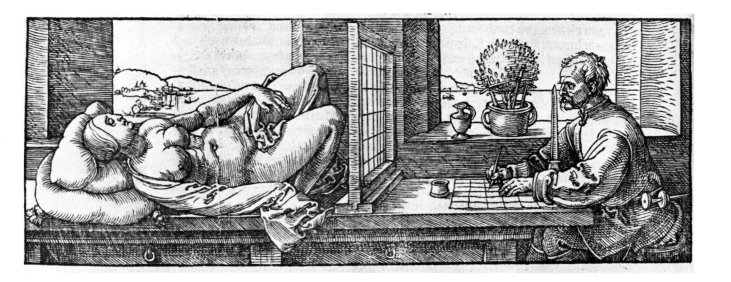

## Drawing Aids in Art History

In a recent survey of American drawing at the Whitney Museum, both Close and Rivers provided videotapes demonstrating their working methods. Despite their obviously creative use of these devices, many people in the art community seemed aghast after viewing these videotapes.

It's difficult to overcome contemporary biases, yet the use of drawing devices has had an amazingly long tradition. Albrecht Dürer's woodcut (**Figure 5.4**), *Draughtsman Making Perspective Drawings of a Woman* was made in the 16th century. The woodcut clearly shows the artist using an aid, a device to assist him in achieving perfect perspective in his drawing. Dürer himself is known to have used similar devices, even though he had complete command of perspective and foreshortening.

Since its invention, the camera has also had a profound influence on art, even though most artists either denied using it or used it unconsciously. In his book *Art and Photography*, Aaron Scharf points out that many artists, including Ingres, Cézanne, Delacroix, Degas, and Courbet, among others, either consciously or unconsciously made use of photographs in their work. Perhaps it would not be unfair to conclude that anything goes if it works! In the hands of a gifted artist, any device or aid that may help him achieve results of artistic significance is acceptable.

*5.4 Albrecht Dürer (German, 1471 –1528). Draughtsman Making Perspective Drawings of a Woman, 1525. Woodcut, 2¹⁵/₁₆″ × 8½″ (7.5 × 21 cm). The Metropolitan Museum of Art, New York, Gift of Felix M. Warburg, 1918.*

*This Northern Renaissance master's drawing shows us that the use of mechanical devices as aids in drawing has had many historical precedents. The vertical grid between the artist and model acts as the equivalent of a picture plane. By keeping his one eye in a fixed position, the draughtsman is able to establish sight lines from the figure to the grid and make corresponding marks on the paper before him. The foreshortening in this pose would be most difficult to draw, but the use of this device makes it relatively simple. You can be sure that the artist would have used projected photographs if they had been available. In a woodcut, the white or negative space is removed with cutting tools. Notice how the shading follows the contour of each specific form. As explained earlier, this is called bracelet shading or hatchuring, and corresponds to the cross-contour exercises suggested in Chapter 2.*

**5.5  Robert Rohm** *(Contemporary American). Untitled, 1975. Graphite on paper, 19¾" × 26½" (25 × 67 cm). Collection Whitney Museum of American Art, New York. Gift of Dr. Marilynn & Ivan C. Karp. Photo: Geoffrey Clements.*

If you look at an entire brick wall it has no particular meaning, unless you read it as the side of a building. But if you move in closer and look at only a small section of it (cropping out the remainder), you begin to see it in an entirely different way. Details that had blended into the texture as a whole suddenly take on a presence and meaning of their own. Out of context, the section of a brick wall in this drawing may at first appear abstract. But once "brick" is read or recognized, it's then nearly impossible not to see it as such. Unbelievably photographic in appearance, if you look at this drawing under a magnifying glass, you will note that the artist has broken the tones down into about four simple values, which are put down in a rather flat manner; they're seldom blended one into another. The excellent composition is the result of cropping rather than inventing it from scratch.

## Finding a Subject by Cropping

When you use grids or projected images, the supposition is that you're drawing from a prior image, such as a photograph, slide, or drawing. But it is not generally recommended that you use photographs from magazines that others have taken unless you plan to treat the image in a very loose fashion or otherwise change it so that the final result is your own. However, *cropped* magazine photographs are the basis of one of my favorite assignments, one that involves using cropped photographs to create original drawings.

For years, artists have used two *L* shapes of cardboard, or even their two hands, to create a lens or picture frame to isolate good compositions in landscapes, still lifes, or figure drawings (**Figure 5.5**). In this exercise, you will use an *L*-shaped viewfinder to arrive at a new, individualized composition of an existing photograph. You will need a stack of old magazines that contain black and white photographs, a razor blade, and two L shapes cut out of typing paper.

Select a photograph that appeals to you and place the two *L* shapes over the photo to create a rectangular frame. (You can make the frame wider or narrower, taller or shorter, by adjusting the two *L*'s.) Keep moving the frame over the photograph until you discover a *new* and *unique* image. Look for interesting contrasts of dark and light, variety of tone and texture, and shapes that oppose or echo one another. Search for the extraordinary passages within what might otherwise be a very ordinary and mundane photograph.

When you've found an image that appears "just right," or perhaps "just wrong," draw a line around it and cut it out with the razor blade. (See drawing by **Jon Wells**.) To isolate each cropped photograph so that you can see and study it without the surrounding "visual pollution," tack each one to a separate sheet of typing paper with a drop of rubber cement. You will note that when a very small section of a photograph is removed, it often looks like a total abstraction because the section is out of context. This is OK, but I suggest that you also create some croppings in which the subject matter, though transformed, is still "readable." I generally ask my students to bring in two dozen of these croppings, but since it becomes a rather compulsive activity, they usually bring in many more. Invariably, their croppings are far superior to any of their prior compositions.

As an exercise, the croppings are valid in themselves; but they can lead to much more. A group of croppings can be the basis of several years of drawing or painting. So often I hear students say, "I don't have any idea of what I want to draw or paint." If you do this exercise, selecting the best two-dozen croppings out of the infinite variety of possibilities, you won't ever have to make such a statement.

Here are a few more suggestions for drawings based on croppings:

• Select one of your croppings and render it as precisely as possible. When you are finished, do a *series* of drawings using the same cropping, but execute them in a very free, spontaneous fashion. A soft material such as charcoal or oil crayons may be less restricting for you. (See the drawings by **Cynthia Picchi**.)

*Using two L shapes like a camera viewfinder, an unusual composition was discovered by cropping an otherwise bland photograph. A light pencil grid was drawn on top of the photograph to serve as a guide. Pencil drawing by Jon Wells.*

• Using your complete range of pencils, render a cropped photograph and be sure to duplicate every variation of gray tone. Try to make each tone as *smooth* as humanly possible. Now repeat the drawing, but put your tones down in such a way that they create wildly different textures than those in the photograph—see if you can do this without ever repeating a texture!

• Using a cropping or a photograph that you've taken yourself, render it exactly but reverse *several* of the values (so that black becomes white or vice versa) so it *completely* transforms the original.

• Now do another one just like it, but this time reverse *all* of the tones. This is an excellent exercise to develop an awareness of the effect of light and dark on a drawing.

• With your complete range of pencils, render a cropping in black and white but develop one or two areas with colored pencils. You must try to relate the color areas to the light and dark values of the pencil drawing. This is a major compositional problem.

• Using one of the renderings you have already made, do another. This time, try to translate all of the light and dark tones into color. Use colored pencils, but you might want to work into some of the colored pencil tones with graphite pencils to modify the intensity and value of particular hues.

• Make a cropping from a colored photograph and try to duplicate all of the colored tones with your colored pencils. Next, try another one in color using soft pastels in a very free interpretation.

• How about a large, say at least 4' × 6' (1.2 × 1.8 m), action or abstract expressionist drawing where, instead of rendering your croppings, you "attack" the page as though you were going into battle! Use lecturer's chalk, mostly black and white with limited color, and then reverse the process using unlimited color and just a little black and white. If you don't like the result, work on it longer. If you still don't like the result, you might use two L shapes to look for compositions (see magazine photograph exercise described earlier) and cut them out as you did with the cropped photographs. You could end up with a half dozen good compositions!

• Now use one of the compositions you cropped during the above exercise. See if, by letting your imagination roam over its surface, you can begin to see new subject matter, just as Leonardo da Vinci claimed that he often found inspiration in cloud formations. By erasing and using spray fixative so you can work over the old chalk, add new tones and lines to push the composition closer to reality.

*(Top) The student first drew a large grid over the rather mundane photograph at the lower left. She then transferred the photograph to a distorted grid, producing an expressive and visually exciting work. The white grid showing is caused by incising the paper with a hard pencil. Pencil drawing by Cynthia Picchi.*
*(Bottom) These are only four of the eight loose drawings the same student made based on the black-and-white distorted grid drawing shown on the left. These drawings were highly expressive, and the series tended to move from reality to abstraction. Oil crayon drawings by Cynthia Picchi.*

## Using Your Own Camera

If you don't already own a camera, you should purchase one as soon as possible and learn how to use it to record picturesque events, scenes, objects, or people for potential drawings. But the camera is not a substitute for your sketchbook; it is simply a different recording device. In an instant you can have a complete record which, like sketches, may be complete within itself or may serve as a motif for later work. The camera is, of course, essential to collect slides for drawing from projected images. In fact, you or your family probably have hundreds of slides that are already perfect for artistic purposes. You may also find it useful to know that 2″ × 2″ (5 × 5 mm) slides can be converted into black and white photographs if you wish, to use with grids.

### Photomontage Portrait or Landscape

Since you have the magazines, rubber cement, and razor blade available from the previous problem, you can use them to create a photomontage. A photomontage is a work of art in itself but it might also serve as subject matter for your drawings. Unlike the cropped photographs, a photomontage is an image created by cutting and gluing bits and pieces of photographs together to form a completely new image. You may start on a blank sheet of paper or find a basic photograph upon which to glue parts of other photographs to transform it into a totally new image. (See collage by **Ann Emonts**.)

You can create a portrait by cutting facial features from a number of sources and gluing them together to create a new portrait, one with strange proportions and changes in scale. You can further transform these materials by drawing with ink directly on the photomontage or, as student **Barbara Betancourt** did, you can transform it into a new medium (pencil, in this case) using either a regular or a distorted grid, which will be described later.

## A Super Rendering—With and Without a Grid

To make a regular or straight grid, simply draw lines over your chosen photograph or cropped photograph in both horizontal and vertical directions **(Figures 5.6 and 5.7)**. If you don't want to spoil the photograph, you can place a piece of acetate over it and draw the grids with a grease pencil. If you use a large grid, such as one consisting of only four squares across and four down, you'll have to do a lot of freehand drawing within each square. On the other hand, if you use a very tiny grid, such as one with ¼″ (6 mm) squares, there will be much less to draw within a given square. This will enable you to create a more exact rendering of the original photograph, if that is your intention.

Draw the same number of horizontal and vertical lines on your drawing paper as you did on the photograph and copy the original square by square. I usually ask my classes to do a *completely freehand* rendering of a photograph, and then draw another photograph with a grid in order to see the difference in the process and the results. In the Chuck Close drawing of *Phil* **(Figure 5.1)**, you will note that he used numerals to identify the horizontal spaces and letters to identify the vertical ones. On a "straight" copy, the grid should be so light that it is almost invisible to the average viewer.

*It is amazing that such severe fracturing of a head still manages to hold together. Both an original photograph and a photocopy of it were cut up, pasted down, and then worked into with oil crayons and magic markers. Drawing by Ann Emonts.*

**5.6** *Pierre Puvis de Chavannes* (French, 1824–1898). Philosopher-Mathematician. Pencil on paper. Collection The Metropolitan Museum of Art, New York, Fletcher Fund, 1935.

Puvis was an academic painter and leader of the late Classicists. He was a muralist who was much influenced by Oriental art, and the relative flatness of his work was to be a strong influence on both Seurat and Gaugin. The overly sentimental and allegorical nature of his work (in this case Philosopher-Mathematician) is apt to bring a smile to our contemporary sensibilities. Historically, when you see a grid over a drawing such as this one, you know that the artist used it to transfer the exact proportions of a preparatory drawing to a painting or mural. The grid was a functional device when it was placed here, but we now look at it as an integral part of the drawing. In fact, with our contemporary sensibilities, we may even be inclined to prefer it this way. By limiting the shading primarily to a single tone, as in the head and stomach, Puvis tends to keep forms relatively flat. The contour line is hard, cold, and almost brittle.

**5.7** *Alan Dworkowitz* (Contemporary American). Bicycle II, 1977. Graphite on paper, 18" × 20" (46 × 51 cm). Courtesy Louis K. Meisel Gallery, New York.

Of his compulsive and disconcerting images, the artist states: "The drawings in the Bicycle Suite are derived from three sources: the bicycle, providing a constant and immovable reality; the photograph, used as a device to transfer the image onto paper; and my conceptual intentions, which give the drawings their ultimate form. I begin by photographing sections of the bicycle. Keeping the camera perfectly still, I change the focal point on consecutive shots, thus allowing individual parts within the frame to appear in focus. After enlarging these photos I cut out the parts which are in focus and paste them together resulting in one sharply defined composite photograph. Using a thirty-two-line grid I transfer (draw) the outline of the photo onto a sheet of paper. This first stage is critical. Decisions made as to where things 'are' in space must be adhered to absolutely since corrections are very difficult to make later on. It usually takes a number of weeks to draw this outline and when achieved further references to the photographs become limited and rare. At this point the rendering stage begins. I work on sections at a time using needle-sharp pencils (9H – HB). Tones are built up slowly in a series of layers: the first, barely visible, the second, more so, and so on until a section is fully resolved. I 'weave' these tones which gives the surface of the drawing an unmarked quality. It is this aspect of the work that is most time consuming. The process takes from four to six months to complete each piece" (Meisel Gallery, Exhibition Catalog, 1979).

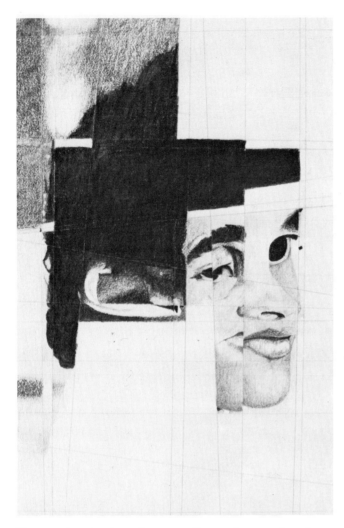

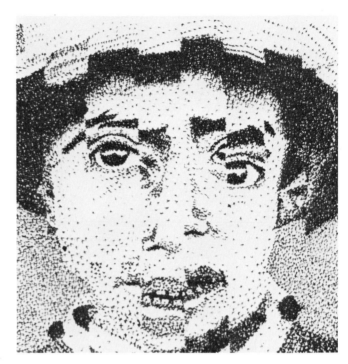

In this distorted grid drawing, every other row was dropped down one square. All of the tones were created by using an X instead of by hatching or cross-hatching. Pen and ink drawing by Jennifer Chotzinoff.

*This is a drawing based on an ordinary photograph, using a distorted grid. Although it may look unfinished, the decision to stop work at this point and allow the distorted grid to show was a very conscious one. The blended values set up a tension with the flat background. Stopping at this point invites the viewer to participate in the creation of the work. Pencil drawing by Barbara Betancourt.*

## Distorted or Irregular Grids

Incredible results can be obtained by radically changing or distorting the grids on your paper from those on the photograph. You can make a few especially wide, a few too close together, slant some, curve some, or drop every other square of the grid slightly lower than the one to its left, as **Jennifer Chotzinoff** did (see above). Just the act of making the distorted grid can become a creative exercise. With a little experience, you'll also begin to predict what will happen to the original photograph as you transpose it onto the distorted grid. The two diagrams on this page illustrate the basic procedure in making a distorted grid. (See **examples** above.)

## Grids—With a Difference

Just as Chuck Close started out to use grids as an aid to exact reproduction and then moved on to using the grids as a *creative* device, I would like you to experiment with grids as a creative force in your work (**Figures 5.8–5.10**). I am going to briefly suggest a few variations on grids my students have devised that you may want to try or combine with other approaches of your own:

• Try to copy a photograph first using a large grid, then with a tiny grid.

• Draw a ¼″ (6 mm) square grid over your photograph. Now, take another sheet of paper, cut a hole in it precisely ¼″ (6 mm) square, then copy one grid at a time onto your paper until all squares have been drawn. Next, take a second piece of paper with a hole in it the same

*This is a graphic illustration of what happens to the image of the regular grid (left) when it is transposed onto a distorted grid (right). The possibilities are limitless.*

*A freehand rendering of a cropped photograph. This exciting and apparently abstract composition was cropped from a clichéd fashion photograph. The lips in the lower left-hand corner help orient you to what the original was like.*

*This time, rather than draw freehand, the student used a regular grid; but she reversed all of the lights and darks. This helps one to realize the power of values in determining form. Pencil drawing by Anna Lorinzoo.*

size as the grids on your *drawing* paper. Draw one square at a time and don't look at the drawing until you've finished the whole thing. Can you accept the varying tones that this process engenders?

• Instead of drawing your grids so they are invisible, draw them very dark, allowing them to show in the finished work.

• Try drawing the grids with a colored pencil or a variety of colored pencils.

• If you use a hard pencil (6H) and press hard as you draw the grid, you will make grooves in the paper. When you draw over these grooves, a white line will appear, since your graphite cannot get into the groove. With a little forethought, you can have white lines form the grooves in one section, colored lines in another, and smooth, finished sections in other areas.

• Try a grid drawing in which you reverse the tones. Where there's a black, leave it white, where there's white it becomes black, and so on. Your result might look like a photographic negative and could be very dramatic. (See the drawings by **Anna Lorinzoo**.)

• Start to copy one photograph in the upper third of the drawing, switch to another, slightly related photograph in the center third, and yet another photograph in the bottom third.

• Use two photographs and combine them into your drawing by switching every other square. Photograph

A in square 1, photograph B in square 2, photograph A in square 3, and so forth.

• What will happen to your drawing if you leave every other square blank (see drawing by **Sunsil Kim**)? Or if you determine what will go into each square by throwing dice? (See **Beth Biegler's** use of I-Ching.)

• Try a drawing in which you radically alter the proportion or shape of the format. For example, you might try to transpose a rectangular photograph into a circular or oval shape. (See the vertical grid drawing by **Joy Guckes**.)

As an end-of-the-term project, I once assigned a drawing (of anything) that had to be at least 12' (3.6 m) long by 1' (0.3 m) wide. One girl did a drawing using grids over a photograph of Toulouse Lautrec. Imagine! Lautrec 12' (3.6 m) tall! She spent weeks and weeks on this work, but it was worth it.

• Using butcher paper create a sheet about 6' × 8' (1.8 × 2.4 m) and work in a juicy manner using black, white, and three or four premixed shades of gray tempera or acrylic paint.

• Do one in which you limit yourself to brushes that are 2" (5 cm) or more in size.

• Compare that one with another in which you limit the brushes to 1" (2.5 cm) or less!

• Don't stop here. I'm sure you now have a hundred other ideas. Try them all! **(Figure. 5.11).**

**5.8** (Above)  **Ben Mahmoud** (Contemporary American). Image 7K28a. Pencil on paper, 22" × 28" (56 × 71 cm). Courtesy Hansen Gallery, New York.

By using a distorted grid in just one section of his drawing, this artist has caused a disorientation of time and space. We have to ask: Just where is the woman on the left? Is she moving or stationary? Why aren't the other figures distorted? Note how the white rectangle held by the central figure cuts into itself as well as into the figure on the right. Note how the cast shadow of the middle person's fingers and the line at the bottom define the white shape he holds, while in other areas, it blends into the background. What kind of strange thing is happening to the right arm of the central figure? What are the three of them trying to do?

**5.9** (Right)  **Ben Mahmoud** (Contemporary American). Image 4 E 9b, 1974. Pencil on Bristol board 28" × 22" (71 × 56 cm). Courtesy Hansen Gallery, New York.

Unlike the other drawing by Mahmoud on the preceding page, in this one he not only shows us the particular grid he used and its distortion at the bottom of the drawing, but he has made the grid an integral part of the total statement. While the diminishing size of the rendered figures and the diagonal movement suggest movement into the picture, the grids keep reminding us of the existence of the picture plane (the surface of the page). Note the slight variations in the sizes of the grids and the cryptic symbols along the lower grids. What do you suppose the titles he gives his drawings mean?

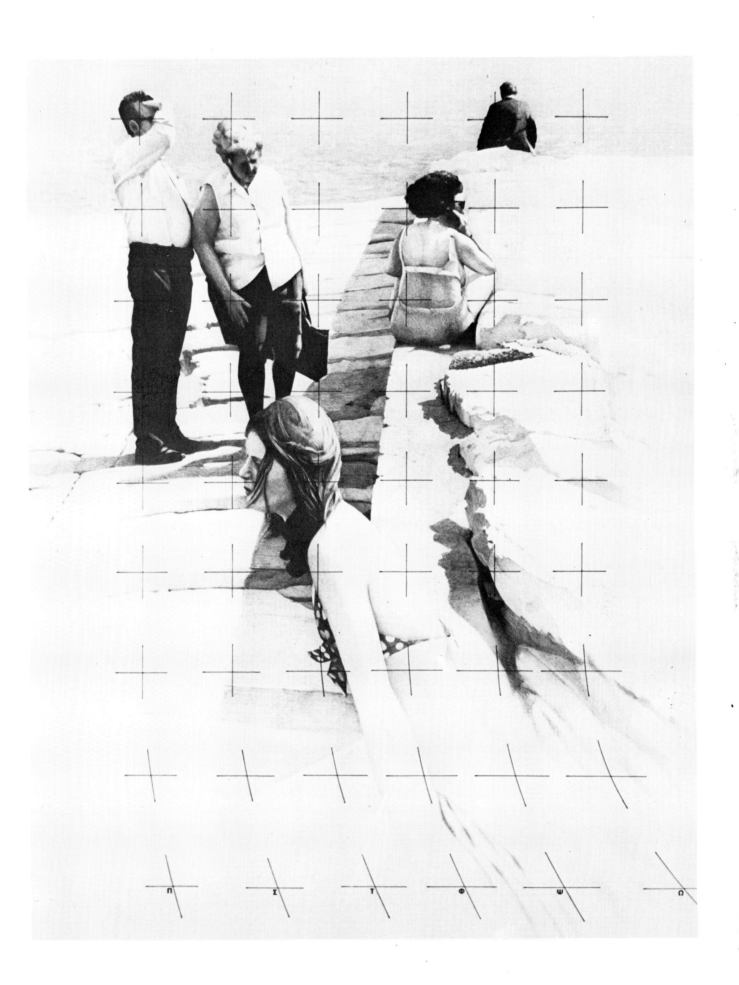

**5.10   Lee Krasner** (Contemporary American). Future Perfect, 1976. Collage on canvas, 50" × 75" (127 × 191 cm). Courtesy The Pace Gallery, New York. Photo: Albert L. Mozell.

An important figure in the development of Abstract Expressionism, Krasner worked with Hans Hofmann (see **Figure 4.19**) between 1937 and 1940. During this time, she produced hundreds of drawings of the figure using charcoal and oil on paper. Many years later (in 1975) sorting through her work, she discovered that because the works weren't stabilized with fixative, the charcoal had rubbed off onto the sheet above, imprinting their ghostlike images much like a monotype. She suddenly saw the potential in these drawings for new work if she cut them up and pasted them on canvas. Despite the sharp light and dark contrasts and the strong diagonals, the composition is held together by the grid structure created by the original size of the drawing pad. Artists are constantly seeing the potential for the creation of form-ideas in everything around them.

This end-of-the-term project was a gigantic effort measuring 48" × 73" (122 × 183 cm). Working from a straight grid laid over this family portrait, the student worked out a system of negatives which she then accepted no matter where they came in the drawing. Pencil drawing by Sunsil Kim.

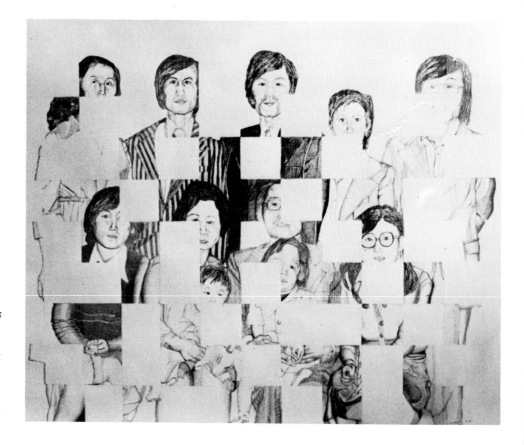

A photograph of Albert Einstein was used as the basis for this drawing. The rearrangement of the squares was arrived at by throwing the I-Ching, a Chinese divining method consisting of 64-line hexagrams. The photograph was divided into 64 squares, as indicated by the chart (above). The student then decided to change every third square by throwing the I-Ching 21 times. She then replaced each square in question with the square corresponding to the hexagram number that came up. Square numbers eliminated in this process were used only if they were indicated at some point by the I-Ching. As a result, some square numbers were never used, while others were repeated. The grid lines in the drawing were arbitrary. Pencil drawing by Beth Biegler.

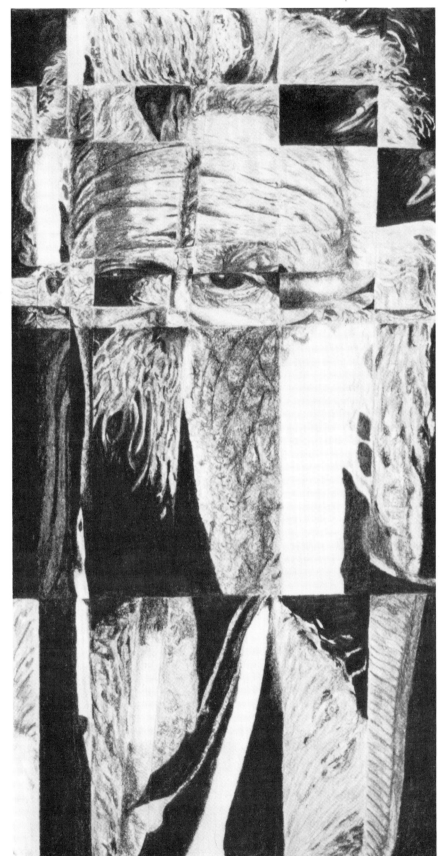

111

A regular grid drawn over a photograph of Theodore Roosevelt (above) served as the basis for this drawing (right), in which the image was forced to fit into an arbitrarily distorted grid. Upon completion of the drawing, an illustration from a magazine was cut into vertical strips and pasted over the vertical grid lines; horizontal lines were erased. Squint to see the second head in the upper right-hand corner. Pencil and collage drawing by Joy Guckes.

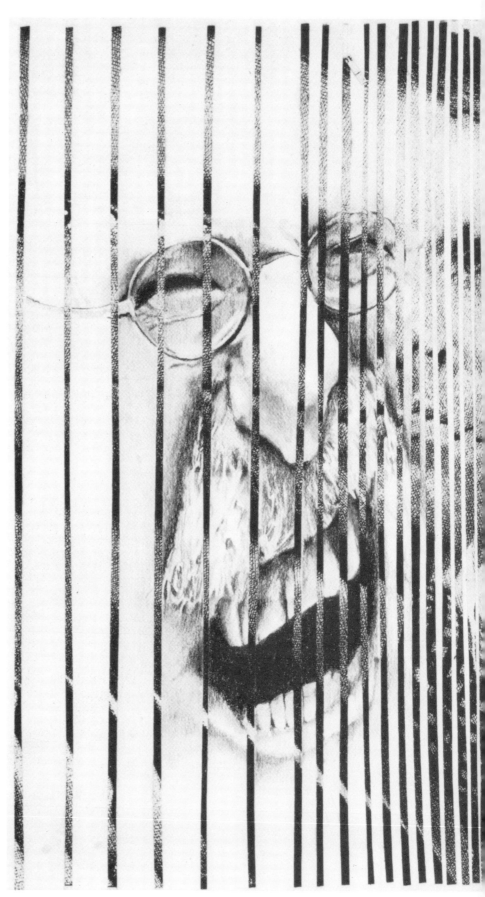

**5.11 Clover Vail** (*Contemporary American*). *Untitled, 1978. Oil crayon on paper, 72" × 72" (183 × 183 cm), 9 sections. Courtesy A.I.R. Gallery, New York. Photo: D. James Dee.*

Many contemporary drawings have eliminated recognizable subject matter in favor of pure formal values. In this case, the artist's interest lies in the horizontal grid, in the nine sections that constitute the whole, and in the very act of making vertical white marks with the oil crayon on the black paper. Beside the imposing size of the drawing, the sheer repetition with the ever-so-slight variation becomes almost hypnotic to the viewer. As for the artist, I imagine the activity must have become rather compulsive, much like the state of mind required of artists who weave or make baskets. A friend of mine stated, "A child could do that!" Make a list of the pro and con arguments that pertain to that statement.

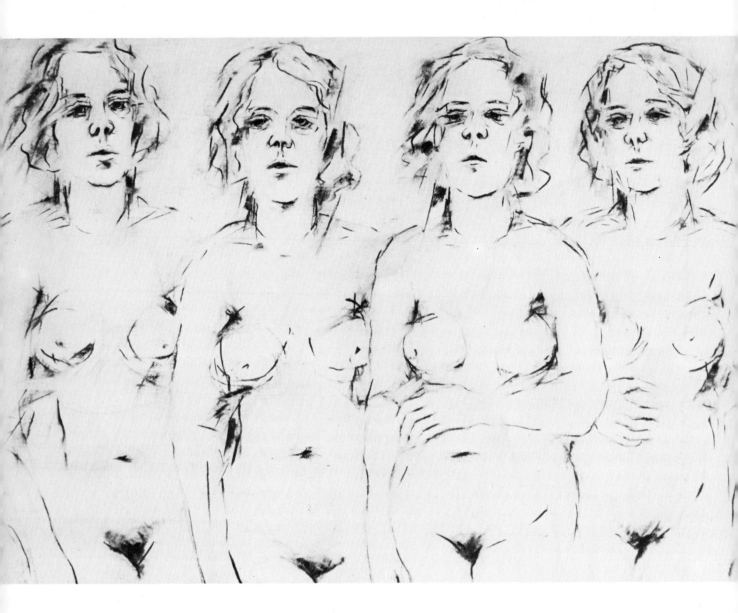

**5.12  Gerald Monroe** (Contemporary American). Untitled.
Charcoal, 24" × 36", (61 × 91 cm). Courtesy the artist.

A skilled draughtsman, Monroe uses photographs to extend his perception in ways that aren't possible with a single posing model. He states: "The model was instructed to take a somewhat nonchalant pose and, as I photographed her, she was to make intuitive sequential adjustments—a tilting of the chin, twist of the shoulders, and so forth. The photographs of the model were cropped to minimize the negative space, then assembled into collages of four figures butted together to create a frieze effect. The collages were designed to emphasize rhythmical interest. Slides were made of the images, projected on paper, and a rough drawing was rapidly traced on the paper in charcoal. The drawings were developed by working and reworking these original images. The use of photography was merely a tool to save time for both the model and myself in arriving at an image that I was searching for." Monroe worked every day for an entire summer on this particular series!

## Working from Projected Images

In this exercise, you'll be projecting the image of a 2″ × 2″ (5 × 5 mm) slide directly onto your sheet of drawing paper to use in any way you see fit. If you stick very close to the image in a rather tight manner, the artistic quality of the slides you use will have a strong influence on your final results. If you use the projected image as just another source of visual stimuli from which to deviate in any number of ways, the artistic quality of the slide will be of less importance. Try to work in both ways.

As you begin to trace contours and apply tones, it may be difficult to see exactly what you have done because the entire image is projected on your paper. If you work in a slightly darkened room and have the projector set up so that you can step in front of (and thus block) the beam of light, you will be able to constantly check on the progress of your work. Even if you are trying to produce a relatively "tight" drawing, you should not be a slave to the image; you may omit areas or objects, or reverse lights and darks. By moving the projector slightly, you can rearrange the image on your paper to get an entirely new juxtaposition of forms. You can

also move it slightly several times to get what resembles a double or triple exposure, or you can combine several different slides into one drawing (**Figure 5.12**). Experiment with a variety of media on the various drawings. Try drawing some pictures very slowly and some very fast.

In order to get started with this new approach to drawing, I suggest that my students work in a soft pencil for a few minutes, blocking in the major forms and tones without looking at the paper. I then have them erase over the whole drawing for several minutes, turn off the projector, and then finish the drawing so that the image becomes an independent work that is motivated by the projection rather than a direct copy of the original slide.

### Using Projected Images for Gesture

Use the same projector arrangement for this exercise as you did for the previous one. The objective here is to look at the projected slide for a few seconds, and then step up to the paper and record the gesture of the whole image in a few seconds.

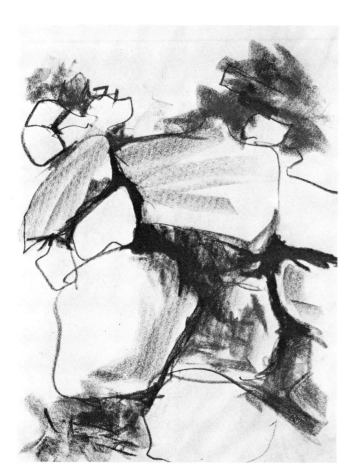

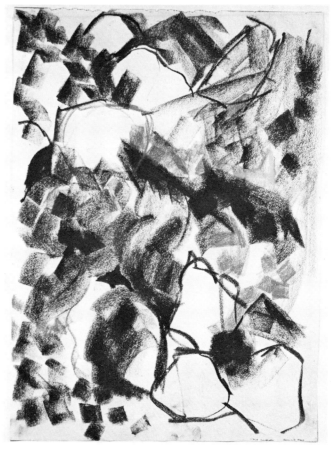

An image of rocks was projected onto a screen in the dark and students were asked to respond with their complete body-selves to the image—not to draw the image, but to become the image. The marks their hands made were a visual trace of their experience. Chalk drawing by Alfred Santullo.

Working from the same slide as the preceding student, this student created an entirely different composition. This student responded to the whole slide, while the other one zeroed in on a section of it. Extra large chalk helps to develop an attitude of freedom. Drawing by Steve Sugarman.

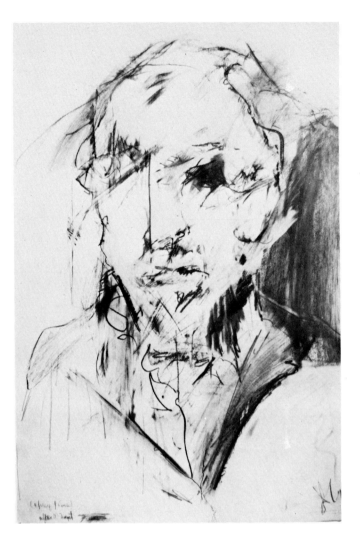

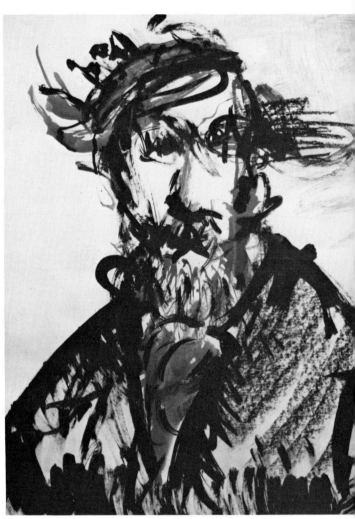

Besides projecting slides of everyday surroundings from which students work in the dark, I also project slides of old and modern masters. These four drawings were all based on a pastel drawing by Edouard Manet. A variety of materials were used, but what astounds me most is the incredible range of results that were obtained. (Above left) Drawing with pencil, crayon, and eraser by John Carey. (Above right) Mixed media drawing by unknown student. (Opposite page, top) Oil and chalk drawing by unknown student. (Opposite page, bottom) Charcoal drawing by Shirley Bedikoglu.

• Try using a 1″ (2.5 cm) varnish brush dripping wet with India ink for this problem. It may be a good idea to gradually limit the number of strokes you make in a sequence of drawings. For example, you might start with only five strokes, then four, three, and ultimately only one! Of course your drawn gestures will be very abstract, and it is most exciting to either stand in front of the beam or turn off the projector to see what you have actually accomplished. Giant 1″ × 1″ × 3″ (2.5 × 2.5 × 7.5 cm) black chalk is also excellent for this exercise.

• When we think of gestures, we almost always think of human gestures. But we do not have to limit ourselves in this fashion. Use humans, yes: but you can also project landscapes, objects, cityscapes, and the like, and create gestures from them. Over the years I have found that the most difficult thing for beginners is to know when to stop on these gestures. They almost always have a tendency to overwork them, and that usually destroys the impact of the initial, forthright, and true gesture.

• Project a slide onto your page and make several dozen gesture drawings from it. Don't let any of them be more than ten seconds long. In the first one, use only the motion of your fingers to move your brush. In the next, use your hand up to your wrist. In the next, work from your elbow, then from your shoulder, then your waist, and then make a dozen moving your entire body. Good gestures reflect the movements of the aritst as much as the implied or actual movement of the motif.

### Gaining Distance from Projected Images

It has only been for the last few years that I've had students project images directly into their paper. For many years I have projected slide images onto a screen at the front of the studio from which the class could create a variety of images.

Working in a darkened room, I usually begin by projecting a slide image for just a few seconds and then ask the class to respond to it in its totality rather than in its parts. They try, in effect, to momentarily *become* the projected image and their marks are simply a "visual trace" of that experience. They're not drawing images so much as empathetically relating to a variety of visual motifs. Most important of all, they are *not* trying to make "good" drawings, although inevitably many excellent drawings do result. (See the drawings by **Alfred Santullo** and **Steve Sugarman**.)

I gradually increase the amount of time on each slide, but in each instance their initial impulse is still put down in the first few seconds. In the remaining time they then elaborate on and enrich this impulse in terms of the projected image.

In addition to my regular collection of ordinary slides, I sometimes project slides of old masters, and the results are generally quite satisfying. The sampling of **drawings** at left based upon a pastel by Manet illustrate some of the range of possibilities.

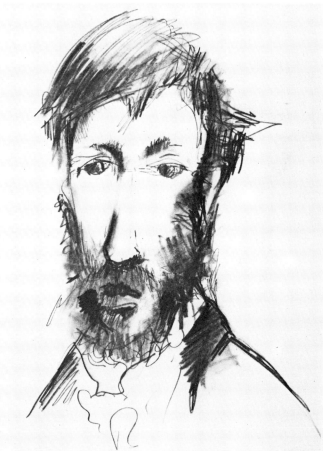

# Probing a Single Form-Idea

To mention the name of Antonio Pisanello, the early 15th-century draughtsman, without thinking about his marvelous drawings of animals is impossible. The magic name of Rembrandt stirs up our memory of thousands of works, but none so much as his self-portraits. Ballet dancers and the name of Degas are practically synonymous. The disasters of war have never been so prodigiously stated as they were by Goya. DeKooning has produced many more abstract paintings than figurative ones, yet the mention of his name immediately causes us to think of his "women." Is it possible for you to think of Cézanne and not see the majesty of Mt. St. Victoire? Or think of Venice without conjuring up images by Canaletto and Guardi (**Figure 6.7**)?

All of these artists, along with most others who have achieved the status of giants, have something in common. That something is their ability to grasp a conception or a form, something that is meaningful to them, and to then search, investigate, and probe beyond the surface into the deeper meaning of their compulsions with compassion (**Figure 6.1**). This seems to be the hallmark of genius.

Of course, the subject is not necessarily the compulsive factor. Often the subject is only the carrier of the form-idea. Monet painted many pictures of cathedrals and haystacks, but he really couldn't have cared less about them. His only concern was how *light* fell upon and affected them at different times of the day. Cézanne's mountain as well as his apples were preferred over figures because they sat still and *didn't move* as he struggled to realize his "sensations" before nature.

Today artists of all persuasions, from photo-realists to conceptual artists, continue to work in series as they strive to probe the deeper meanings of their subjects, their materials and processes, and their concepts and ideas in their search for artistic form-ideas (**Figure 6.2**). This chapter offers exercises and examples of work that may start you on your own in-depth probing.

**6.1** *Hale Woodruff (Contemporary American). Torso #2. Crayon on paper, 23⅛" × 16⅝" (59 × 42 cm). The Metropolitan Museum of Art, New York, Rogers Fund, 1972.*

*One of America's great artist-teachers, Professor Woodruff has been consumed by this figurative image for many years and has produced hundreds of drawings in this series. He is not interested in the figure as such, but rather in the space in which the figure exists and moves. As he stated in a letter to the author: "I have come to consider drawing as the crux or basis of art expression. I have done a bit of thinking in this direction as well as trying to create form (new forms of my own)—all based chiefly on drawing (linear, if you will). In this attitude, color is decorative—I'm trying to get away from color as anything but mood."*

## Nonstop—50 Drawings in Four Hours

"50 drawings in four hours? You have to be kidding!" That's the typical reaction I get from my students when I assign this problem. But when it's over, the reactions are always animated. The vast majority of students say that it was a profound learning experience, demanding an intensity of concentration seldom experienced by them before. Instead of fighting against time, they realize that they have to use this limitation to their advantage; they have to accept it and work within it. They discover that the *time* they spend and the *quality* of the drawing aren't necessarily related. They're forced to loosen up, either in their way of drawing or in their concept of the problem. (See the ink drawing by **Brenda Holtz.**)

A few always find it fiercely frustrating and complain that there's no way they can work that fast. But generally speaking, those who are frustrated are the students whose concept of drawing is extremely narrow.

Most of the students, no matter how broad their concepts of drawing, start out with rather stiff, labored, self-conscious drawings. Then suddenly they realize that they've used up a half hour and that they're only on their second or third work! At this point, they realize that they have to make some radical changes in their approach in order to finish. They may have to change their entire concept of the problem. Or perhaps they've chosen a subject or form-idea which doesn't lend itself to rapid execution. The creative individual soon adapts his entire physical and emotional being to finding a solution. In the work of about 90 percent of the students, there is a very obvious continuum from complexity to simplicity as they go from the first to the last drawing. However, this doesn't necessarily mean that this is the "right" way to do it. There's no one way. The drawings might be just as good if they are developed from the simple to the complex.

One of the more revealing experiences for a student is to see how others attack the problem. Some students will look around for 50 different objects to draw. Some will choose 10 or 12 subjects and do variations on them. Some will use one drawing medium throughout. Some will change medium from page to page. Others might work with a different tool in each hand.

I once had a student, **Leslie Gold,** who drew exceptionally well, but could never break out of her tight preconceptions about drawing. She chose to try 50 different self-portraits in four hours. She was unable to reach 50, but she did reach 37. The 29th and 33rd drawings are illustrated here and show a remarkable breakthrough.

The possible ways of solving this problem are unlimited, but here are a few more suggestions you may want to try:

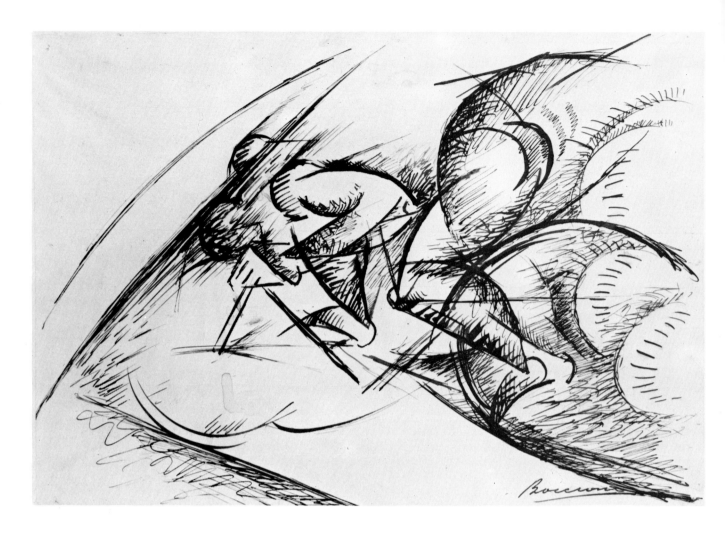

**6.2** **Umberto Boccioni** *(Italian, 1882–1916). Study for Dynamic Force of a Cyclist I, 1913. Pen and ink on paper, 8¼" × 12⅜" (21 × 31 cm). Yale University Art Gallery, New Haven, Conn., Gift of Collection Société Anonyme.*

Probing a single form-idea in depth, has not been limited to individual artists. Form-ideas pursued in depth by groups of artists have given us a vast array of art movements and "isms." Romanticism, Impressionism, Dadaism, Vorticism, Purism, and Abstract Expressionism are among such movements. Boccioni was one of a group of Italian artists called Futurists who, through their paintings, poems, and manifestoes, extolled the dynamism of modern life. They worshipped speed, the machine, war, and wanted to destroy all remnants of the past, such as libraries and museums. This drawing was one of many Boccioni made in preparation for a painting of the same title. There is an amazing difference between the drawings in the series as he searched for forms that would become the visual equivalent of speed, action, and forward thrust. The bike and rider are integrated into one "system," an integrated totality of energy creating an arrow shape that seems to be cutting through space.

To produce 50 drawings in four hours is an assignment which can be attacked in a vast variety of ways. This student's work became more and more reductivist or simplified as she proceeded until, toward the end, she was able to produce this straightforward "essence of sneaker"! Ink drawing by Brenda Holtz.

*Until this exercise, the student was "stuck" in the academic tradition of drawing. Unable to finish 50 drawings in four hours, she produced 37 self-portraits. Here are numbers 29 and 33 in the series. Chalk drawings by Leslie Gold.*

• 50 variations on a single old master. Choose one you either love a lot or dislike violently—certainly not one to whom you are indifferent.

• 50 variations on a painting you are currently working on or one you have recently finished. Imagine, from that one painting you will have 50 new possibilities!

• 50 drawings, all abstract, and work with both hands simultaneously on each page. (See the drawing by **Angela Fremont**.)

• 50 drawings made completely blind. Don't look at a single page until you have finished the complete series!

• Having made 50 drawings, go back through them and crop each one to improve its composition. (Cropping is explained in Chapter 5.)

• Using a tracing pad, start on the last page and proceed to make a drawing, the first in what is to be a series of 50. When you finish it, cover it with the next sheet and begin the second drawing. Allow the second drawing to be influenced by, or to evolve from, the first one which, of course, is visible. The visible portion of the first drawing can be considered a part of the second one and will have a gray tone because of the translucency of the tracing paper. These are single drawings, but they are also a part of the whole, which consists of the entire pad. In effect, you are creating a "visual book" that may become rather cinematic in its overall effect. Both Willem deKooning and Auguste Rodin have used tracing paper over drawings in a manner similar to this one.

• In order to completely change from the fast, spontaneous drawings produced by working so rapidly to the slower-paced one I want you to do now, I suggest that you select *one* of these and again take *four uninterrupted hours* to devote to this single drawing. You are to rework, reconsider, and refine the whole thing. At the end of four hours, it is unlikely that your work will have any resemblance to your first image. (See the two drawings by **Janet Siskind**.)

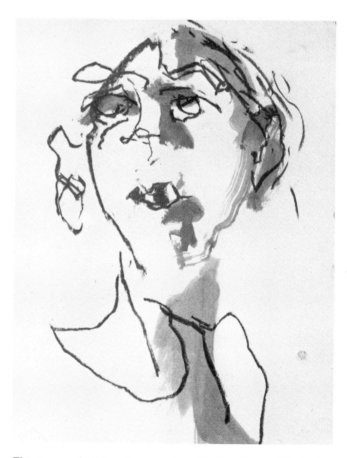

*This is one of 50 drawings produced in four hours. Much of the spontaneity of this work exists because both hands were used simultaneously. Oil paint and chalk drawing by Angela Fremont.*

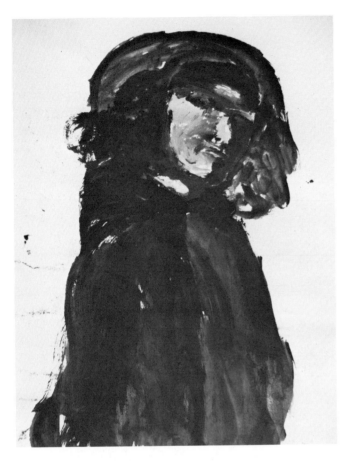

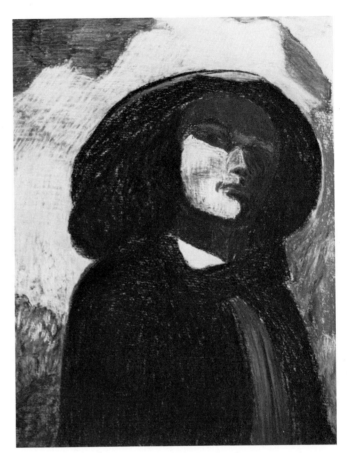

*Using a reproduction of Gustave Courbet's Self-Portrait as a motif, this student produced 50 variations in a variety of materials working nonstop for four hours. Acrylic on paper by Janet Siskind.*

*A few days later, after producing 50 variations on the Courbet Self-Portrait, the student spent about four hours developing this single work on the same motif. Pastel drawing by Janet Siskind.*

• Working with crayons or pastels, incorporate 50 different colors in the first drawing, 49 in the next, 48 in the next, and so on down to just one color in the final drawing! Now reverse the procedure and do 50 more drawings!

• Try 50 drawings of a potato or some other mundane object in pen and ink, and then try another 50 in wash.

• Try to produce 50 drawings using a ruler, compass, triangles, and other mechanical drawing instruments. This is wild departure from their usual use!

• Select a single drawing from one of these 50 drawing exercises and make another 50 variations on that single work!

• Don't stop now. Try 100 in four hours. Or 200 on small index cards. Try to probe this process deeper and deeper and deeper. Keep it going . . . .

## Series Drawings—Minutes/Hours/Years

In the 50-drawings-in-four-hours exercise, the approach necessitated that each drawing had to be completed in a few minutes. Needless to say, artists have spent months and even years on a single work which may be a part of a larger series (**Figure 6.3**). I am now suggesting that you, too, get involved in a series of drawings where there will not be any time or number limitations.

The series will be finished only at such time that you feel that there is no place else for you to go—that you've "milked it dry"—or that you have either intentionally or accidentally come across another subject, media, process, or concept that might be more rewarding for your development. When I have assigned a "series" project to my students in the past, they almost always ask, "How many do you want?" That, of course, is the wrong question. Series problems may be finished overnight, but I have also known students who many years later were still probing the possibilities in a series assignment that began in one of my classes.

Here are a few general subjects, processes, or concepts that might help you to get started on one or more series problems. A series based on:

• A single old master drawing.

• A twenty-five cent piece.

• Your own eyes.

• The concept of motion.

• The concept of low-keyed drawings.

• The concept of drawings with severe value contrasts.

• Tire tracks on muddy roads.

• Thumbnails.

- The process of making marks with other than "regular" drawing materials.

- The *growth* of a bean plant.

- The concept of building forms that are to be destroyed by some means, but in which the process of destruction becomes the new form.

- Insects.

- "Color" in black and white drawings.

- A pictorial space that disregards the picture plane.

- The idea of achieving the effects of cinematography in still drawings.

- "Painterly" realism with drawing materials.

- Eggs.

- Charred ruins.

- The figure in motion.

- Cropping croppings of croppings.

- Working from miniscule objects on a *gigantic* scale.

- Working on gigantic objects on a *miniscule* scale.

- Creating "visual" books.

- Making all-white or all-black drawings.

**6.3  Judith Bernstein** *(Contemporary American).  Three Panel Vertical, 1977–1978. Charcoal on paper, 12½' × 16' (3.8 × 4.8 m) overall. Courtesy Iolas Gallery—Brooks Jackson, Inc., New York. Photo: Bevan Davies.*

Bernstein has been using this single image in her work for nearly a decade and the differences from one drawing to the next are subtle. But as you view her work, these minor differences become major because you begin to anxiously search them out. She has always produced large drawings, but they have been getting larger and larger until, in her most recent show, the largest one was 9' high and 28' long (2.7 × 8.4 m)! Imagine the sheer energy needed to produce a charcoal drawing of this dimension! She has stated: "My work is all in series. I started doing the drawings in 1969 and, at that time, they were mechanical looking. Now they're more fetishistic. . . . I think you have to continue what you want to do until you have no more energy to do that kind of thing."

- Creating drawings without marking implements, by folding and creasing.

- Recreating the chiaroscuro of old masters in drawings which are contemporary in character.

- Using perspective as a creative device.

- Making drawings in which *every* perspective precept is violated.

- Using written words *as* drawing.

- Using written words *in* drawing.

- Keeping a "visual diary" of every single day's experience for a week, a month, or a year.

- A scroll drawing on which you work every day, but do not look back upon until the end of the year.

- Realistic drawings in which all media are applied directly and only with the hands or fingers.

- Developing a means of delineating form through pure chance, such as a particular kind of line to be made on a certain throw of dice.

- Beginning a search for the "ideal" drawn figure.

With all the ideas that you can develop from each of the above, you have enough to keep going for years. *The choices are yours and yours alone.*

### Eye Series—A Case Study

When objects or ideas are overused in any area of human endeavor, there is a tendency for them to become trite. The human eye is a case in point. Artists have used it in so many symbolic ways that it is now almost impossible to use it without creating a cliché. It is for this precise reason that one of my favorite assignments has been to create a series of drawings based on the human eye.

The seven drawings by **Riki Tannanbaum** illustrate how one student progressed in exploring the form possibilities of the human eye. Notice how each idea seemed to grow out of the preceding one, and how the effect of having changed material, in this case beginning to use water with the chalk in the third drawing, had a profound effect on the emergent form. The last drawing in this series was developed to the point where the drawing was actually about the effect of water and chalk mixed together in a drawing.

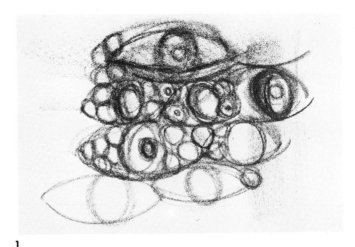

1

2

3

**4**

**5**

**6**

**7**

*Through a series of creative leaps from one drawing to the next, this student has responded to both the subject of eyes and the manipulation of her art materials to arrive at dynamic and unique solutions to a subject that could easily have become trite. Eye Series Nos. 1 to 7 by Riki Tannanbaum. Nos. 1 and 2 black chalk on paper; Nos. 3 to 7 black chalk and water on paper.*

## Probing the Psyche—Quasi-automatic Drawings

The great contemporary French artist Jean Dubuffet **(Figure 8.8)** claimed that ". . . only what grows naturally and is projected spontaneously from within the psychic depth of the artist can be considered valid as original form; all else remains tainted or distorted. . . ." (Roger Cardinal, *Outsider Art*. New York: Praeger, 1972, p. 29.) Whether or not you agree with this statement, artists have been probing their unconscious in search of artistic form for years. I suggest that you try to do likewise through a series of "automatic" drawings.

The idea behind doing automatic drawings is to try to forget everything you have ever learned about drawing and begin to make marks **(Figure 6.4)**. What kind of marks? *Don't think* about it, just make them! After you have made a few marks, let your inner self react (in effect, "listen" to what the marks "are begging for") and make whatever others seem appropriate and necessary. Whenever it "feels right," go on to your next drawing. It is not easy to achieve this sort of abandon since most people are probably working in art because of the praise they have received in the past for conforming to the narrow, primarily academic concepts accepted by the culture at large.

Automatic drawings generally start out as abstract marks, but if they begin to suggest "real" images, you might want to *flow* with these suggestions. When you react in this manner, it is perhaps more appropriate to call your drawing process "quasi-automatic." However, the very nature and premise of automatic drawing makes it impossible to tell whether or not another person is proceeding in an appropriate fashion. When it is right for you, you will *feel* it.

### Frottage Series—A Case Study

Frottage is a technique of transferring the texture of a given surface to paper by rubbing over it with some material; in this case, graphite. You have probably done this with coins: Haven't you placed a penny under a paper, rubbed it with a pencil to see Abraham Lincoln appear as if by magic? A student of mine recently decided to explore the reproduction of textural patterns and objects on watercolor paper using frottage and rubbing techniques. Before starting, he stated: "I plan to complete 16 texture studies, each one measuring 32" × 24" (81 × 61 cm). They will be joined to form a 16' × 5'4" (4.8 × 1.6 m) drawing. Each unit will be different, but each will contain the grain pattern of an oak plank as a unifying element." Because no one modern artist has used frottage to the extent that the Dada and Surrealist painter Max Ernst has, the student began by reading about half a dozen books devoted to Ernst. Then he proceeded to work.

It is important for you to visualize the wooden plank to appreciate what the student did with it. The plank, except for an obvious grain, measured about 4' (1.2 m) in length and was completely without visual interest. It had been lying around the drawing studio for some time and on the first day of class he asked if he might use it. Anyone could have simply rubbed the plank and recorded the grain—but see what he has done with it! He has literally twisted it about itself to form knots! An amazing achievement. The density and clarity of the rubbing was never to his satisfaction and he had to "draw back" into every inch of it. You can also discern parts of a birdcage, a pulley and hook as well as some other objects and textures. "A man possessed" is the only way to describe his commitment for the next three weeks. Since he was determined to finish it during the workshop, he worked for four hours in class each day and about four hours each night. The final work was a prodigious and monumental achievement! (See the series of 12 panels by **Thomas Fitzpatrick**.)

**6.4** *Alfonso Ossorio (Contemporary American). The Garden, 1952. Ink, wax, and watercolor on paper, 39⅞" × 26⅛" (101 × 66 cm). New York University Art Collection, Grey Art Gallery and Study Center, New York, Anonymous Gift. Photo: Charles Uht.*

*Ossorio committed himself to art at age 14. He gradually developed a proclivity for the art of the Surrealists and his own work reflected this interest. (Ossorio was friends with both Jackson Pollack and Jean Dubuffet **(Figure 8.5)**, and all three artists mutually influenced each other.) In his mature phase, he created works that were "accumulations" of actual objects (with glass eyes being a compulsive favorite) glued onto the work. Just as his "accumulations" were the result of chance or automatic (unconscious) juxtapositions, he also produced works on paper that were the result of automatic or accidental forms and compositions caused by his movements and the effect of one material acting with or against another. In this case, he seems to have brushed the paper with wax which repelled the subsequent washes of watercolor. While the paper was still wet, he drew into it with ink, which dispersed in random patterns throughout the work. The work is not structured in the traditional architectural sense of the word; it is an all-over pattern which appears as though it could go on forever. This kind of composition is sometimes referred to as "field painting."*

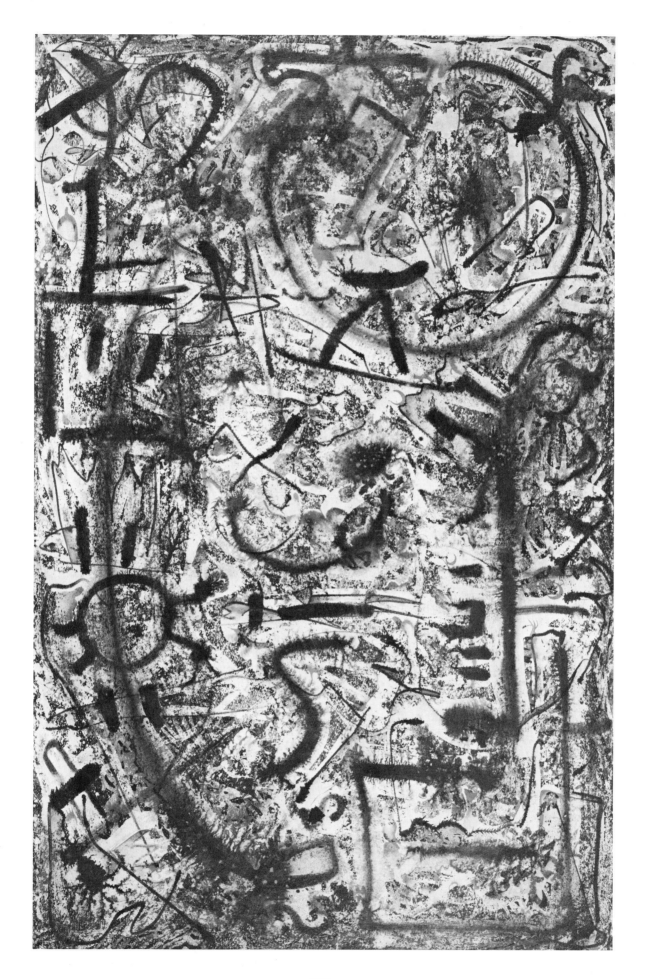

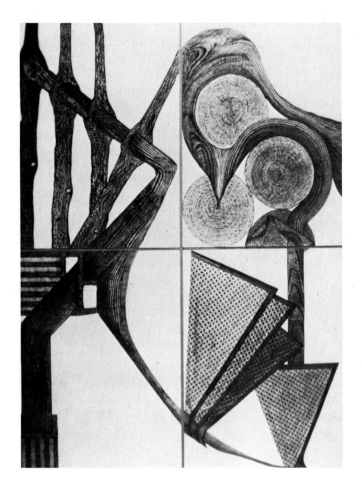

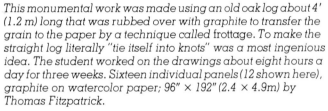

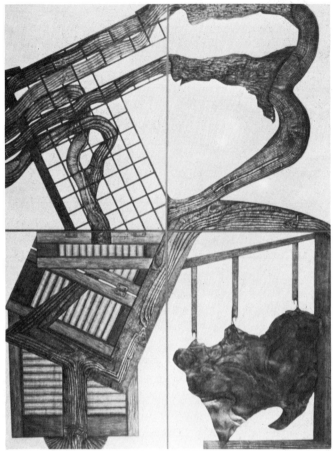

This monumental work was made using an old oak log about 4' (1.2 m) long that was rubbed over with graphite to transfer the grain to the paper by a technique called frottage. To make the straight log literally "tie itself into knots" was a most ingenious idea. The student worked on the drawings about eight hours a day for three weeks. Sixteen individual panels (12 shown here), graphite on watercolor paper; 96" × 192" (2.4 × 4.9m) by Thomas Fitzpatrick.

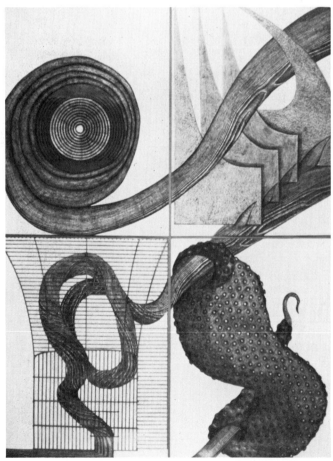

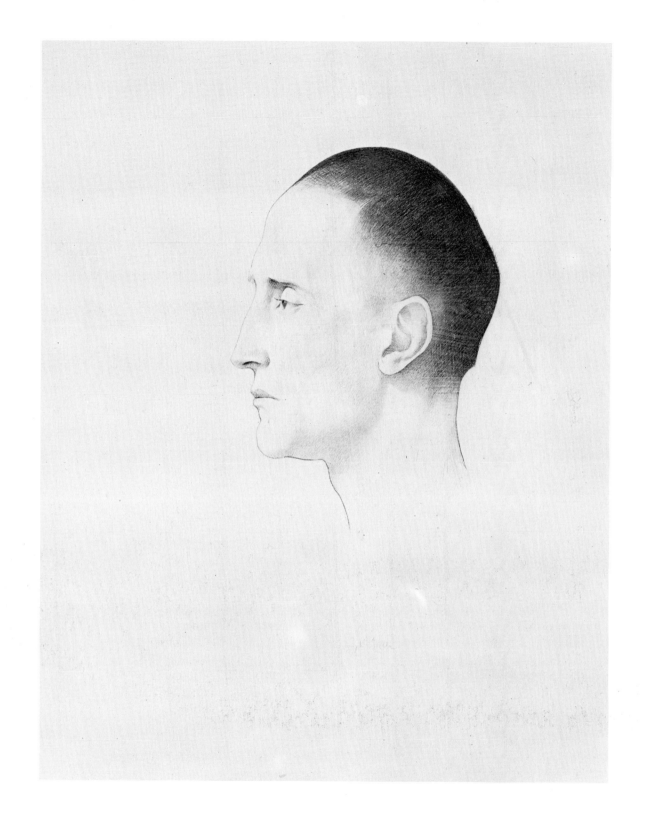

**6.5** *Joseph Stella* (American, 1877–1946). Portrait of Marcel Duchamp, c. 1920. Silverpoint, 27¼" × 21" (69 × 53 cm). Collection *The Museum of Modern Art, New York, The Katherine S. Dreir Bequest.*

This drawing should be compared with the other one of Marcel Duchamp by Jean Crotti on the following page. The point is that two very talented artists can arrive at portraits of the same individual which have such an astounding difference in appearance. It is impossible to say that one is better than the other; they are simply different. Silverpoint drawings such as this one are made with a piece of silver wire, ground to a point and used to make marks on a paper prepared with a gesso surface. Silverpoint is difficult to work with since it cannot be erased, but it produces a delicate line that was much favored by old masters. The head is sharply delineated with very slight modeling on all of the features except the ear, which is the most developed area of the drawing. The head is a self-contained composition that relates to the page only at the base of the neck, where the neck and ground have become one and the same thing. Evoking a rather eerie quality, this is one of the "tightest" drawings in this book.

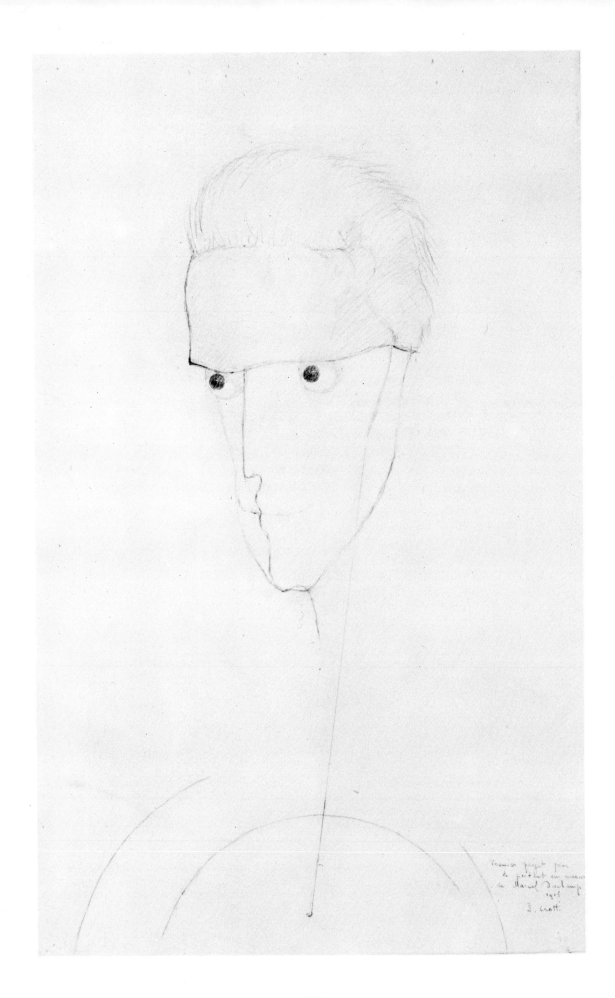

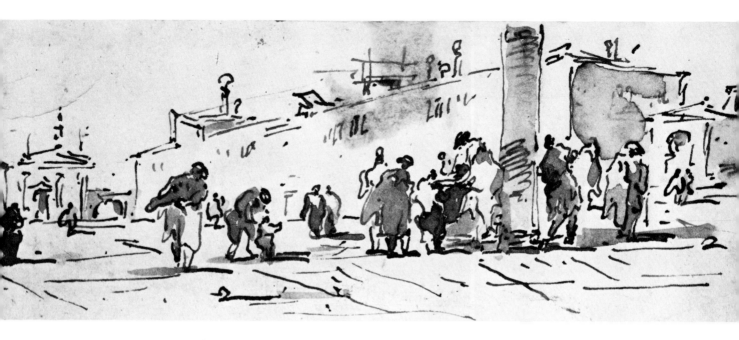

**6.7 Francesco Guardi** (Italian, 1712–1793). A Venetian Scene. Pen and sepia wash, 2¹⁵/₁₆″ × 7⅝″ (74 × 193 mm). Collection Fogg Art Museum, Harvard University, Cambridge, Mass., Bequest of Charles Loeser.

Guardi was quite obsessed with the city of Venice and spent most of his life producing hundreds of drawings and paintings depicting scenes and events from the everyday life of his people (called "genre painting"). His economy of means was incredible. Note how few improvisational and spontaneous lines and tones he has used to indicate this most complex scene! It seems impossible to indicate intricately ornate buildings with so few lines. Which figures organize as a group because of similarity in their size? What is the function of the small dark figure on the far left? What makes that "blob" read as a figure? Can you count the figures? What has he done to prevent the column from leading our eye right out of the picture? Why did he use such an unusual format? It is not easy to make such a tiny drawing take on the look of monumentality!

**6.6** (Left)  **Jean Crotti** (French 1878–1958). (Portrait of) Marcel Duchamp, 1915. Pencil, 21½″ × 13½″ (55 × 34 cm). Collection The Museum of Modern Art, New York, Purchase.

Compare this drawing with the Joseph Stella drawing on the preceding page. Duchamp was Crotti's friend and brother-in-law. A member of the New York Dada movement, Crotti soon quit because he disliked the destructive and negative aspects of it. This is a drawing for a wire sculpture of Duchamp's which has since been lost. At the time, the sculpture was received with ridicule, to which Crotti responded: "It is an absolute expression of my idea of Marcel Duchamp. Not my idea of how he looks, so much as my appreciation of the amicable character that he IS. How may such an appreciation be resolved without making it conventional and commonplace? . . . I have completed the lower part of the face in bent wire outline. This is pure detached drawing, in its way." (Dickran Tashjian, Skyscraper Primitives. Middletown, Conn.: Wesleyan University Press, 1975, Note 24, p. 249.) The original wire sculpture included a mass of wire hair, a fabric brow, and false optician's eyes. The possibilities of making drawings out of wire in real three-dimensional space are limitless, and I suggest that you try it!

## Self-Portraits Repeated—Again and Again and Again

The scope of subjects artists have probed deeply and with unrelenting compulsion would seem to know no limit. One of the most popular has been the self-portrait. Since most artists are interested in not only the visual but also the psychological and social aspects of mankind, it is only natural that many are attracted to images of themselves. More pragmatically, we might conclude that the abundance of self-portraits exists because the artist's face is always ready and available on an instant's notice!

Rembrandt's hundreds of self-portraits are fairly familiar to most everyone. It seems that he never tired of probing ever more deeply into his psyche to better know and represent himself. Students who become frustrated at their inability to catch an exact likeness in their portrait work will be relieved after observing a group of portraits from any single period of Rembrandt's career—they're all so different! What *did* he look like? Are the differences due to his lack of ability? Is it possible to create an exact likeness? Is it desirable? "What, indeed, *is* the purpose of a portrait?" is the question you should keep in mind.

Study the range of form by artists who were intrigued with self-portraits, such as Egon Schiele (**Figure 2.3**), Max Beckmann, Courbet, van Gogh, or Oscar Kokoschka. Not only is it interesting to see how differently artists see themselves at various times, but it is also fascinating to see how different artists choose to represent the same sitter. Is it possible to say whether the drawing of Duchamp by Joseph Stella (**Figure 6.5**) is more accurate than the one by Jean Crotti (**Figure 6.6**)?

### Creative Leaps—A Case Study

For student **Robin McKinney,** the move from the original and uninspired photograph to the final image (see pages 131–2) represented a "creative leap" which might seem unfathomable. How ever did she get there?

The initial class assignment was to produce a rendering of a photograph using a distorted grid (explained in Chapter 5). The first drawing on the page was the result of that assignment. At this point, I suggested that the class create a series based on this rendering. So Ms. McKinney then took her work to a Copy Center and had a number of photocopy prints made. (The use of the photocopier is described in greater detail in Chapter 8). The second drawing shown was based on one of the photocopies that she worked over with pencils and gold and red acrylic paint. In the third drawing shown, the student made a collage by cutting out the negative space under the right arm from six copies of the second drawing. She then worked into it with colored pencils to create an image of pantyhose! Then using that same basic negative shape, but flipping it over and adding red, white, and blue stripes plus a pencil rendering of a navel, the student now suggested a female torso! Can you imagine what might have happened if she had pushed the series another dozen steps?

There's so much to do. Why don't you set this book down for a while and get started . . . .

*This is the squared-off photograph the student used to create the next four drawings.*

*Opposite page*
*(Top left) The student used a distorted grid to achieve these fascinating distortions in the first drawing in this series (see Chapter 5). Pencil drawing by Robin McKinney.*
*(Top right) This is a photocopy of the first drawing, with graphite, gold, and red pencil and acrylic paint worked into it. Drawing by Robin McKinney.*
*(Bottom left) The student cut out the negative space under the right arm of six photocopies of the first drawing, pasted them down into a new configuration, and drew into them with colored pencils. Photocopy collage with colored pencils by Robin McKinney.*
*(Bottom right) By again taking the negative space under the right arm of the first drawn figure, flipping it, adding stripes and a rendering of a navel, the student has suggested a female torso—a tremendous "creative leap" from the original photograph. It is unlikely that she would have arrived at this image if she had not been working in a series. Photocopy collage with graphite and red, white, and blue pencils by Robin McKinney.*

NEW ALLSHEER PANTYHOSE IN SIX SEXY SHADES

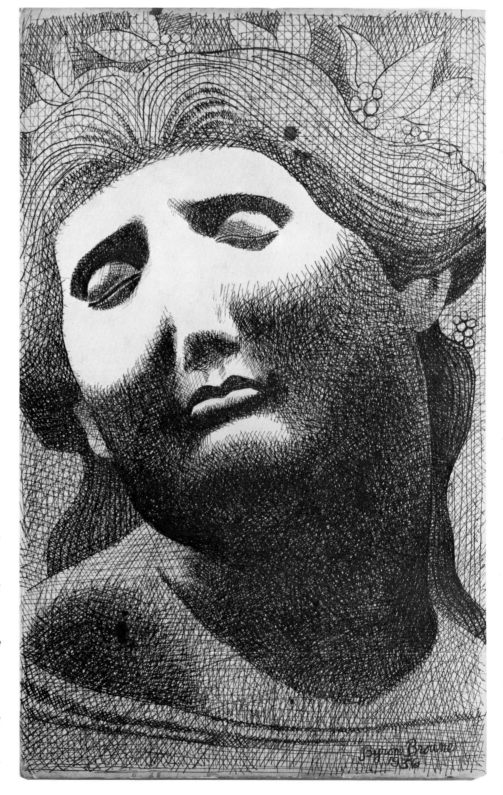

**7.1 Byron Browne** *(American, 1907–1961).* Homage to Michelangelo, 1936. *Ink on paper, 22″ × 13¾″ (56 × 35 cm). Courtesy Washburn Gallery, New York. Photo: Geoffrey Clements.*

*Out of admiration and respect for the influence of an artist who died 372 years before the creation of this drawing, Browne has entitled this powerful drawing* Homage to Michelangelo. *The head has a classical countenance and the cross-hatching almost seems to carve the forms out of the page. The face is lit from above and halftones are eliminated to achieve the dramatic contrast of light and dark. The chin and side of the face are enveloped in the dark tone to the point where they disappear. Notice how the cross-hatching in the hair extends into the flowery background, relating the two planes and making it all subordinate to the strong light. By bleeding the hair at each edge of the page, the negative shapes are simplified and the scale of the head appears larger than its actual size. Almost all detail has been eliminated in deference to the formal aspects of the total work.*

# Old and Modern Masters
## Appreciated and Exploited

*"Every intelligent painter carries the whole culture of modern painting in his head. It is his real subject, of which everything he paints is both an homage and a critique."*

Robert Motherwell, *The New York Times*, June 19, 1977.

*"Whatever else art is good for, its chief effectiveness lies in propagating more art. Or: Of all the things art has an impact on, art is the most susceptible and responsive. All art is infested by other art."*

Leo Steinberg, quoted in *Art About Art* by Jean Lipman and Richard Marshall. New York: E.P. Dutton, 1978 (paperback), p. 9.

Incredible! A few short years ago I attended a conference where one of our foremost art educators spoke *against* exhibiting reproductions of old or modern masters in art classrooms. He was afraid that they would have a *negative* influence on students by inhibiting their own creative/expressive potential. As ridiculous as this sounds now, I do believe that it is healthy to have artist-teachers who are passionately committed to the left and right sides of the teaching spectrum debate, discuss, and argue their respective positions. It has always been my belief that the more art that students are exposed to, the better off they are. Nonetheless, I was very slow in coming to the point where I had students work directly or indirectly from master works.

One day a student having grave difficulties in drawing the nostrils of the nose, asked for my assistance. I showed her how I approach drawing that particular form and, then and there, it occurred to me that what I was showing her was my synthesis of all of the master drawings of noses I had experienced! Artists have always learned from those masters who preceded them **(Figure 7.1)**. I had taken her very close to the model and pointed out the structure of this difficult feature, and still she had difficulties. But as soon as she *watched* me draw my particular symbol or schema (basic modes of representing specific objects or features over and over again until something, a feeling or emotion, intervenes which demands that we adapt the schema to the new expressive or pictorial demands) for nostrils, her frustration was immediately alleviated and she was able to draw a rather convincing face. Eureka!

I realized at this moment that all of my basic approaches to drawing people, features, objects, trees, and most everything else was derived from one of two sources; either old masters or comic books! Almost every artist I have talked to over the years copied comics as a youngster! Don't misunderstand me—I am not advocating that you and other art students across the country stop producing your own creative/expressive work and start copying comics and masters.

But on the other hand, to ignore all of the lessons available to us from old and modern masters is nothing less than stupid! We must begin *somewhere*. I suggest to my students that if they want to be truly original and free from any artistic influences that they would have to revert back to the state of the caveman before he first recognized his footprints in the sand and proceeded to consciously duplicate that mark. Imagine his excitement at discovering that he could *make marks!*

I firmly believe that most art is born from art. You don't see a beautiful scene and then decide to become an artist in order to paint it. No, no, no! You see a *painting* of a beautiful scene, and you are astounded at this appearance of a *reality* that you've looked at many times but had never seen until your complete and total identification with this particular *illusion*. It is at this point that you look around and see other scenes that might become the motif for an artistic statement. (See student drawing by **Karina Cravat**.)

If you are interested in knowing more about the way in which people develop their artistic symbols or schema from comics, masters, or their peers, I suggest reading an article by Brent and Marjorie Wilson called "An Iconoclastic View of the Imagery Sources in the Drawings of Young People" (*Art Education*, January 1977, vol. 30, no. 1, pp. 5ff). Through research methodology, the Wilsons arrived at conclusions similar to those I've been struggling intuitively with for years. Did you know that Michelangelo at age 14 was copying Masaccio **(Figure 7.2)**? That Pisanello made copies after ancient reliefs? That Rubens copied Leonardo? That Watteau made studies after Veronese, Rubens, and Titian? That Degas made copies after Pontormo? That Raphael once used a "free" version copy after Donatello in his own work? That Francis Bacon did a copy after van Gogh that van Gogh himself had copied from Millet? Or that probably no one has copied prior art as much as Picasso?

It is now time to suggest some ways you might approach master works not only to increase your own ability as a draughtsman, but also to make creative, *contemporary* drawings by exploiting them.

### Selecting Masters to Copy
There is no valid criteria to tell you or anyone else how to choose an old or modern master from whom to work. There are two approaches, however, that may be helpful and prove beneficial to your artistic growth:

• You might try all of the problems in this chapter and work from a single master so that you get to know him in depth.

• You might choose a different master for each and every

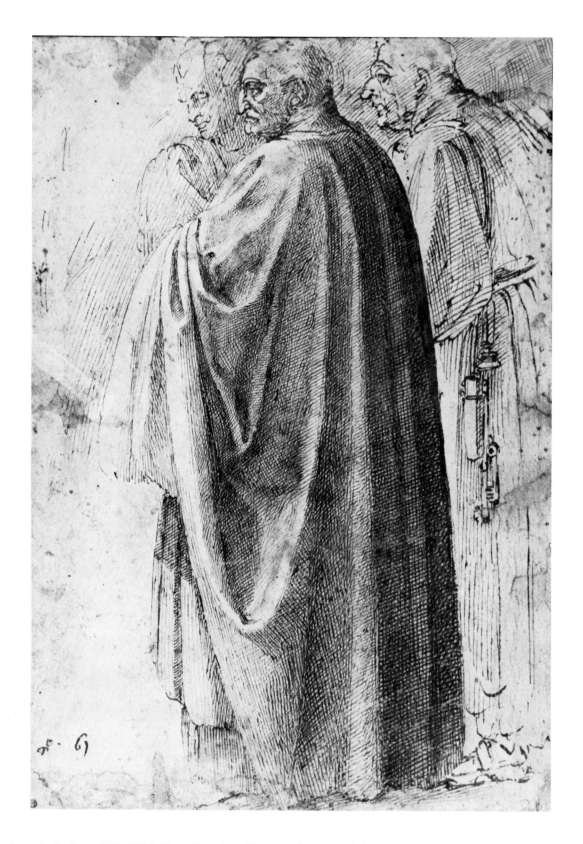

**7.2 Michelangelo** *(Italian, 1475–1564). Three Standing Men in Profile to the Left. Pen and ink, 11½" × 7⅞" (29.4 × 20.1 cm). Courtesy Albertina Museum, Vienna.*

It is believed that this imposing work was copied from a lost fresco by Masaccio when Michelangelo was about 14 years old! At this time in his life he also did a lot of copying after Giotto. Compared to the outer figures, the one in the middle is drawn in a very tight manner. The cross-hatching is somewhat similar at this time to his teacher Ghirlandaio, and he almost seems to be

"sculpting" the forms with the pen-and-ink hatching. Notice how the colonnades of drapery catch a highlight on one side, then cast a shadow on the opposite side. Despite the fact that he was copying and was strongly influenced by his teacher, the genius of Michelangelo is already obvious. Compare this drawing with the other Michelangelo **(Figure 1.2),** which was believed to be the last one he created. If you find this performance a little threatening, remember that van Gogh didn't start to paint until he was 27, and Dubuffet until he was 40!

drawing, thus encountering a much broader range of expressive/artistic means. It may also be advantageous if, on occasion, you choose a master or work you are not particularly fond of. This kind of study and exposure may be just enough to give you a "taste" for it (most people hate their first taste of an olive), thus extending your general art appreciation.

## Exact Copies

If the best way to develop a symbol or schema for drawing is to study the way others have worked out these problems, there can be no doubt that the best source for this information is both old and modern masters. The problem that I am suggesting is to find a master drawing and, through careful study of it, try to copy the picture in a manner as nearly like that of the master as possible (**Figure 7.3**). Before you start to draw, spend a considerable amount of time just looking at the drawing. Try to analyze as much about it as you can:

• How do you think he initiated the work?

• Were his initial marks in the same medium as the finished drawing? Why or why not?

• Did he erase to correct forms or did he let his mistakes show?

• Were his initial gestures a mistake or an integral part of the finished drawing? Would the drawing be as good without them?

• Were his movements fast, slow, or hesitant, or were they a combination of these? Can you tell which are which?

• Are there many "garbage" lines, lines that seem extraneous to the major thrust of the work or lines that, if removed, would not be significant to the finished work?

• How much pressure do you think he applied to his drawing implement in various passages of the work?

• Was the drawing produced on smooth, rough, absorbent, or non-absorbent paper?

• What size is the original, as opposed to the reproduction you are studying? What effect does this change in scale have on the marks you are studying and those you will be making to duplicate them?

• Why did he use both tone and line to define forms in one area, and only one of these elements in other areas?

• What must his creative/thinking processes have been like as he was executing the work?

• What mood was he in?

All of the above are some of the questions which you should think about before beginning your copy. Certainly many of them will become clearer as you proceed in this difficult endeavor.

In duplicating a master work, you can't hope to achieve a content that reads anything other than superficially similar to the original because there are vast differences between your motives and relationships to the subject and those of the master. For the master, the

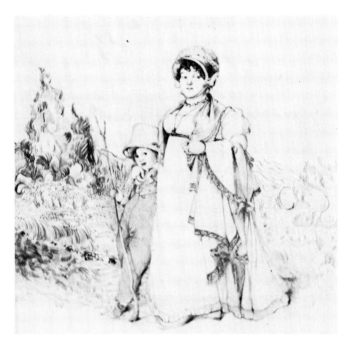

*This student was almost addicted to the drawings of Ingres. In this copy after the master, she placed the figures in a landscape copied from van Gogh. The two work together surprisingly well, considering the disparate techniques of the two masters. Pencil drawing by Karina Cravat.*

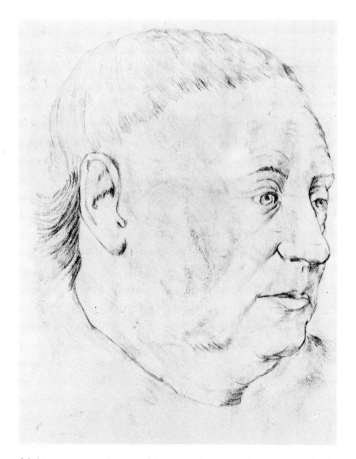

*Making a copy after an old master forces a student to study the way he constructed such details as eyes, lips, and nose. This close observation helps to enrich the student's own "sign" or schema for representing these and other body parts. Charcoal copy by Nancy Dresner.*

137

subject of the work was the object, scene, or person from which he was working—more than likely he stood before his subject and related to it on a one-to-one basis. Thus he was able to establish an empathetic or compassionate relationship that both guided, tempered, and informed each and every stroke, mark, and expressive and artistic decision he made. On the other hand, your subject is the master's *drawing*, in and of itself. That is why there is no way you can truly reproduce the master's work in any manner but a superficial one (though this is useful for your general artistic growth). This is not to say that you cannot have empathy and compassion with the drawing, for you must if you are to realize any of the benefits of this problem. But the circumstances *are different*, and it is important for you to realize this.

If your early copies are not very close to the original (reproduction), do not despair. You will still derive many benefits from the artistic and intellectual processes involved. The end product, after all, is nothing more or less than a facile (or not so facile) copy of a work of art. That copy, however, will help you to be better informed and equipped to produce your own work through that incredible process, the experience of drawing! (See drawing by **Nancy Dresner.**)

A few final thoughts about producing "exact" copies: It is possible to sign your own name to the work, but to acknowledge that 95 percent of what is viewed is by someone else, you should also state on the front of the work "After Rubens" or whichever master it may be. Finally, in making exact copies, it is proper form to always produce copies in both size and proportions different from the original.

## Copies "In the Manner of . . ."
Unlike the previous problem, where master drawings were used in a tight fashion to make exact copies of a particular artist's work, this problem will entail a looser, more relaxed approach to copying his work (**Figure 7.4**).

Before starting to draw, study the work and ask yourself the same questions I suggested previously in making exact copies. Then, after having spent considerable time analyzing the work in this fashion, and using the master reproduction as a motif, make a drawing of it, attempting to reproduce the master's original attitude and approach. (See drawing by **Heleen Maitland**). In other words, rather than copying Rembrandt, try to *become* Rembrandt and perform in ways that he would. The results shouldn't be a stroke-for-stroke duplication, but they should certainly be inundated with the flavor of the master.

Very often when I see a student who appears hesitant and overly cautious in his own drawing mode, I suggest that he pretend he is Matisse and draw with a similar kind of confidence in both himself and in each and every mark he produces. (See the series of drawings by **Ann Helaine Jahren.**) I believe that this kind of role-playing can become a very important part of your education in becoming an artist. I don't know of anyone in the visual arts, including myself, who has sufficiently exploited this possibility. The parallels with acting, where role-playing is a basic means of discovering an actor's own acting identity, are fairly obvious.

*After a careful study of the great French master Claude Lorraine, this student produced a whole series of works "in the manner of" the master. She became much more aware of the shape of her brushstrokes and the use of the untouched paper to indicate figure and ground. Sepia ink and brush drawing with touch of chalk by Heleen Maitland.*

**7.3  Copy after Jacopo Pontormo** *(Italian, 16th century). Sibyl (recto). Red crayon on buff paper, 11¼" × 8⅛" (28.6 × 20.6 cm). Courtesy Fogg Art Museum, Harvard University, Cambridge, Mass., Bequest of Charles Loeser.*

*Pontormo was a magnificent Renaissance draughtsman and this is probably a copy by one of his students. The style and "handwriting" of the master has been duplicated with an unusual degree of fidelity. Throughout history, artists have learned from their predecessors and during this period of time it was customary for artists to learn their craft by apprenticing themselves to a master. The underdrawing and search for just the right line as in the shoulder and leg gives the viewer an opportunity to reconstruct the very process that gradually brought the work to its final conclusion. Is it possible that you have been too consciously avoiding construction lines and "mistakes" in your own work, thus robbing them of their vitality?*

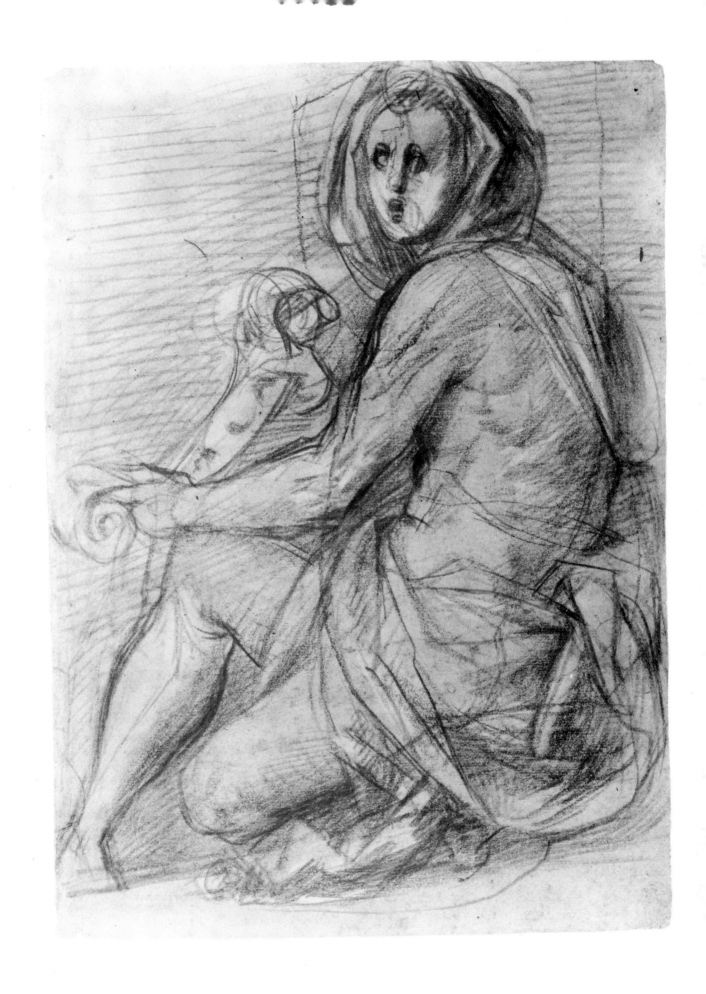

**7.4  Rembrandt van Rijn** (Dutch, 1606–1669). After Leonardo's The Last Supper, 1635. Red chalk, 14" × 18¼" (36 × 46 cm). The Metropolitan Museum of Art, New York, Robert Lehman Collection, 1975.

"Rembrandt was both a collector and a great copyist of works of art. This sketch was based on a feeble Milanese engraving after Leonardo's fresco. . . . Rembrandt first made a rather careful copy, which he then went over in bolder and heavier strokes of the chalk. The earlier version is clearly visible, for example, in the figure of Christ. The two main features of Leonardo's masterpiece that must have attracted Rembrandt were the brilliance of the composition, with the twelve Disciples arranged in four groups of three, and the variety of the gestures and expressions. . . . He has modified Leonardo's strict symmetry by introducing an off-center canopy behind the figures, more in keeping with seventeenth-century principles of Baroque design." (Keith Roberts, Rembrandt Master Drawings. New York: E.P. Dutton, 1976, p. 11.)

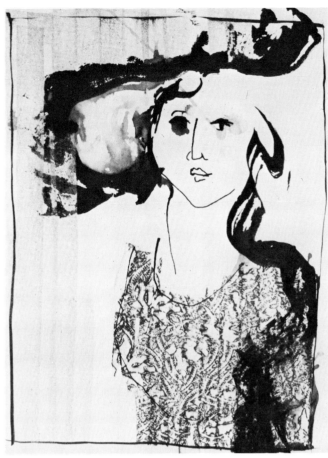

This student made a careful study of Matisse, then produced this series of drawings using a variety of materials. Each drawing moved further and further away from the original, although the simplification of form paralleled the way Matisse often worked from a particular motif. The first drawing is in charcoal; the second in ink, chalk, and frottage (see discussion of frottage in Chapter 6); and the third drawing in ink and watercolor. Series of drawings by Ann Helaine Jahren.

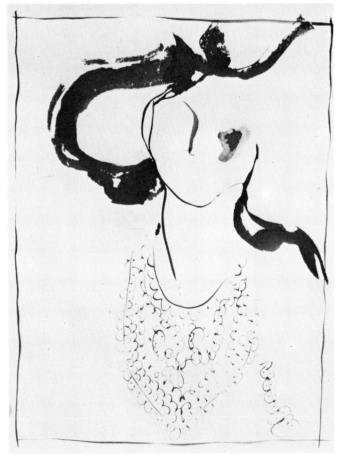

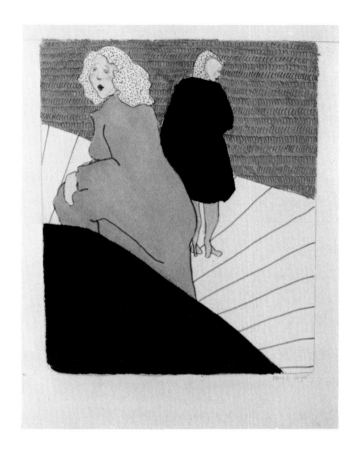

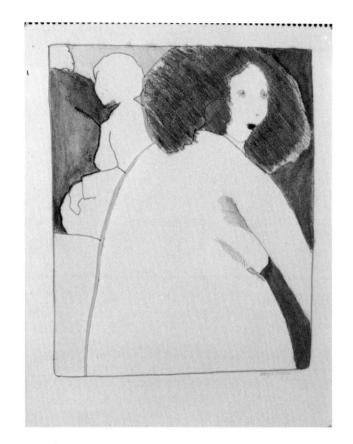

(Above) Just as Toulouse-Lautrec studied and was influenced by Oriental prints, the positioning of figures in the composition and the treatment of space with large flat planes was produced by this student after a careful study of Lautrec's work. Mixed media and collage-drawings by Mary Dwyer.

(Right) Dürer's Awake in the Wastelands provided the compositional motif for this imaginative fantasy of the student's own invention and also provided the inspiration to extend her "normal" parameter of pen technique. Drawing by Debra Hull.

## Originals "In the Manner of . . ."

Here you have to create your own motif (such as a portrait or a still life) and execute it "in the manner" of a particular master. The approach, once again, is to study the master work, asking some of the questions outlined under "Exact Copies." For example, if you are going to produce a landscape, you'll attempt to achieve many of the compositional devices in your drawing that were used by the master you're emulating.

In addition to imitating spatial similarities, try to use a similar light and dark structure as well as similar line and textural qualities. (See **Mary Dwyer's** drawings based on Toulouse Lautrec.) It will be helpful to keep the master reproduction in sight as you work and refer to it as often as you would your own subject.

As in the preceding exercises, the purpose is not to cramp your own approach, style, or technique, but rather to provide you with greater depth of knowledge and experience on which you may draw in the future. Nothing says that you must accept or reject a particular master's mode of working. But once having tried it, whatever action you take will then be based on an informed opinion rather than on ignorance or lack of experience. (See student work by **Debra Hull.**)

Another useful approach to this exercise is to produce a number of drawings of the same subject, but based on a variety of disparate masters. For example, do a series on the same portrait "in the manner" of Degas, Dubuffet, Holbein, and Oskar Kokoschka!

## Copies Translated into Different Media

An impossible problem? Hooray, the very best kind! Yes, this problem is not only impossible to completely resolve, but it also may prove offensive to some purists in the visual arts who believe that form must always follow function and that the use of particular materials should be limited to those processes most appropriate to them. At one time I was a tyrannical believer in these propositions and, I confess, I still have affinities for the kind of expressive/creative integrity they imply. However, I have encountered too many exceptions to these propositions which "work" to remain a slave to them.

Here I am suggesting that you go back and repeat several of the prior problems in this chapter. But instead of working in the same material that was used by the old or modern master, you are now to select a *different* material. How in the world can you make a copy or work "in the manner of" with a different material and achieve any degree of success? You can and you can't. Exact copying is impossible, but success can be yours if in your attempt to duplicate the master's work, you discover ways and means of extending the normal range of possibilities of using the "foreign" material. You can't make a pen and ink drawing look like the original which was produced in charcoal; but, hopefully, your realization of the possibilities of pen and ink will be *extended* as you search for means of exploiting the medium beyond its usual limits. (See work by **Donna Esposito, Shelley Speiser, Pearl Joy Muller,** and **Jennifer Chotzinoff.**)

*Working from a drawing by Dürer, this student has repeated the original to see the effect of materials on form. Left to right: Steel pen and brown ink; pencil; bamboo pen and ink. Drawings by Pearl Joy Muller.*

An "impossible" problem is to attempt an exact copy of an old master, but translate it into a different medium. This forces you to extend a medium beyond its limitations. Leonardo's drawing was originally in ink; this one is in pencil. Drawing by Donna Esposito.

A chalk drawing by Rubens translated into pen and ink resulted in this strong copy. This forces students to look at the original more closely than they ever looked at a drawing previously. Pen drawing by Shelley Speiser.

"Impossible" problems are the ones that make you stretch your mind and your imagination, that provide a springboard for meaningful creative leaps. Stick with problems such as this one through the initial period of frustration, and the future rewards can be rich indeed!

## Facial Features by Old Masters—How Did They Do It?

In this project, you are to study the ways master artists drew particular facial features in order to further enrich your own schema or symbol for these features. You should *not* attempt to copy the entire facial features of a particular drawing, but rather select individual features to study. You are to relate these to your page and to each other in such a manner that your new compositions will be fresh and vital and able to stand up as successful drawings in their own right. (See the pencil drawing by **Gwen Marcus**.)

Spend a considerable amount of time looking at master drawings and determine which ones seem to provide the most information about particular features. Also, try to choose features that are drawn from a variety of angles—front, side, three-quarter—in order to discover how the master handles these problems. Look as thoroughly as possible! Notice how he drew the eyebrows, the thickness of the eyelids, the curve of the eyeball, the eyelashes, the nostrils, and the bridge of the nose. You will discover that different masters handle these problems in various ways, and you should attempt to discern the differences—and the similarities—between them. (See the work by **Jennifer Chotzinoff** on the following page.)

As you choose between various drawings, you may want to select some features that are very detailed and others where the artist used a "shorthand" effect to indicate more than he drew. For example, a single dot in relation to an eyebrow that may read as a complex, human eye! As you work, these aspects of the drawings will become even more evident to you. Don't worry about the unique quality of the artist's "handwriting" or his style in this project. You are not now trying to produce a facsimile Dürer or Degas. You are trying to see how they put lines and tones together to create these particular features. Don't hesitate to erase and redraw the forms if they are not satisfying to you. In order to create an interesting composition, you will have to be very aware of the negative spaces between the shapes, as well as the direction that's implied by the structural center of each feature. Scale is another area you might experiment with; some features might be drawn extremely large and others very tiny, creating unusual and absorbing spatial effects.

Even though you are copying old masters, this exercise will give you an incredible amount of leeway to exercise your own creative faculties.

## Update an Old Master—to 1998!

A Leonardo that looks like it was produced in 1998? Yes, at least something like that. To create a drawing *after* Leonardo that looks contemporary or avant garde is not *too* difficult, but to make it reach into the year 1998, I suppose, is asking for a bit too much. OK. Strive for that 1998 look, but let's both be happy if you simply create a

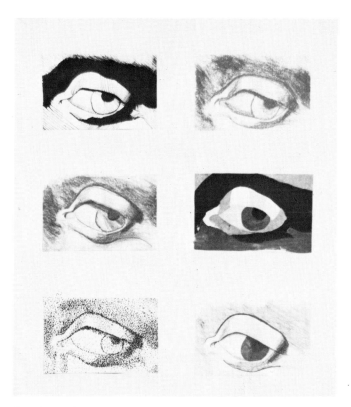

*Here's another example illustrating the effect of materials on artistic form, working from an old master. Left to right, top to bottom: ink; Conté pencil; collage; ink; pencil; watercolor. Drawings by Jennifer Chotzinoff.*

*This student was given the problem of creating an unusual and compelling composition at the same time that she studied how a variety of masters constructed their drawings of eyes. The result was this simple and elegant work. Pencil drawing by Gwen Marcus.*

*This strange image was created by using a composite of features from a wide range of masters: the shape of the face after Pisanello, the ear after Dürer, the neck and shoulders after Degas, the hat after Goya, one eye after Picasso and the other after Dürer, the nose after Michelangelo, and finally the lips after Dürer. Drawing by Jennifer Chotzinoff.*

highly original and contemporary work of art based on a Leonardo or whomever. The old or modern master should be one of your own choice but the problem remains the same.

It is difficult to suggest how you should tackle this problem since it is wide open to your personal interpretation. However, to get started, treat the master reproduction as though it were a still life or scene of your own choosing and proceed to react to it *in your own way*. It is the motif for *your* work, a point of departure, a jumping off place beyond which the possibilities are limitless and only dependent upon your own expressive/creative potential. (See update of Dürer by **Linda Braun**.)

It may also help if you think about your procedure as simply making "art about art." This, incidentally, was the name of an exhibition recently held at the Whitney Museum of American Art as well as the title of a book by Jean Lipman and Richard Marshall (see Bibliography). It will be worth your while to look this book up in your local library. Another variation on this general idea is to update an old master and incorporate the actual reproduction of the master in your finished work—a collage/drawing. (See work by **Susan Kare, Harriet Taub,** and **Mary Dwyer**.) It's not easy to incorporate this fragment of reality into the drawing without having it stick out like a sore thumb. (Needless to say, the master reproduction you cut out must be from your own books and magazines, not from library books!)

## Making an Old Master "Fit"

By this time you are certainly aware that a primary influence on any composition is the format or shape and scale of the page on which the drawing exists. As an exercise in both copying from masters as well as in making important compositional decisions, your problem at this time is to choose an old master and make it "fit" into a radically different format.

Thus, if the original is a rectangle, for instance, you may choose to make it fit into a tondo (circle), a triangle, an extended, or "stretched" rectangle, or perhaps into a format whose axis is opposite to the original, changing it, for example, from a horizontal to a vertical shape. This means that you will have to take great liberties in adding new elements, changing the direction of objects already in the picture, or other radical steps. (See **Kathy Albers'** tondo after Tintoretto.) Perhaps you will even want to further complicate the entire procedure by translating the black and white drawing into a full range of color! Colored pencils? Sure. Pastels? Why not? Make the whole thing life-size on mural paper? Great. Keep thinking *and* drawing!

## Copy Machines and Old Masters

The use of photocopiers or Xerox machines as a means of extending the possibilities of form in drawing is explained in considerable depth in Chapter 6. Just think about some of the possibilities of the photocopier in relation to the problems already set forth in this chapter!

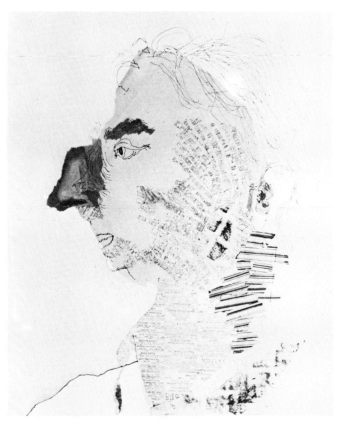

A section of the actual reproduction of Fra Angelico's fresco The Annunciation (c. 1440–1450) became an integral part of this student's take-off on an old master. It is difficult to make such different elements work in the same composition. Collage, pencil, and watercolor drawing by Susan Kare.

A work by Dürer was used by this student to create an image that's contemporary in its use of a combination of materials, as well as in its total content. An updated old master drawing by Linda Braun.

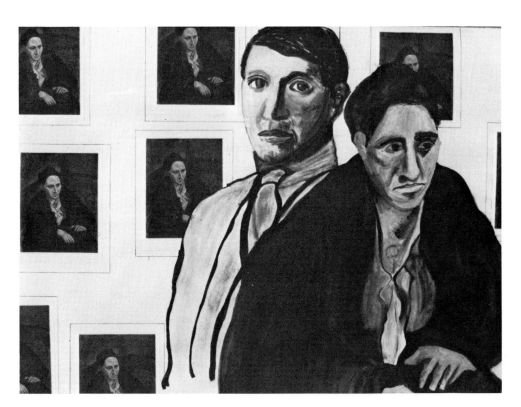

The problem here was to incorporate master reproductions into a new and contemporary work. Here reproductions of Picasso's portrait of Gertrude Stein, set as a background for a copy of the portrait, but the student also painted Picasso himself into the composition. Mixed media drawing by Harriet Taub.

A Bicentennial Mona. . . is the name student Mary Dwyer has given to this complex work. The mixed media used include a photocopy of the original collage elements, a portion of the original at the far right, pencil, and oil crayons. Is this a take-off on Leonardo? Or one on Duchamp, who earlier transformed the Mona Lisa by providing her with a mustache?

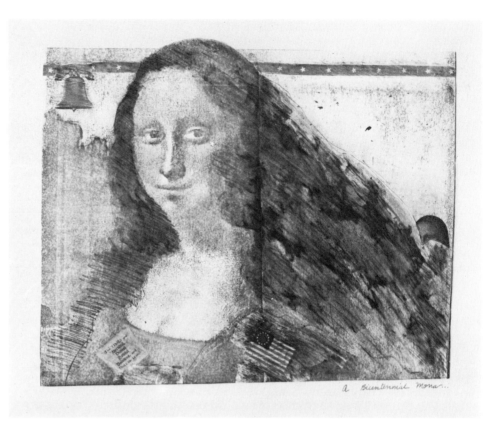

Taking a small detail from a Tintoretto drawing, this student has not only made the image seem to fit most naturally into the shape of a tondo, but she has also created an image that looks convincingly contemporary. Pastel and carbon pencils on blue tinted paper by Kathy Albers.

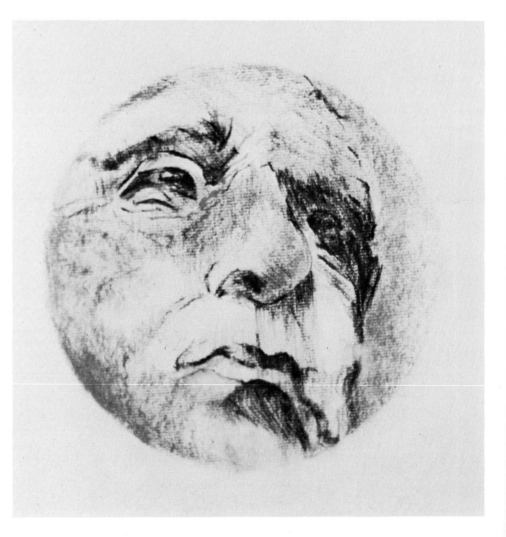

- You can make 20 or more copies of your drawing of an old master, and can then cut up and reassemble them —something that it would be difficult to do with the original.

- You can draw back into each of the 20 copies, then have copies made of them.

- You can have your black-and-white interpretations copied on a *color* copier, and suddenly have all the values translated into red, blue, or whatever color you decide.

The possibilities are limitless. If you don't believe it, just give it a try.

## Compositions Cropped from Master Drawings

In Chapter 5, I suggested using two *L* shapes to find new compositions in photographs. This process is called *cropping*. Instead of direct copies from master drawings, it is also an excellent idea to crop sections that you find particularly interesting and render these. In this process, it is not the overall composition or "attack" of the master drawing that you are studying, but simply tonal and linear details of the master's "handwriting." (See student work by **Kathryn Hellstrom.**) If you are working from a tonal drawing by an old master, it can also prove interesting to reverse the light and dark tones of the original. A light tone in the master drawing could be changed into a dark tone and vice versa.

Startling effects can also be obtained if you have a photostatic *enlargement* made of the original as well as a negative image, which would make all the tones read as white on a black ground. Photostats as a means of extending our ways to produce drawings are discussed in Chapter 8.

*After carefully studying a reproduction by Matisse (upper left), this student cropped a photograph and used it as the subject of this sensitive study (right). Students must eventually shed both the direct and indirect influences of masters and teachers in order to discover themselves. Pencil drawings by Kathryn Hellstrom.*

# Drawing Extended

Most artists and instructors would agree that drawing is the basis of all art, whether it is painting, sculpture, architecture, or whatever. But the variety of work going under the name of "drawing" makes it increasingly more difficult to define the term. Traditionally when artists spoke of drawing, they meant the simulation of objects, people, or events in the everyday world on a piece of paper, which is what the majority of students still have in mind when they take an art course to learn how to draw. But today, even though the old definition is still valid and is a pervasive one in our society, the restrictions imposed by that narrow definition have been challenged by the historical, sociological, psychological, and technological facts of life today.

Drawing as an act and as an end has many functions and its history is difficult, if not impossible, to separate from the general course of art history; and today, more than ever, the ramifications that 20th-century technology has had upon art (drawing) has made it inevitable that its forms would likewise change and extend themselves. That is precisely the point of this chapter. Just as modern painting and sculpture have evolved and *extended* their forms in radical ways, so too has drawing.

There are paintings being made today which are three-dimensional and sculpture which is *painted* with photographic likenesses or that may even be flat! Artists have been and are becoming more and more concerned with "happenings" and performance pieces in which it is difficult to decide if the event is visual art or theater **(Figure 8.1)**. *Boundaries and barriers are being broken!*

While most art teachers have continued to teach drawing according to precepts of the 19th century, the very nature of their discipline has changed and ex-

panded. To ignore this fact is to exist with your head in the sand. If you can accept the simple definition of drawing as "the making of marks with meaning" and if you will allow that there is no one way or any specific tools necessary for making marks, the work in this section, rather than seeming strange, will become for you exactly what it is: a result of art history, contemporary psychology and sociology, and the scientific and technological developments of modern man **(Figure 8.2)**.

In actuality, most of the work in this chapter is not *radically* contemporary. Some of it goes back to the turn of the century and earlier. It has been included here because most art instruction books rarely mention these works, let alone suggest you roll up your sleeves and, in your own way, see if you can extend the parameters and precepts of drawing.

## Time and Form

One of the most difficult preconceptions for students to break is that the longer you spend on a drawing, the better it will be. If you have already done a broad range of the problems in this book, you must realize by now that it is possible to spend 30 hours on a drawing and end up with a horrendous mess! On the other hand, it is possible that your best drawing to date was executed in a matter of seconds. The element of time is a profound factor in the development of artistic form, and in this section I am going to suggest a number of problems in which time is a primary element.

### Revolving Still Life

Set up a relatively simple still life so you can revolve the entire setup or so you can move completely around it. In this exercise, every five minutes, you will either turn the setup slightly or make a slight change in your own position. You may approach your drawing in many ways, but its final form should always reflect the fact that you or the setup have changed position every five minutes. (See drawing by **Joan Adelson**.) Here's a working sequence I often follow:

1. Start with a contour drawing and begin to think about how it would look if you took a double or triple exposure photograph of the setup using a Polaroid camera. We actually took photographs in several classes, and the results were better than other times when we failed to do so.

2. Attempt to erase about three-quarters of the contour lines. The "ghosts" will show and can become the crux of the work.

3. Begin to work a variety of tonal areas into the drawing.

**8.1 Christo** *(Contemporary American).* Whitney Museum of American Art Packed (Project for Whitney Museum, New York), *1971. Lithograph with collage (Edition: 7/100) 27⅞" x 21⅞" (71 × 56 cm). Collection Whitney Museum of American Art, New York. Gift of Mr. and Mrs. B.H. Friedman. Photo: Geoffrey Clements.*

*Among many other projects, some of which have taken him several years to realize, this conceptual artist has actually wrapped two miles of the Australian coastline. In this particular work, he envisions what the Whitney Museum would look like if he were able to wrap it! Beginning with an actual photograph of the Whitney, he has stapled paper, cord, and cellophane on top of the photograph; drawn shadows on top of the collage materials; and then using photographic reproduction means, he has turned the whole thing into a color lithograph. Along with many other contemporary artists, Christo has extended our concept of drawing beyond the usual pen, pencil, and charcoal of the past. Is this a photograph, a collage, a drawing, a working plan, a lithograph or an independent work of art?`*

*A relatively simple still life was set up and as the students drew from it, the whole thing was rotated slightly about every five minutes. They had to constantly adapt their drawing to each new angle the setup presented. The results are often comparable to a photographic double or triple exposure. Carbon pencil drawing by Joan Adelson.*

**8.2** *Jochen Seidel (German, 1924–1971). Standing Nude, 1961. Pencil, 34" x 24⅛" (86 × 61 cm). Collection The Museum of Modern Art, New York, Gift of Mr. and Mrs. Walter Bareiss.*

*Asked what the subject of this drawing is, you might respond in several ways. Perhaps the first answer to come to mind would be that it is a drawing of a woman. The second response might well be that it is a drawing of movement, of a woman moving. Another might be that it is an attempt to fuse or relate the figure to the background. All of these responses are either more or less acceptable, but I am inclined to think that the prime subject of this work is the act of erasing! It would appear that Seidel made dozens upon dozens of marks in relationship to the pose very rapidly and then, using his eraser, went back over the marks, erasing into them—almost "carving" into them with his eraser to modify their contours, their tones, their textures, and their relationship to one another and to the space surrounding the figure. He may have repeated this process several times and while doing so he also established the direction of planes with both the pencil and the eraser. Seidel had strong anti-establishment views and didn't seem to care about his lack of economic success and material impoverishment. He would find discarded lumber for his stretchers and then proceed to paint one painting over another again and again.*

4. Add one or two arbitrary spots of collage material that don't seem to "fit" into the evolving form. (This helps to shake up any too-precious preconceptions that may be taking charge of the process.)

5. Change the form in whatever ways are necessary to make it and the collage work together as an integrated or harmonious whole.

6. Try adding a few spots of color without upsetting the delicate balance of the work.

### Mark, Mark, Mark . . .

Using chalk or charcoal and working as rapidly as you can, counting out loud, make 500 (or any other pre-determined number) short marks that reflect the pose of a model or a still life. Keep your eyes on the subject during the entire process. When you are finished, look at your page and try to think of it as a large piece of clay to be modeled and carved into. You are, in effect, trying to re-establish a greater affinity with the original motif by erasing into the tones and re-drawing areas as you see fit. Do not strive for photographic realism. This drawing is expressionistic—a result of the process and your total involvement in it. (See work by **Heleen Maitland**.)

### Blindfolded Time and Form Drawings

The object here, as in the Robert Morris drawing (**Figure 8.3**), is to set up some kind of problem for yourself which has to be executed within a certain period of time. A variety of materials may be used, and you are to keep your eyes shut or wear a blindfold during the actual execution. Before starting you might want to write the actual problem as well as the amount of time you execute it in directly on the drawing paper. Here are a few examples to get you started:

• In two minutes, make 200 1" (25 mm) vertical lines in the middle of the paper which will create a 3" (75 mm) square. The resulting form is a result of the problem/process, and you should be ready to accept the results without "doctoring" it after seeing the final product.

• In three minutes (or whatever time you choose), create a series of 6" (15 cm) horizontal lines down the center of the page with a ⅛" (3 mm) space separating them.

• Create a tone that will be jet black in the center and range through lighter values to white at the perimeters of the page in ten minutes.

• Create a 6" (15 cm) equilateral triangle that is defined by little ¼" (6 mm) triangles in three minutes.

• Draw 15 1" (25 mm) cubes with cast shadows in ten minutes.

• Taking a piece of chalk in both hands, try to establish a 1" (25 mm) blank stripe down the center of the page by drawing lines from it to the sides of the page. Use both hands simultaneously. Five minutes?

• In ten minutes, write and erase the word "art" as many times as you can. Make a notation of how many times you did so at the bottom of the page. (See results by **Frank Bosketti**.)

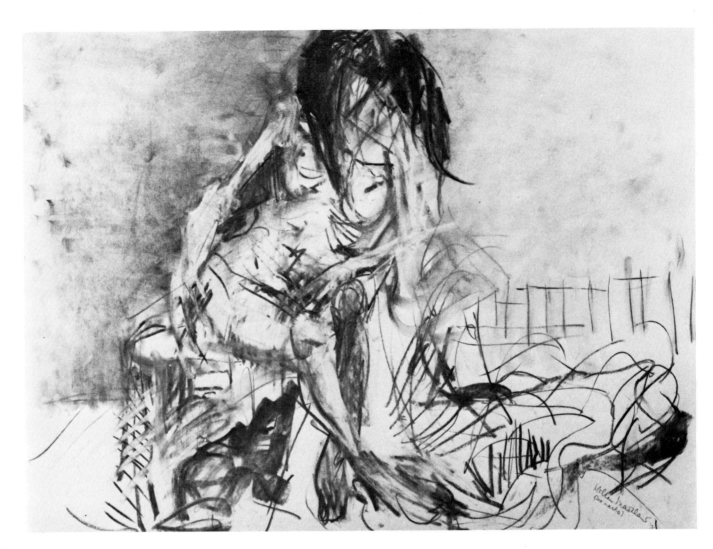

(Above) The student kept her eyes on the model during the entire process while three hundred marks were set down, at the rate of about one each second, in relationship to the pose. With sight, the result was then studied and erasures as well as more marks were made to re-establish greater affinity with the pose. Time and form drawing in charcoal by Heleen Maitland.

(Right) Given a period of five minutes, students were to write the word "art" and erase it as many times as possible without looking at the paper. This student, working very slowly, did it seven times. Others wrote and erased the word hundreds of times. Charcoal time-form drawing by Frank Bosketti.

**8.3  Robert Morris** (*Contemporary American*). *Blind Time II, Number 2, December 6, 1976. Estimated working time: one minute, 30 seconds. Actual working time: one minute, 55 seconds. Etching ink on paper, 39″ × 51″ (99 × 130 cm). Courtesy Leo Castelli Gallery, New York. Photo: Bevan Davies.*

It would be possible to argue that the most forward-looking drawings being made on the contemporary scene are those which are the result of a process or action that was determined prior to the actual art of drawing. Such is the case when an artist such as Sol Lewitt decides in advance that a particular wall space is to be covered with 10,000 3″ (7.5 cm) lines and another with 10,000 6″ (15 cm) lines. Here, Morris has set up working propositions as well as time limitations/factors to create a very beautiful series of drawings in which the freshness and spontaneity of the process becomes the subject matter and content of the work. He did not state the proposition for this particular work, but he did want to spend a minute and a half to accomplish it but in actuality it took a minute and 55 seconds. In this case he dipped his hands into etching ink but he has also used powdered graphite in other works in this series. Work of this nature has a conceptual basis and we are left wondering if he accepted the results in each instance or whether he edited out some of those works where the aesthetic merits were less than satisfactory. What do you think?

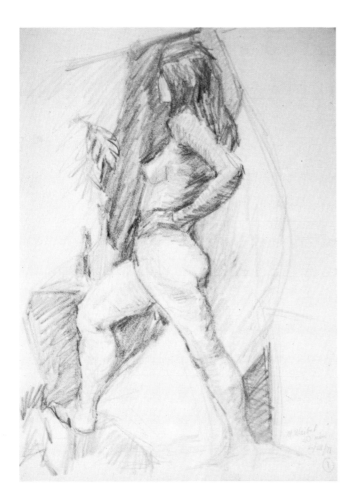

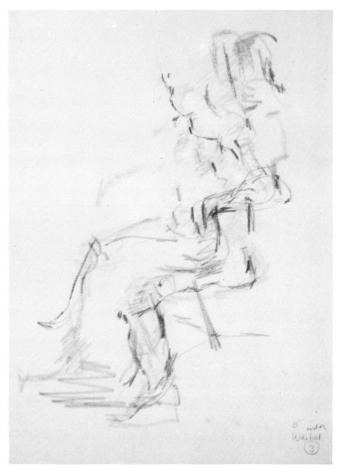

*The drawing on the left was produced in 20 minutes with sight prior to the one on the right, which was produced in five minutes wearing a blindfold. The student had to "see" the pose in her mind's eye and reproduce it. The blindfold drawing in this instance seems less "free" than the original. Graphite stick drawings by Margaret Waibel.*

I'm sure you can think of hundreds of other variations on this exercise, which relates to the important art movement called Conceptual Art, a movement in which the "idea" for a work of art is primary and the execution either secondary or even completely eliminated. [See *Idea Art: A Critique,* edited by Gregory Battcock (New York: E.P. Dutton, 1973) for more information on this contemporary art form.]

### Blindfold Drawing—From the Model!

One day, in a silly mood, I posed the model, then had the class members assume the same pose so they could literally "feel" it, then I passed out big, black blindfolds and asked the students to put them on. I then asked the model to change from a standing pose to a reclining one and told the class to draw the reclining pose as they "saw" it in their mind's eye, since they were now blindfolded.

With a good deal of laughing and giggling, we tried several other poses and modes of drawing for about half an hour. But when I had the students remove their blindfolds, we were all quite astounded by the entire experience. We knew that something *important* (rather than silly) had transpired, and we struggled to pinpoint that "something." None of the students had ever been literally sightless for so long. And the drawings were unlike anything we'd ever seen. Some were simply marvelous, but not in any traditional sense. The class had produced visual art that was filled with energy without the sense of sight!

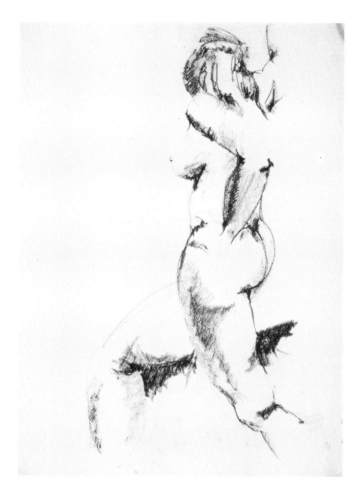

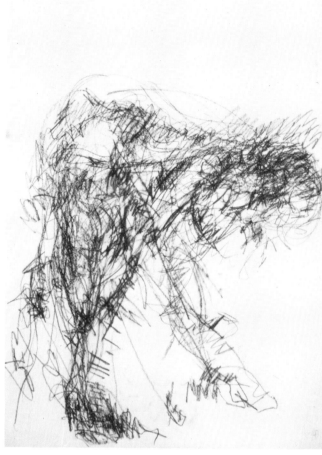

Over the years I've continued to work with the "blindfold bit." Here's the form it's taken, more or less:

1. I ask the class to do a 20-minute sighted drawing from the posed model. This drawing is later used for comparison with our unsighted work.

2. The class attaches their blindfolds and I ask them to be absolutely silent while they're on. I then ask them to think of their heads as a camera and to "fix" on a pose that they can absolutely "see" in living Technicolor. They're instructed to get the pose down onto the paper, in any way they choose, in about five minutes. (Compare the 20-minute sighted drawings to the blindfolded ones by **Margaret Waibel** and **Corinne Barbera**.)

3. Without removing the blindfold, they go on to the next pose and make a two-minute gesture drawing. They try to "see" the pose on the paper as well as in the back of their minds.

4. The next pose is usually about ten minutes long and the class attempts a blind contour drawing (blindfolded literally, but also "blind" in attitude) with their left or opposite hand! The model is actually posing all this time—the students claim it wouldn't be the same without the model! (See work by **Connie Chew**.)

5. Before removing the blindfolds, I ask how many think they've done at least one "blind" drawing which is better than the original sighted one. Usually about one-third of the class thinks they *might* have a better draw-

*Prior to the drawing above, which was produced wearing an actual blindfold, the one on the left was produced in 20 minutes with the sense of sight intact. Both works have qualities to commend them, but the blindfold drawing is freer and less self-conscious. Carbon pencil drawings by Corinne Barbera.*

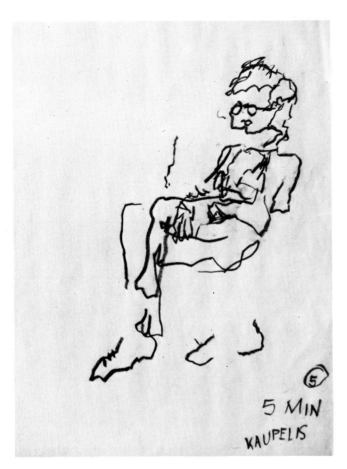

5 MIN

KAUPELIS

*The students, who were literally blindfolded, had been working from a live model whose pose they tried to visualize in their mind's eye. During a five-minute model break, the class was asked to make a blind contour drawing of the instructor. (Of course they kept their actual blindfolds on during the whole process.) Blindfolded blind contour drawing with chalk by Connie Chew.*

**8.4** *(Opposite page)* **Willem deKooning** *(Contemporary American). Untitled, 1966. Charcoal on paper, 8" × 10" (20 × 25 cm). Courtesy Xavier Fourcade, Inc., New York. Photo: Bruce C. Jones.*

*At the height of his career, deKooning, one of America's foremost artists, decided to produce a series of drawings in which he kept his eyes closed while working, ". . . some with a charcoal stick in both hands; others using the left hand only; still others while watching television." (Thomas B. Hess, Willem deKooning. The Museum of Modern Art, New York, 1968, p. 124.)*

*Regarding the series of "blind" drawings, the artist has stated: "I am the source of a rumor concerning these drawings, and it is true that I made them with closed eyes. Also, the pad I used was always held horizontally. The drawings often started by the feet. . . but more often by the center of the body, in the middle of the page. There is nothing special about this, I admit, and I am certain that many artists have found similar ways. . . but I found that closing my eyes was very helpful to me. Many drawings were made this way. . . ." (DeKooning Drawings, Walker and Co., New York, 1967.) This drawing is one of a group based on the theme of the crucifixion. It's important to compare this to another deKooning work, Dish with Jugs (Figure 1.1), which he produced when he was 18 years old. Try to get a discussion going with several artist friends about the relative merits of the two works and the reasons the artist changed so radically.*

ing. After removing the blindfold and allowing them a few minutes to regain their equilibrium, about *three quarters* of them prefer the blindfolded drawings!

We've discussed the pros and cons of this experience over the years and have gained many insights, but perhaps no one has expressed them better than Barbara Spiller, a student of mine who wrote an extensive paper on the subject. Here are a few excerpts from this exceptionally poetic statement:

"Habits are stops in process. We must break habits in order to grow. Learning, information, and experience-gathering is a process of integration and dis-integration . . . leading to (feeding to) growth. To learn, one must allow dis-integration. . . . To learn, to grow, one must unclench, relax, *dis-integrate*, and let new stuff *in*. Then, re-integrate, as a slightly new entity around a new mixture of new and old material.

"Dis-integration is scary as hell. It is loss of self. It is the absence of being. It means letting go of everything in order to have more. . . . People cling to habit (safety) out of fear. People cling to habit to avoid the abyss, *the crossing of which is the creative leap.*

"The experience itself: vivid, technicolor certainty of the model and the pose, no black and white vision of the drawing. Wonderful lack of distances. Everything telescoped. Model, seeing model, pose, knowing pose, drawing pose—all one. Paper, graphite, movement, present, past—all one. Not seeing the drawing at all made no past; everything was always fresh and *present*. Every line was a first line. It related directly to the model, not to any other line on the paper. The paper surface was no problem. Freedom from the tyranny of the surface!" **(Figure 8.4)**.

## Touch and Feel Portraits

Similar to the previous blindfold exercise, this one also helps to force us out of our cultural preconceptions of what drawing is or should be **(Figure 8.5)**. When we set aside a basic cultural factor, such as using the sense of sight to create visual art, and replace it with the sense of touch, it's important to look at the work produced under these conditions (sightlessness) and accept it for what it is. A "touch and feel" portrait does not fit into our previous culturally conditioned concept of how to produce art, so we can only accept this exercise for what it is or for the effect that it might have on our tradition-bound precepts. To stretch this point, I might go so far as to say that if you accept the proposition that all art has to be unique, then it is impossible to call anything art which, indeed, "fits" any *prior* conditions or canons of art.

One day in class I was going to present my "blindfold bit," but the model failed to appear and I had to instantly revise my plans for the day. It then occurred to me that we could draw one another without sight, but by using our sense of touch. This exercise has proven about as beneficial as the blindfold drawings. The class proceeds more or less as follows:

1. Sitting opposite a classmate and using black chalk, the students are instructed to do the best portrait they can in 20 minutes. This is a "normal" drawing with sight.

158

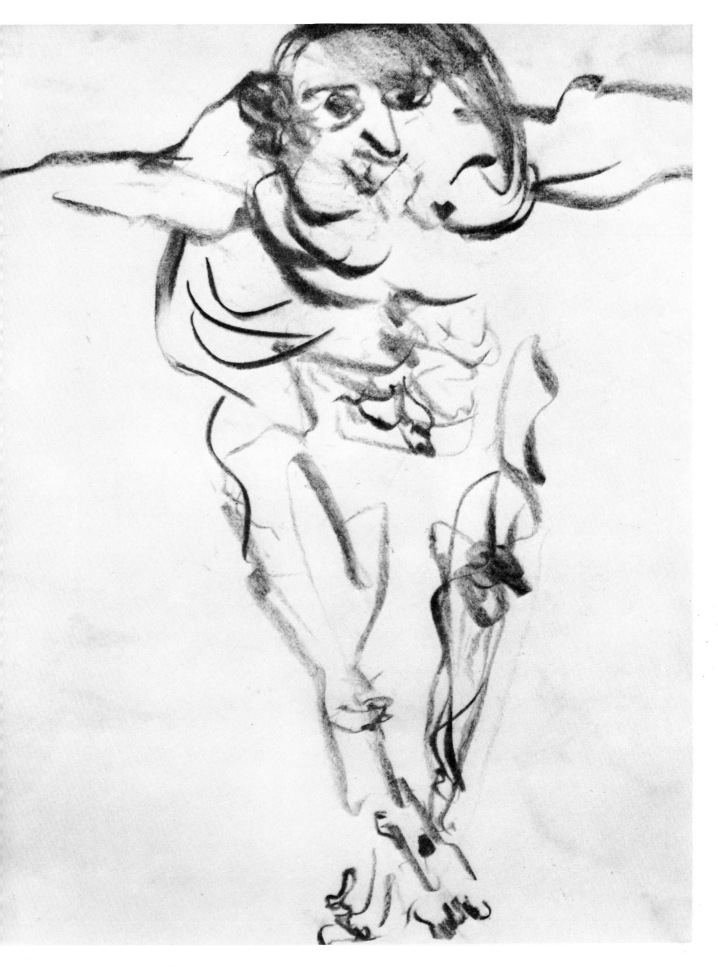

160

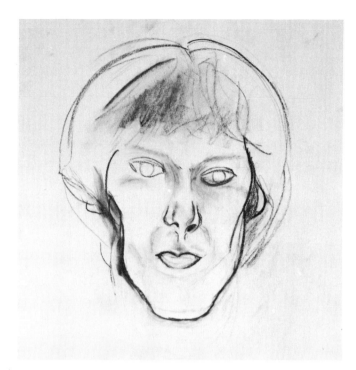

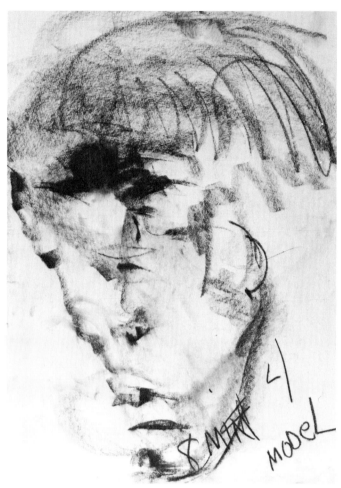

(Above) With sight and 20 minutes allocated to the task, this student drew a portrait of a classmate (left). Keeping her eyes continuously closed after the first drawing, a series was produced in various modes with only that information that could be obtained by touching and feeling the head and features. In this case a modeled drawing was produced by pushing hard on the chalk as the foms moved back and pressing more gently as they came forward (right). Twenty-minute sight and eight-minute touch-and-feel drawings by Jeanne Gordon.

**8.5** (Left) **Jean Dubuffet** (Contemporary French). Personage dans un paysage, 1960. Ink on paper, 12" × 9½" (30 × 24 cm). Courtesy Robert Elkon Gallery, New York. Photo: Bevan Davies.

Few artists have done as much to break down our preconceptions of what drawings should be about, how they are created, or what they should look like, as Dubuffet. Spontaneity and intensity of expression without any preconception is the goal he tries to achieve in protest of the socially and culturally acceptable art of the 20th century. Raw art or "art brut" is the name he has given his own work and the art of other alienated people, such as the clinically insane. However, it also includes "other art of an authentically untutored, original, and extracultural nature." (Roger Cardinal, Outside Art. New York: Praeger, 1972, p. 24.) Dubuffet believes that, "Only what grows naturally and is projected spontaneously from within the psychic depths of the artist can be considered valid as original form: all else remains tainted or distorted. . . . The strongest applicants for recognition under these rigorous conditions are bound to be the insane, since madness is par excellence the refusal to conform, and the cultivation of individualism." (Outsider Art, p. 29.) The removal of sight during the blindfold drawings and touch-and-feel exercises is, in a sense, of an "extra-cultural" nature, since they demand stepping outside the cultural traditions associated with the creation of the art DuBuffet so abhors. Indeed, this may be the very reason why so many students respond favorably to the work they create under these abnormal "cultural" conditions. To break away from that which is may be a step in the direction of what may be—and it is precisely here that the creative act begins.

2. Next they are instructed to sit side by side, and they must promise to keep their eyes closed until I tell them to open them. (Since these are portraits, a blindfold would impede the touching of their partners' eyes). Now, allowing one hand to roam over their partners' faces, they are asked to create a gesture drawing in five minutes.

3. In the next ten minutes, they are asked to do a "blind" contour drawing while continuing to keep their own eyes shut. This is a contour line drawing which is created by allowing the chalk to make a mark while the other hand literally traces (touches) the contours of the face. (We are all filthy dirty at the end of this experience.)

4. A modeled drawing as described in Chapter 2 is their next task. As their free hand traverses the face, the hand holding the chalk must press harder as the forms of the face move back, and press more gently as they protrude. After about ten minutes, continuing to keep their eyes shut, I asked them to "look" (in their imaginations) at their partner's work and to make "suggestions for improvement"! They then erase into and further develop their work, paying heed to the criticism. This may sound like pure madness, but it has proven effective time after time. (See work by **Jeanne Gordon** and **Gwen Marcus**.)

5. For another ten minutes, they are then asked to produce a cross-contour drawing of their partners' faces.

*Sightless, and limited to her sense of touch, this student produced a cross-contour drawing by allowing her hand to move back and forth from one side of her classmate's head to the other while her other hand was recording all of these reactions. Compare this to a sighted cross-contour drawing by the same student on page 27, Chapter 2. Both are uniquely individual. Eight-minute chalk drawing by Gwen Marcus.*

6. We now open our eyes (slowly, to get used to the bright light) and, without looking at our work, we have a discussion of the "blind experience." After a short break, we then go back through this whole process with our sense of sight, but without having looked at the sightless drawings. This now gives us material to compare with the comparable sightless work as well as with the very first sighted portrait. Some typical reactions are:

"I make sure I don't ever lift my hand or I'll get lost."

"I felt very relaxed."

"I've never touched another person's face continuously for forty-five minutes."

"I felt exposed."

"I kept *seeing* the same prior image of him that I did with sight."

"I was uncomfortable. My hand got tired!"

"Sometimes I couldn't help but put things in that I just knew should be there—like eyeballs."

"I felt more comfortable blind than in the first sighted one."

"I felt completely *free* since I knew everyone else was in the same boat."

The vast majority of students usually agree that they prefer their sightless drawings to their sighted ones. In one class, 18 out of 24 students felt that their crude "unreal" portraits were better *drawings* than the original sighted ones. One girl kept saying, "I can't believe it, I thought you were crazy when you said a drawing is simply a group of marks on a paper, made with meaning, but now I can see it—it's *all* right there!"

Why don't you get started on some of your own right now? They don't have to be limited to portraits—try to draw anything you can *touch.*

**The Exquisite Corpse (sort of)**

In *Dada, Surrealism, and Their Heritage*, p. 83, William Rubin describes an "exquisite corpse" as follows: "Based on an old parlor game, it was played by several people, each of whom would write a phrase on a sheet of paper, fold the paper to conceal part of it, and pass it on to the next player for his contribution. The technique got its name from the results obtained in an initial playing . . . [The exquisite corpse will drink the young wine]. The game was adapted [by the Surrealists] to the possibilities of drawing, and even collage, by assigning a section of a body to each player, though the Surrealist principle of metaphoric displacement led to images that only vaguely resembled the human form" (*Dada, Surrealism, and Their Heritage*, Museum of Modern Art, New York, 1978).

Because an exquisite corpse is not expressive of an individual artist, but rather of the entire group who creates it, its nature is contrary to most of the prior precepts of art. Therefore, making an exquisite corpse can help free you of inhibitions since you *alone are not responsible for what it looks like*—you're only partially responsible!

These problems are a lot of fun! The approaches to creating these strange works are only limited to the imagination of the group. However, the suggestions that follow may be of some help in getting you and your friends started:

• Fold a sheet of paper into about eight even or uneven sections. The first person starts at the top and draws a head and neck. He then folds his drawing under so the next person cannot see his work and only tells him how far down he drew on the figure and places two dots in the next fold. The second person then begins to draw the next section of the figure and so forth. You may or may not be producing art, but it's a lot of fun and a good device for relaxing after an intense drawing experience.

• In a larger group situation, everyone can simply begin to draw on a page for five minutes and then pass it to the next person to continue however he sees fit.

• This variation calls for only one other person. Each of you should cover the entire page of your drawing with an even gray tone of charcoal. Next, proceed to create a two-minute gesture drawing using both additional charcoal and erasers. After two minutes, switch drawings and continue to develop the gesture in your own way, but try to learn from and adapt your work to the marks already on the page. Switch back and forth several times. Both of you will have to sign the drawings (See the collaboration of **Dianne Goodman** and **Arline Metz**.)

• Repeat the above exercise in other modes, such as contour or modeled drawing. This is an excellent device since it forces you to stop being overly precious about your work.

• An exercise a bit removed from the original idea of the exquisite corpse was developed by two of my students one day. Working at easels positioned so that they could not see each other's work, they took turns giving instructions that had to be followed. For instance, they were ordered to: make five geometric shapes in the upper half of the page, create a tonal "ground" around two of them, create a tone from very light to very dark to very light near the bottom of the page, erase two of the geometric shapes which are nearest to triangular in shape, and so forth. There is no reason why this couldn't be done with objects, with commands like: draw a room, add two people, add a table, etc. . . .

## Using Pre-Existing Shapes
Since the first caveman recognized the mark left in the earth by his footprint and then repeated it, artists have been using pre-existing shapes in their paintings and drawings.

Marcel Duchamp, the originator of the "ready-made" (a pre-existing shape with inherent aesthetic value, such as a urinal) has used the typewriter to create portraits. Jasper Johns (**Figure 8.6**) has used pre-existing shapes ranging from targets, American flags, and his own body, to letter and numeral stencils as the very core of his personal aesthetic. Olga Moore (**Figure 8.7**) has approximately 500 stencils which she traces to create

*"Exquisite corpse" is the name the Dada painters gave to cooperative works. Each of these students started a drawing which was then passed back and forth with their partner every five minutes, forcing each one to adapt her ideas to whatever the other person had done to the drawing while it was in her possession. This ink and chalk drawing by Dianne Goodman and Arline Metz took about 30 minutes to produce.*

**8.6** (Left) **Jasper Johns** (Contemporary American). Jubilee, 1960. Pencil and graphite wash, 28" × 21" (71 × 53 cm). Collection The Museum of Modern Art, New York, The Joan and Lester Avnet Collection. Photo: Charles Uht.

The use of pre-existing shapes such as the American flag, targets, light bulbs, his own body, and numeral and letter stencils is at the very core of Johns' aesthetic. Along with Robert Rauschenberg, Johns was a precursor of the Pop Art movement. Johns' drawings can't be separated from his paintings and, as often as not (as in this instance), his drawings are made after, rather than prior to, a particular painting. Graphite in powdered form can be purchased from large artist supply houses and applied directly to the drawing or combined first with water or turpentine, as the artist has done here. Traditional ideas about composition are eliminated here in favor of a surface that is shallow and continuous. This drawing is not a picture of an object; it is an object!

**8.7** (Above) **Olga Moore.** (Contemporary American). #27, 1978. Ink on paper, 22" × 30", (56 × 76 cm). Courtesy the artist.

Olga Moore is a young American artist who has developed a highly personal style of drawing by limiting herself almost exclusively (occasionally she draws some freehand textures and also adds color) to tracing around approximately 500 pre-existing shapes. She states in a letter to the author: "I begin my drawings with template forms, that is, a vocabulary of symbols belonging to architecture, mathematics, engineering, plumbing, electronics, etc. All the template forms are non-organic and static. From these often geometric, precise, symbols/forms, I build my whimsical abstractions through the use of texture, linear mutations, and color. Industrial notations are transformed into organic, whimsical, abstract forms in my drawings."

This is a highly structured work consisting of four horizontals and a vertical ruled form on each side that acts as a foil to the horizontals and forces us to "read" the drawing very much as we do a printed page. It is marvelous to come across a work occasionally that makes you laugh out loud. Can you think of other kinds of pre-existing shapes that you might transform into a potential "belly laugh"?

*Having carried a paper clip and a screw eye in their hand constantly for about a week, the students were asked to "write a drawing" about their experience. As in many other instances this student's writing/drawing took the form of the objects, which in poetic terms is called a "calligram." Pen and ink "written" drawing by Karen Berman.*

*8.8* (Opposite page) **Yves Tanguy** (French, 1900–1955). Letter to Paul Eluard, 1933. Pen and ink and pencil, 10½" × 7½" (27 × 19 cm). The Museum of Modern Art Library, New York, Eluard and Dausse Collection.

*In 1923 Tanguy saw a picture by the Italian metaphysical painter Giorgio de Chirico and instantly decided to take up painting. He associated himself with the Surrealists and produced paintings of dreamlike, enigmatic landscapes with rocks that cast long shadows. Many of the Surrealists produced picture-poems where they were preoccupied with the use of words in images as well as images in words. William Rubin tells us that "Tanguy's picture-letter . . . is another type of invention based on the fusion of words and images. The conceit requires that we imagine a perspective drawing of a letter folded into the morphological patterns of Tanguy's paintings. Some words disappear or are broken off by the projections of the biomorphic 'hill town,' and 'birds' in the form of punctuation marks fly around the margins." (Dada, Surrealism, and Their Heritage. New York: New York Graphic Society and The Museum of Modern Art, 1978, p. 94.) Why don't you try to invent a totally new way of incorporating words into visual images or vice versa?*

both abstract drawings as well as figurative works, each of which is composed of dozens of these stencils put together to create "humanoid" figures. No doubt about it; in the hands of artists, pre-existing shapes can become powerful forces for the release of creative/expressive energy.

The problem here is to find a pre-existing shape you can either trace or, when dipped in ink, use as a stamp to create a vigorous and imaginative work. It is possible to use "Fragile" or "Do Not Bend" stamps, which are readily available, but remember that other more unusual objects can also be used as a stamp, such as a pair of scissors, a fork, or, as Chuck Close did **(Figure 5.1)**, your own fingerprint. Objects such as forks or scissors can be both traced *and* used as a stamp!

### Writing a Drawing—Calligrams

A *calligram* is any kind of writing that suggests or physically illustrates the subject being written about. My own discovery of the calligram was quite by accident. A favorite assignment of mine for several years was to pass out a couple of small objects to my class, such as two thumbtacks, or a couple of paper clips and a screw eye. I gave them instructions to carry them in their hands *constantly* for a period of one week. "Set them down on your night table just before you turn out the light at night and in the morning they should be the first things you reach for. You might give them names and I sug-

gest that you show them to as many people as possible," I told the class. Yes, they were baffled, but the majority (perhaps to humor me!) *did* carry out the instructions.

The next week, upon returning to class, my instructions were: "I'd like to have you settle down for two hours and, without any talking whatever, I'd like you to 'write' a drawing." Write a drawing?

They were dumbfounded, but proceeded as best they could—and the results were quite remarkable from both a literary and an artistic viewpoint. (See drawing by **Karen Berman**.) The aspect which most astounded me, however, was that a high percentage, in writing about their experiences, did so in such a manner as to create what I only later learned were called calligrams. In 1913–1916 French poet and art critic, Guillaume Apollinaire, wrote an entire volume of calligrams: a poem about a necktie took on that shape, a poem about time took on the shape of a pocket watch, and so forth. forth.

It is indeed possible to "write a drawing" *without* creating a calligram, and many of my students, as well as important artists, have done so. (Note the drawings by Yves Tanguy **(Figure 8.8)** and Christian Dotremont **(Figure 8.9.)** Writing a drawing is a good challenge and something of a mind-bender for you. Write a *drawing* about some important or inane experience of your own.

**8.9  Christian Dotremont** *(Contemporary Belgian).* Logogus, *1976. Ink on paper, 25″ × 35½″ (63.5 × 90 cm). Courtesy Lefebre Gallery, New York. Photo: Otto E. Nelson.*

*Along with a number of other artists, Dotremont founded a group named Cobra (artists from Copenhagen, Brussels, and Amsterdam) that allowed themselves to be propelled in their art by their impulses. Color, ink, brush, pen–the material "means"—furnished their inspiration, for they never knew in advance what they would express. Dotremont calls his visual poems "logograms." He states: "The logogram is an exaggeration of natural writing, the writing that everybody uses when he writes spontaneously, when he no longer respects the neat school calligraphy. . . . my decision never to make two logograms with the same text (which is written at the bottom of the page) . . . is, in practice, very difficult. . . ."(Letter to John Lefebre, October 20, 1972, quoted in Exhibition Catalog, Lefebre Gallery, New York, 1973.) In one three-month period he created about 200 logograms and threw away about 180 others that had failed to meet his rigorous standards in relation to "the text and the writing/drawing."*

## Photo Magic

Since the invention of the camera, everyone has had it within his power to record images from his visual experience onto a sheet of paper. Since image-making has always been the province of the artist, it is only natural that artists would begin to use this new technological advance to their own ends. The mutual influence of photography on the visual arts and vice versa have been extensively documented and need not be repeated here. Our primary interest is in photography's potential for extending our conceptions and drawing procedures. I have already discussed the use of photographic means as an aid in arriving at a drawn image in Chapter 5. Now we will see how drawing and photography can be *combined* in the end product.

### Using the Photograph Directly

For this project, collect a number of photographs, both black and white and color, that you don't particularly care about saving. Unlike previous exercises, where you used photographs as the motif from which you worked, you are now going to use the photographs as the actual ground or surface upon which to draw, scrape, scratch, soak, stain, rip, tear, burn, or otherwise work to change the image with your drawing materials. Photographs have either a glossy or a matte surface, and each surface receives drawing media in different

ways. Most of your marking implements will hold better on the matte surface; however, the way that ink lines or washes are repelled by the glossy surfaces may be a factor you can use to advantage.

Before the development of color photography, artists often earned extra cash by tinting black-and-white photo portraits with transparent oil colors. Although simply coloring in the various shapes is probably the least creative thing you can do with these photographs, perhaps even this approach could be used creatively if you started thinking about using the color in new and startling ways, or if you used opaque color to cover some portions of the photo. You might also try to radically change the light and dark structure of the original. Or work with oil crayons, or pen and ink. How about pasting a photograph onto a piece of paper and through drawing extend the photographic image into an imaginatively drawn area that will extend to the boundaries of the page (**Figure 8.10**)? Portions of the photographs might also be cut out and incorporated into a drawing, forcing the viewer to ponder the meaning of reality. (See work by **Pam Schafler**.)

Artists of all persuasions have used photographs in this direct fashion, but perhaps none has used them as much as those we call conceptual artists, artists for whom the idea takes precedence over its execution. Christo is a conceptual artist who uses photographs both

**8.10  Joan Semmel** (*Contemporary American*). Study for Cross Over, 1979. Color xerox and pastel, 24" × 32" (61 × 81 cm). Courtesy Lerner Heller Gallery, New York.

*Making use of 20th-century technology, this artist first took a photograph of a figure and then transformed the photograph into a color photocopy. She cut out a section which she wanted to use as the basis, as well as an integral part of, this work and then used it to repeat the image in painterly, nearly abstract expressionistic images around this photocopy focal point. The original is beautiful and subtly colored. The combination of a "photocopied reality" with the drawn marks creates an image impossible to attain until the advent of color xerography. It would be possible to have this same photocopied image in dozens of drawings, while varying the drawn elements ad infinitum! Can you envision other, more radical possibilities?*

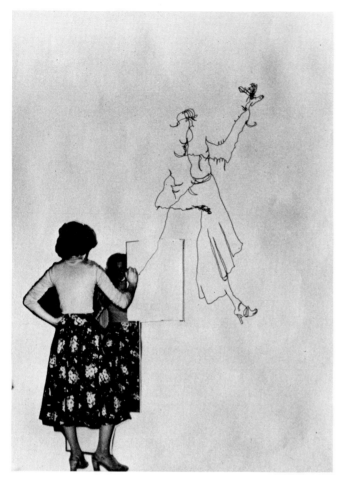

*Combining drawing and photography, this non-art student had a photograph taken of herself before a mirror working on a self-portrait. She then very ingeniously combined the photograph with a blind contour drawing. Photo-collage, pen and ink drawing by Pam Schafler.*

in the planning stages and as a means of documenting some of his projects. Although he has actually wrapped two miles of the Australian coastline, the lithograph of the wrapped Whitney Museum of American Art (**Figure 8.1**) has never been realized.

### *Foto Drawings—A Case Study*

According to the contemporary American artist Nancy Goldring, "A Foto Drawing is a drawing which has a slide projected onto it or one in which the drawing is projected onto a 'view' or 'place' and which is then photographed and printed." Creating her Foto Drawings (**Figure 8.11** and **8.12**) involves a rather long and compulsive process which she breaks down into several different phases as follows:

*Phase 1:* 1. She makes a very careful drawing of a "view" or "place," in this case a window. 2. She takes a black-and-white photograph of the window which more or less serves as her motif. 3. She takes a photograph of her own drawing (Step 1). 4. The negative of the drawing (Step 3) and the negative of the view (Step 2) are printed using the two negatives superimposed, thus producing a Foto Drawing that is a combination of Steps 1 and 2. (**See Figure 8.12**).

*Phase 2.* In this phase, the artist makes a photographic slide of the Foto Drawing produced in Phase 1 which is then projected onto the acutal window at night. This image is then photographed and printed.

*Phase 3.* In this phase, a variety of "views" or "places" are photographed as slides and are projected onto the drawing, which is then photographed and printed.

Although the Foto Drawing illustrated here was originally in black and white, the artist is also working with colored drawings in combination with colored film. Among many other processes the artist is using to produce spectacular Foto Drawings, another one consists of: 1. Making a drawing. 2. Making a second drawing. 3. Photographing either of the above drawings as a slide. 4. Projecting the slide from Step 3 onto the other drawing, then photographing and printing it.

There can be no doubt that the camera and the images it produces are invaluable assets to those artists who choose to exploit its possibilities as they strive to extend the meaning and means of our visual vocabulary.

### Transfers

"Transfers" refers to a process that enables you to transfer a photographic image from a newspaper or magazine to your drawing paper. I recall that when I was a child we used to rub paraffin over the comic strips; and by rubbing the reverse side with a pencil, we were able to transfer the comic to our paper as though by magic! It was not until the '50's, however, that Robert Rauschenberg began to experiment with the process and was able to produce an impressive body of work as he also *extended* our concept of drawing (**Figure 8.13**).

The transfer of an image is obtained by soaking the image with a solvent, such as lighter fluid, acetone, turpentine, benzine, or lacquer thinner; turning the image face-down on a clean surface; and rubbing with a pencil or a spoon. (You must exercise extreme cau-

**8.11 Nancy Goldring** (Contemporary American). Grey Window, 1976. Crayon, pencil, and gesso relief on paper, 22" × 30" (56 × 76 cm). Private collection.

The artist has made dozens and dozens of drawings of her studio window and this is one of them. In the hands of an imaginative and talented artist, the most mundane subject matter can be transformed into a profound aesthetic statement. A composition of strong verticals and horizontals, the subtleties of the shading are lost in the reproduction. The white plant forms in the lower right are solid white gesso (usually used to prime canvas prior to painting). They are built up, by painting and repainting, with a brush into a relief of about ⅛" so that it casts a very subtle (but important compositionally) shadow. Although this drawing exists as a separate and beautiful entity, the artist has also used it as Phase I of the Foto Drawing which is reproduced below. Although the drawing is square, the 22" × 30" (56 × 76 cm) measurement refers correctly to the full size of the sheet on which the drawing is produced.

**8.12 Nancy Goldring** (Contemporary American). Grey Window, 1976. Foto Drawing, 12" × 12" (30 × 30 cm). Courtesy the artist.

This work is a combination of the preceding drawing and a photograph of the same "view." To achieve this effect, a black and white photographic negative of the view and a black and white negative of the original drawing were placed into the enlarger together and printed. Subsequent phases involved projecting a view onto the drawing or projecting a slide of the black and white photograph from the first phase onto other surfaces and photographing them. Each Foto Drawing is unique since the artist makes only one print. Her most recent Foto Drawings are in color and are printed in an extraordinarily large scale. Without being aware of the steps in their creation, the final works are somewhat mind-boggling, for they don't look like drawings, they don't look like double exposures of a photograph, and they don't look like photographs. They're different; they're Foto Drawings!

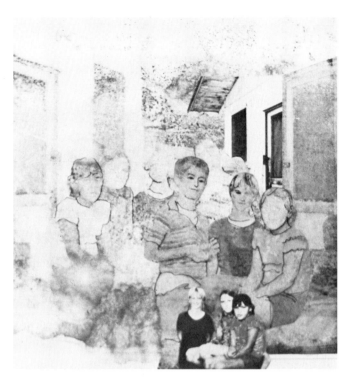

*(Above) This is a combination of transfers, collage, photographs, and drawing. The left background is a transfer of the image on the right, but a photograph of a house has been collaged on top of it. The three figures in the back are a transfer from the central group of three, which was then pasted in this location. The bottom group whose pose resembles the pose in the other group was cut out of a black-and-white photograph and was colored with markers. The entire work was finally "drawn into" with colored pencils and an occasional pen line. Mixed media drawing by Barbara Thompson.*

**8.13** *(Left)* **Robert Rauschenberg** *(Contemporary American). Illustrations for* Dante: Inferno, *1959–60. XXXI of thirty-four transfer drawings, red and graphite pencil and gouache, 14½" × 11½" (37 × 29 cm). Collection The Museum of Modern Art, New York, Given anonymously.*

*If you soak a photograph from a newspaper or magazine with a solvent such as benzine or turpentine, place it face down on a piece of paper, and rub the back with a pencil, it's possible to transfer the image to another surface. That is basically what Rauschenberg has done here as he has illustrated this particular Canto from Dante with contemporary imagery. This is one of the most important developments in contemporary drawing since the introduction of collage. Among the many symbols in this work, the three weight-lifters at the bottom represent the "guardians of the final gate to Hell." This artist's desire to explore the expressive possibilities of processes and materials not usually associated with art seems insatiable. He has used clocks, radios, sounds, technology, tires, and even a stuffed goat! In addition, he often designs sets for the contemporary dancer and choreographer Merce Cunningham.*

tion, since most of the solvents are highly volatile.) If your image fails to transfer, try one of the other solvents. My students have found that one solvent may work on images taken from *The New York Times* and be almost ineffectual on an image from a different source. Some experimentation is necessary.

In outlining this assignment to my classes I always tell them that they are to experiment with the process, but that they must attempt to create final works that do not look like "Rauschenberg rip-offs"! One of my students, **Barbara Thompson,** realized her objectives in a most interesting fashion using a combination of transfers, collage, photographs, and drawing. The background on the left is a transfer of the image on the right, but a photograph of a house has been collaged on top of the right-hand background. The three figures in the back are a transfer of the central group of three; the original was then pasted in this location. The bottom group was cut out of a black-and-white photograph that resembled the pose of the other group, but to make it relate to the rest of the work, the artist colored some sections of it with markers. After that, the entire work was "drawn into" with colored pencils and an occasional pen line. The qualities of this drawing could not be obtained by any other means.

Like this student, I hope that you, too, are beginning to see that none of these modes is precious and that combinations of them may be most exciting.

## Photostats

Photostats are basically photographs of an original art work that are usually enlarged or diminished in size, and in which it is possible to reverse the light and dark of the original. The Yellow Pages of your telephone directory should have a listing of firms that can photostat your work. Photostats make it possible for you to create a tiny drawing—let's say about 2" × 3" (50 × 70 mm) and blow it up to 3' × 4' (0.9 × 1.2 m)! A blow up such as this will completely change the line quality because the texture is magnified so many times. Not only can you have it enlarged, but you can have the light and dark reversed so that you have a white line drawing on a black background. It's also possible to have them reverse your drawing and create a mirror image of it. Naturally, you can also have large works reduced in size, which means that a relatively sloppy line in the original may appear perfect in the print.

You may want to try reworking the print with black-and-white materials or even with colors. If you use transparent color, the original lights and darks will show through and each color will automatically take on the range of values of the original. On the other hand, opaque color will naturally cover all traces of the original. Exciting works can be created by using a combination of color and the original print.

In the past, for the most part, photostats have been used by commercial artists. But more and more fine artists are beginning to exploit the possibilities inherent in the photostatic process **(Figures 8.14 and 8.15).**

**8.14** *(Below)* **Robert Kaupelis** *(Contemporary American). Untitled 1/13/78. Mixed media on gesso paper, 39½" × 27½" (100 × 70 cm).*

**8.15** *(Right)* **Robert Kaupelis.** *Untitled, 1978. Photostat and red ink, 21" × 17" (53 × 43 cm). Courtesy Bell Gallery, Greenwich, Conn.*

*These two works illustrate how it is possible to use mechanical means to change and alter a given image. The mixed media drawing on the left shows a wide range of values and texture. The original had a slight amount of color. With the exception of the large square at the bottom of the right-hand drawing, the instrument for producing changes in the image on the left are machines which have resulted from modern technology. The*

procedure is as follows:    1. Original mixed media drawing (first generation).    2. Photostatic reduction to 8 ½" × 11" (22 × 28 cm) of the first drawing (third generation; negative was the second generation).    3. Dark blue copy of the second step using a No. 6500 Color Copier (fourth generation).    4. Dark blue copy of the third step using a No. 6500 Color Copier (fifth generation).    5. Offset print in black and white of the fourth step at maximum contrast (sixth generation).    6. Hand-drawn red line on the fifth step (seventh generation).    7. Photostatic blow-up of the sixth step to 21" × 17" (53 × 43 cm)

(eighth generation). These processes are written in red ink on the bottom of the photostat, but since they do not reproduce, I have repeated them here. Having made only one final photostat, it is an original one-of-a-kind work. If I had continued to make copies of the copies, all resemblance to the original drawing would disappear. As it is now, all of the value changes and much of the texture has already been dissipated. How much use can we make of machines to alter our work and still call it our own?

## Blueprints and Whiteprints

Blueprints are yet another form of copying original work, one used primarily by architects. Drawings translated into this medium must be made originally on tracing paper and take on entirely different characteristics when made into blueprints. It is now possible to obtain white prints as well as blueprints. Most of the suggestions that I've made for projects using copiers and photostat machines can be applied to the blueprint process. Again, your telephone directory should put you in contact with these facilities.

## Xerography—The Age of "Copy Art"

Like most technology, copiers were developed to serve the needs of our industrial society. Whenever a new means for making marks is developed, you can be sure that it won't be long before artists begin to exploit it for their own ends. During a class critique concerning the copying of old masters, I suggested that if Leonardo had the task of copying to do today, he would hasten to his nearest copy center and have a *perfect* copy in a matter of seconds! Of course, this comment led to a lot of discussion on whether it would be honest, would it be considered art, could it conceivably be classified as drawing, and so forth. Right then and there I gave a simple assignment: see if you can produce art making use of a copy machine. The results were phenomenal. Since the days of that first assignment, copy machines have been introduced that print *full color* in seconds! Within the last month of this writing, there have been two group exhibitions of copy art in New York, and a book has been published that outlines most of the basic procedures: *Copy Art: The First Complete Guide to the Copy Machine* by Patrick Firpoetal (see Bibliography). Furthermore, the Department of Prints and Drawings at the Museum of Modern Art now has examples of art produced in this manner in its collection, should further justification of its legitimacy seem necessary **(Figure 8.16)**.

## *Copy Machine Projects*

A number of specific suggestions may serve as a springboard for your own experimentation with this new and exciting technology:

• Take any drawing you have done and create multiples of it on a copy machine. Note that the copy is *different* from the original. It has its own inherent characteristics which, like any drawing process, you must learn to accept. That "difference" is what it's all about! Having a number of copies, you will be free to try drawing back into each one to develop the forms in different ways. Each one can be made uniquely different—and all of this without risking the ruination of the original! This is only the beginning. Now any one of these "new" or modified copies of the original can also be copied (which tends to make the new graphite or ink marks you worked into and over the photocopies look more "homogenized"— that is, all marks once again have the unique quality of a photocopy. Go on, and on, and on! (See work by **Donna Ostrove**.)

Using a drawing made on a distorted grid (see Chapter 5), this student had several photocopies made of it. Then, without destroying the original, she created this photocopy collage, which "reads" as a head in motion. Drawing and photocopy collage by Donna Ostrove.

*8.16 (Right)* **Joellen Bard** *(Contemporary American). Sewn Xerox Series #1, 1979. Xerox print with hand-sewn thread (Number 6 in a series of 7), each 8½" × 11" (22 × 28 cm). Courtesy Pleiades Gallery, New York. Photo: Mort Greenspun.*

*Bard has experimented with a vast array of materials and means for making marks, from drawing on acetate with ink to this current series in which her lines are not drawn but sewn with needle and thread on canvas. Her "image" is generally rows upon rows of horizontal "lines," but to create this photocopy print, she turned the sewn canvas to the reverse side, which contains all of the ends of her thread. These ends create a completely different and accidental or "found" image unlike the intentional one she had produced on the other side. A print was taken of this reverse side and then six rectangular areas of the paper were hand stitched with real thread (which in this reproduction appear slightly grayer and more solid). Bard also took photocopy prints of the "correct" side, the character of which is completely and totally unlike this one. 207 Hours is the name that she gave to another free-hanging, 4' × 6' (1.2 × 1.8 m) field of canvas she had sewn horizontally with row after row of tiny black stitches, because that is how long it took her to complete this compulsive project. Do you have any trouble accepting drawings in which the marks are made of thread?*

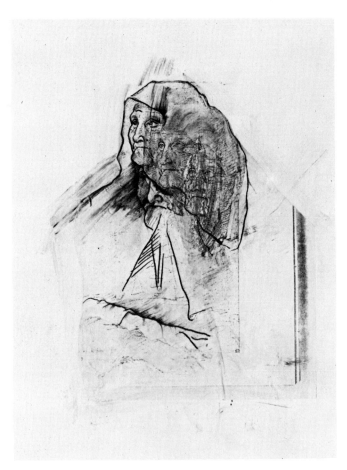

*(Above) This image is the result of contemporary technology being pressed into the service of art. Three photocopies of a reproduction of Federico Zuccaro's Portrait of an Old Lady were cut and pasted together with acrylic medium; ink lines were drawn in a few selected areas, then smeared with more medium. Photocopy drawing by an unknown student.*

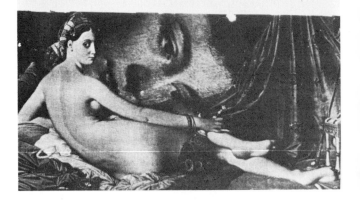

*(Right) This serial work started with the bottom panel which is a color photocopy of a collage the student created using parts of paintings by Ingres and Degas. The top three are black and white photocopies of this collage, each colored in radically different hues. This is a single work consisting of four variations on a theme. Collage, photocopy, and colored pencil drawings by Carrie Goldman.*

• Repeat the above, but if you have a black and white drawing, copy it on a color machine and discover what happens. And if you have a colored drawing, copy it in black and white. You might then add new colors on top of the black and white and then copy it once again in color. By this time there will only be a vague resemblance to the original.

• Make a number of copies of one of your favorite old masters. Work into each one or combine them, as in a collage, to see if you can turn it into a work that looks contemporary and for which you can take the credit. If you have made a drawn copy of an old master (as suggested in Chapter 7), you might use that for your original copies. Of course, you can now also photocopy your new interpretation. (See **drawings** on page 178.)

• Try to figure out a means of creating a work which will be larger than the standard-size photocopy by pasting several or several dozen copies together. I have seen 6' × 8' (1.8 × 2.4 m) paintings that were composed of pasted down photocopies.

• Take a delicate and subtly shaded drawing of your own and make copies of it, first with maximum contrast and then with minimal contrast. You will barely recognize the new prints as your own. Remember that the machine is an *instrument* that you are using to achieve new form for your art.

• Using a drawing which you have made in color, reproduce it as exactly as is possible. Next cut out all of the blue in the machine and make a print, then cut out the red, and then the yellow. The variety of color you can achieve in a matter of seconds will astound and (hopefully) delight you.

• Copy a drawing on either a black and white or a color machine. Then turn the original around, put the prints back into the machine and copy the work upside down on the original print.

• Place your face directly on the machine and take a print. (Be sure to keep your eyes closed.) This may suffice—or you may want to draw back into it or make other additions. If you move your face as the light passes thorugh, you will discover that you achieve amazing distortions which will record the movement. (See **Risa Honest's** "hair" photocopy collage.)

• The possibilities are obviously unlimited. If this mode of working interests you, I suggest that you read the book *Copy Art*.

## Computer Art—Would Leonardo?

There is absolutely no doubt in my mind that Leonardo would be involved in every aspect of computer science, including its capacity to generate images, if he were alive today. Just think of it: thousands upon thousands of variations on a particular "instruction" to make marks can be produced in a matter of seconds! You may well ask whether or not it is "drawing" (or art?) if it is produced by a computer? Remember—a computer is nothing more than another *tool*, a tool that will sit as idly as a pen and brush until someone, a programmer (or artist?), "feeds" it the necessary information. For many years,

*The artist first created a collage from a drawing of a face and a photocopy of her own hair. She then made a photocopy of the finished collage, causing the very different elements to "homogenize" or look like they belong together. Drawing and photocopy collage by Risa Honest.*

my more-or-less standard and simplistic response to all questions surrounding the use of computers to generate art has been, "When you show me a computer which can get sick and throw up, I'll show you a computer that can produce art." Admittedly I continue to have some reservations, but I also find myself becoming more and more excited over the possibilities as I come into contact with ingenious and interesting examples of computer art.

Computers are becoming more and more accessible, and the curtain of mystery concerning their use is rapidly being lifted. A recent *New York Times* article reported students at Dartmouth College don't have to receive any special permission to gain access to the more than 300 terminals that are spread around that campus, and also that there are more than 2100 colleges and universities presently allowing students to actively use computers. Music students at Dartmouth use a computer capable of reproducing dozens of musical sounds ranging from the human voice and piano to electronic music. After an hour of instruction, students at New York University can begin to generate graphic images using a computer programming language called ARTSPEAK. Even if you may not have access to a computer at the moment, the point is that they are available in many places and in the very near future they will be as accessible as library books! And it will be as necessary to be literate in their use as it is now to know how to read!

A cursory look at a few possibilities will suggest some of the directions computer drawing is taking:

### ARTSPEAK, *A Graphic Computer Language*

The Courant Institute of Mathematical Sciences at New York University had become aware that most liberal arts students and non-mathematically oriented students at the university had little or no appreciation of the implications of computer programming. Professor Henry Mullish, who is Senior Research Scientist at the Courant Institute, was given the task of developing a course called "The Computer and Society" which was to be a "hands-on" course, in addition to the lecture-discussions. He realized that general students would not be very interested in computer printouts that consisted of innumerable and mysterious pages of numbers, so he developed a new graphics language for producing computer art, graphic images that the students could *see*. It was called ARTSPEAK (**Figure 8.17**).

After about an hour of instruction in ARTSPEAK, students are able to write computer programs which have considerable merit and interest. Without too much difficulty, ARTSPEAK has been taught to students as young as six years old! Mullish states that, "After an ARTSPEAK program, that is, a series of instructions intended to create a specific design, is submitted to the computer, together with the appropriate control cards, the operation becomes automatic. . . ." Here, as in other areas of visual art, Mullish has also observed that errors in a particular program, rather than detracting, often tend to enhance the design!

### AARON, *A Computer Program*

Unlike Professor Mullish, who is a computer scientist using its possibilities to teach students to produce artistic designs, Harold Cohen is an artist who uses the computer to control a device (a "turtle") of his own design "to produce an endless series of gigantic 'freehand' drawings, no two of which are alike (see **Figure 8.18**). Because the drawings are so freehand and intelligent in appearance—and so unlike any existing notion of what machine-made art is capable of producing—you might assume that the drawings were made in advance and fed into the machine. Not so. They are a result of a complex programming that allows an unending number of variations of images to be 'invented' by the computer." (This quote and those that follow are from an interview by Moira Roth, "Harold Cohen on Art and the Machine," in *Art in America*, September–October 1978, pp. 106–110.)

As a teacher of art at the University of California, San Diego, Cohen's first introduction to the machine came by chance. "There was a student in the music department who appeared to have a life ambition to make computers available for people outside the sciences. . . . When he said, 'Why don't you try it,' I thought, 'Why not?' After having learned the rudiments of programming, I was told I should set up a project. I said 'Why do I have to do a project?'. . . Then I thought, 'Let's see if the machine can do one of the things I can do.' One of the things I can do is to draw a freehand closed figure. To get the machine to simulate freehand drawing turned out to be a very interesting problem.

"It was about a year before it occurred to me that what I was doing with the computer had any bearing, or could have any bearing, on issues that interested me as an artist, though programming turned me on in a way that other things hadn't done for a long time. Then I started to see the machine as an analogue for human intellectual processes. At this point, it was more exciting than painting."

Cohen does not care to show these drawings out of the context of the computer and the "turtle" which produces them because, as he says, "The drawing itself is merely the tip of the iceberg, in *terms of the content* and of what is involved in its making. The *real content* is the problem with which the spectator is engaged the moment he realizes that this curious drawing is actually being generated by a machine. I should say here that while it is the machine which generates these drawings—I mean that it is not churning out drawings I've done in advance—the program does not have the intent of communicating any meaning at all. The computer doesn't know anything about the world, and therefore has no meaning to communicate." (My italics.)

"Computer art" is a term Cohen rejects. He has also never exhibited in a computer art show since, he says, "The computer *is* neutral, neutral in the limited but important sense that until you put a program in it, it isn't anything. The computer is like a tool-design kit rather than a tool. Every time you sit down to write a program, you are suddenly thrown into the position of being not a tool user, but a tool designer. That, I think, is what makes the machine special."

**8.17  Henry Mullish** (Contemporary American). SQUONG, 1973. Ballpoint pen drawing on paper under the control of a computer. Courtesy the scientist/artist.

As Senior Research Scientist at The Courant Institute of Mathematical Sciences at New York University, Mullish was searching for a way to introduce non-mathematically oriented students to an appreciation of what is implied by computer programming. He developed a graphics language for computer art called ARTSPEAK which, after about one hour of instruc-tion, permits students to write computer programs that have considerable merit and interest. Children as young as six years of age have been taught to use ARTSPEAK. After an ARTSPEAK program (i.e. a series of instructions intended to create a specific design) is submitted to the computer, together with the appropriate control cards, the operation becomes au-tomatic. Particularly interesting is the fact that Mullish has observed that errors in the program often enhance the de-sign! Is it a drawing? Is it art? If we ignore it, will it go away?

## Computers and the Aesthetic Reaction

The way that Sonya Rapoport has used computers is totally unlike and unrelated to the work of either Mullish or Cohen, and its inclusion here might be challenged by a "purist," if such individuals continue to exist.

Rapoport does not use the computer directly to generate marks. She works in collaboration with an archeologist from the University of California at Berkeley who has used the computer to study parallel elements of Indian culture and the artist's own studio. In the detail shown here of her work **(Figures 8.19)**, there are comparisons between maps of Mesa Verde and Berkeley; between masks donned by the Indians for a rain dance and the face of the artist wearing makeup; and between drawings of a Kiva (an Indian place of worship) and transfer photographs of the artist's studio.

The information provided to the artist may be on computer print-outs as long as 110" (2.8 m), which she "reads" and then responds to in a purely aesthetic and humanistic manner. Every line, dot, picture, or symbol that she places directly on top of the computer printout relates to the data, but the *particular* choices as well as the medium are purely aesthetic decisions. She uses tempera, colored pencils, graphite, ink, and photographs which she has had photocopied and then transfers (using acetone) to the printout. (See the description of transfers earlier in this chapter.)

The incredible and most fascinating aspect of the experience of drawing is that there are absolutely no limits to the manner, media, or modes in which it has been—and can still be — *extended*.

**8.18  Harold Cohen** (*Contemporary American*). *Installation in Documenta 6, Kessel, West Germany, 1977. Artist shown with computer, turtle, electronic display (Tektonix No. 4014), and work in progress. Courtesy the artist. Photo: Becky Cohen.*

*Cohen rejects the term "Computer Art" to describe his work because he feels that the computer, unlike other tools, is completely neutral since it isn't anything until it is programmed. He is shown here watching his "turtle" (a device of his own invention) generate one of its endless series of "freehand" drawings, no two of which are alike. He has been adding to this particular program for five years and as time goes on, its image-making* capacity has grown richer and richer. His program "is capable of differentiating between open and closed, between inside and outside. It is capable of handling repetition. It knows when spaces are occupied and when they are not." (Moira Roth, "Harold Cohen on Art & the Machine," Art in America, September–October 1970, pp. 106–110.) Cohen prefers showing the entire process rather than individual drawings since "the real content is the problem with which the spectator is engaged the moment he realizes that this curious drawing is actually being generated by a machine."

**8.19  Sonya Rapoport** *(Contemporary American). Details of Kiva–Studio, 1978. Pencil, color pencil, and Xerox transfer on computer printout. Courtesy Truman Gallery, New York.*

This is a small detail from two of eight panels, each 15″ × 110″ (38 × 140 cm) high. The piece concerns parallel elements of Indian culture and the artist's studio. Shown are comparisons of maps, masks (artist's makeup chart), respective places of ritual (Kiva and studio), and wall decoration. The Indian panels are drawn on computer printouts describing Indian ceramic analysis provided by an archeologist. The data from the computer printout underlining the studio panels was collected and organized by the artist, but in this case she did not use the computer directly. Hers is an aesthetic and humanistic response triggered by computerized research. Drawing directly on top of the printout, Rapoport's marks and symbols are relevant to the computer data.

# Now to Begin...

Yes, coming to the final pages of this book is not the ending but an opportunity to start afresh. Whatever you have learned is now a part of your experience—but it is your *past* experience. As with all instruction or influences, you must pick and choose from those which were significant for you. Do not hesitate to reject those with little further meaning for your continued development.

The most significant strides in the history of art have always been made by artists who have either rejected or reacted against their immediate peers or those artistic forms which most seemed to characterize that particular moment in time. Speaking of his student days working under the American Regionalist painter Thomas Hart Benton, Jackson Pollock has stated: "My work with Benton was important as something against which to react very strongly, later on; in this, it was better to have worked with him than with a less resistant personality who would have provided a much less strong opposition." (Irving Sandler, *The Triumph of American Painting: A History of Abstract Expressionism*. New York: Harper & Row, 1976, p. 103.)

The ending is to begin? Yes. As in one of Robert Rauschenberg's most famous works, the *Erased DeKooning Drawing* (**Figure 9.1**), the image of the past and present is obliterated and there remains only a ghost, a nearly empty space (the past is still there). In erasing this drawing, Rauschenberg has declared symbolically that the past and even the present are over. All that is left is a space, a space in which to begin again. . . .

The next page is reserved for you—for you to begin again. . . .

9.1  *Robert Rauschenberg (Contemporary American).* Erased DeKooning Drawing, *1953. (Erased drawing), 19" × 14½" (48 × 37 cm). Collection the artist. Courtesy Leo Castelli Gallery, New York. Photo: Walter Russell.*

*"I shall become a master in this art only after a great deal of practice, until eventually the results of my theoretical knowledge and the results of my practice are blended into one—my intuition, the essence of the mastery of any art. But, aside from learning the theory and practice, there is a third factor necessary to becoming a master in any art—the mastery of the art must be a matter of ultimate concern; there must be nothing else in the world more important than the art. This holds true for music, for medicine, for carpentry—and for love."*

Erich Fromm, *The Art of Loving.*
New York: Harper and Row, 1974, p. 4.

**I HAVE NEVER SAID THAT IT WOULD BE EASY.**

# Bibliography

It is possible for a bibliography for a book of this nature to take many forms. To list all of the important books on drawing would comprise a pretty extensive text. There are literally dozens of books which deal with most of the major old and modern masters and I suggest that you refer to your library's card catalog to find books on particular artists who interest you or who you feel would be beneficial to study in considerable depth. As an artist or student of drawing you should own several books (or at least borrow them from your local library) that survey the broad history of drawing. I have listed a number of them in the section on *Histories and Surveys*, although it would be quite possible to have an entirely different list which would be equally satisfactory. The books listed under the section on *Composition, Techniques, and Aesthetics* cover a vast range of material I have found exceptionally useful to my students and myself. An afternoon spent in the library browsing through these titles will be nothing short of an exciting adventure.

## Histories and Surveys

Battcock, Gregory, ed. and introduction by. *Idea Art: A Critique*. New York: E.P. Dutton, 1973. (paperback).

Bertram, Anthony. *1000 Years of Drawing*. London: Studio Vista Ltd., 1966.

Clark, Kenneth. *The Nude*. New York: Pantheon Books, 1956.

*Drawings of the Masters* (twelve volumes by various authors). New York: Shorewood Publishers, Inc., 1963.

Guggenheim Museum, The Solomon R., *Twentieth-Century American Drawing: Three Avant-Garde Generations*. New York: The Solomon R. Guggenheim Museum, 1976.

Lindemann, Gottfried. *Prints & Drawings: A Pictorial History*. New York: Praeger Publishers, 1970.

Mendelowitz, Daniel M., *Drawing*. New York: Holt, Rinehart & Winston, 1967.

Moskowitz, Ira, ed. *Great Drawings of All Time*, 4 vols. New York: Shorewood Publishers, 1962.

Rose, Bernice. *Drawing Now*. New York: The Museum of Modern Art, 1976.

Rosenberg, Jakob. *Great Draughtsmen from Pisanello to Picasso*. New York: Harper & Row. Revised edition, 1974.

Sachs, Paul J. *Modern Prints and Drawings*. New York: Alfred A. Knopf Inc., 1954.

Scharf, Aaron. *Art and Photography*. Baltimore: Penguin Books, 1974.

Stebbins, Theodore E., Jr. *American Master Drawings and Watercolors*. New York: Harper and Row, 1976.

Toney, Anthony. *150 Masterpieces of Drawing*. New York: Dover Publications, Inc., 1963.

## Composition, Techniques, and Aesthetics

Arnheim, Rudolf. *Art and Visual Perception*. Berkeley and Los Angeles: University of California Press, 1969.

Ballinger, Louise. *Perspective, Space and Design*. New York: Van Nostrand Reinhold Co., 1969.

Bridgeman, George. *Life Drawing*. New York: Sterling Publishing Co., Inc., 1961.

Cardinal, Roger. *Outsider Art*. New York: Praeger Publishers, 1972.

Chipp, Herschel B., *Theories of Modern Art*. Berkeley and Los Angeles: University of California Press, 1968.

Collier, Graham. *Form, Space and Vision*. Englewood Cliffs, N.J.: Prentice-Hall, Inc., 1972.

Firpo, Patrick; Alexander, Lester; Katayanagi, Claudia, and Ditlea, Steve. *Copyart: The First Complete Guide to the Copy Machine*. New York: Richard Marek Publishers, 1978 (paperback).

Hale, Robert Beverly. *Drawing Lessons from the Great Masters*. New York: Watson-Guptill, 1964.

Hill, Edward. *The Language of Drawing*. Englewood Cliffs, N.J.: Prentice-Hall, Inc., 1966.

Kaupelis, Robert. *Learning to Draw*. New York: Watson-Guptill, 1966.

Loran, Erle. *Cézanne's Composition*. Berkeley: University of California Press, 1943.

Mayer, Ralph. *The Artist's Handbook of Materials and Techniques*. New York: The Viking Press, Inc., 1957.

Nicolaides, Kimon. *The Natural Way to Draw*. Boston: Houghton Mifflin, 1941.

Peck, S.R. *Atlas of Human Anatomy for the Artist*. New York: Oxford University Press, 1951.

Rawson, Philip. *Drawing: An Appreciation*. New York: Oxford University Press, 1969.

Ruskin, John. *The Elements of Drawing*. New York: Dover Publications, 1971. (First published 1857).

Watrous, James. *The Craft of Old-Master Drawings*. Madison, Wisconsin: The University of Wisconsin Press, 1957.

Watson, Ernest W. *How to Use Creative Perspective*. New York: Reinhold Publishing Co., 1955.

# Index

Edited by Bonnie Silverstein
Designed by Jay Anning
Graphic Production by Hector Campbell
Set in 10-point Memphis Light